"Imbued with powerful lyrical im

"Goodison's memoir reaches back over generations to evoke the mythic power of childhood, the magnetic tug of home, and the friction between desire and duty that gives life its unexpected jolts."

—*Publishers Weekly* (starred review)

"Goodison unveils intimate worlds teeming with all the local flavor and poignancy of a Zora Neale Hurston novel. . . . A tender, thoughtful portrait of four generations, prompting hopes that the author's first full-length prose work won't be her last."

—*Kirkus Reviews*

"A memoir so exquisite it stands as an example of the possibilities of the form . . . rich in loving detail." —*Toronto Star*

"Fascinating. . . . Goodison's prose creates memorable characters."

—*Globe and Mail*

"Sensuous and evocative." —*Elle* (Canada)

"Glows with the lyricism that has made the author one of the leading poets of the Caribbean region." —*Winnipeg Free Press*

"Goodison has pieced together an intricate story of her family's evolution. . . . Wonderful, intimate."

—*The Gazette* (Montreal, Quebec)

"A lyrical, luscious book, *From Harvey River* is not just the story of a family and a village, it is a passport to an island where the plaiting lineages of a footloose world come home. Shaped with intoxicating grace and clarity, these characters will move right in and take up permanent residence in your heart." —Merilyn Simonds

"Compelling, [Goodison's] characters come to life with deft strokes."

—*National Post*

"Goodison's poetry language washes over us, elevating her observations of place and people to the realm of a masterpiece."

—Austin Clarke, author of *The Polished Hoe*

"A fabulous book." —*The Sun Times* (Owen Sound, Ontario)

"If you are looking for a book about a place with an exotic culture, a more interesting history than you might expect, and the tale of a large and loving family all woven together in a colourful tapestry of story, *From Harvey River* is the book to read."

—*Parry Sound North Star*

From Harvey River

FROM HARVEY RIVER

a memoir

of my mother

and her island

LORNA GOODISON

Amistad

An Imprint of HarperCollinsPublishers

Originally published in Canada in 2007 by McClelland & Stewart Ltd.
Reprinted by arrangement with McClelland & Stewart Ltd. A hardcover edition
was published in 2008 by Amistad, an imprint of HarperCollins Publishers.

FROM HARVEY RIVER. Copyright © 2007 by Lorna Goodison.
All rights reserved. Printed in the United States of America. No part of this
book may be used or reproduced in any manner whatsoever without written
permission except in the case of brief quotations embodied in critical articles and
reviews. For information address HarperCollins Publishers, 10 East 53rd Street,
New York, NY 10022.

HarperCollins books may be purchased for educational, business, or sales
promotional use. For information please write: Special Markets Department,
HarperCollins Publishers, 10 East 53rd Street, New York, NY 10022.

First Amistad paperback edition published 2009.

Library of Congress Cataloging-in-Publication Data has been applied for.

ISBN 978-0-06-133756-7

09 10 11 12 13 ID/RRD 10 9 8 7 6 5 4 3 2 1

To Doris and Marcus

Family Tree

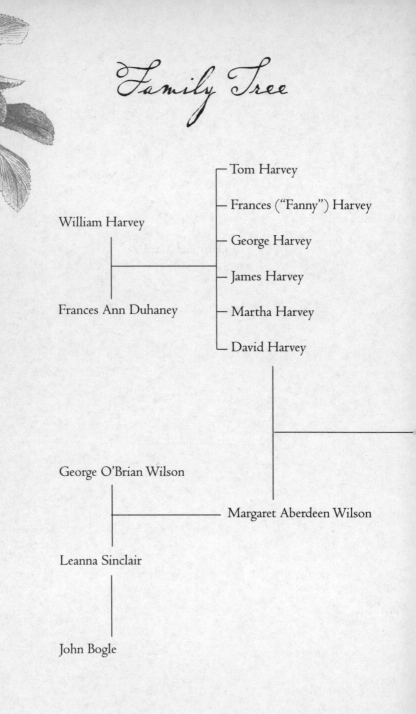

William Harvey

Frances Ann Duhaney

- Tom Harvey
- Frances ("Fanny") Harvey
- George Harvey
- James Harvey
- Martha Harvey
- David Harvey

George O'Brian Wilson

Leanna Sinclair

John Bogle

Margaret Aberdeen Wilson

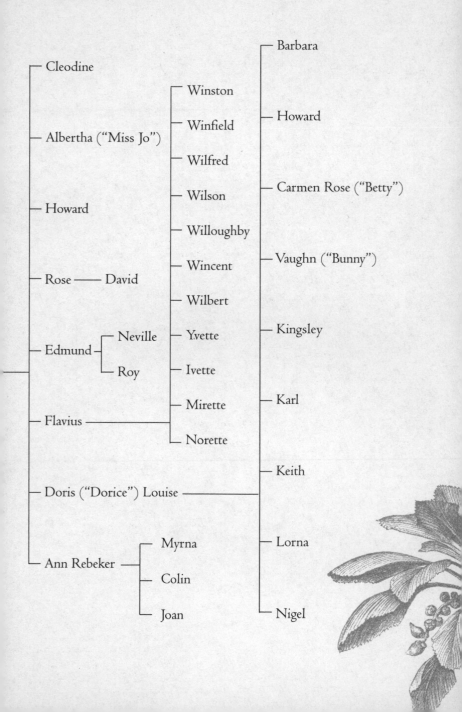

- Cleodine
- Albertha ("Miss Jo")
- Howard
- Rose —— David
- Edmund
 - Neville
 - Roy
- Flavius
 - Winston
 - Winfield
 - Wilfred
 - Wilson
 - Willoughby
 - Wincent
 - Wilbert
 - Yvette
 - Ivette
 - Mirette
 - Norette
- Doris ("Dorice") Louise
- Ann Rebeker
 - Myrna
 - Colin
 - Joan

- Barbara
- Howard
- Carmen Rose ("Betty")
- Vaughn ("Bunny")
- Kingsley
- Karl
- Keith
- Lorna
- Nigel

From Harney River

Prologue

Throughout her life my mother lived in two places at once: Kingston, Jamaica, where she raised a family of nine children, and Harvey River, in the parish of Hanover, where she was born and grew up. Harvey River had been settled by her grandfather William Harvey, who gave his name to the river, and the river in turn gave its name to the village. I do not think that there was ever a day in my childhood when the river or the village was not mentioned in our house. Over the years Harvey River came to function as an enchanted place in my imagination, an Eden from which we fell to the city of Kingston. But over time I have come to see that my parents' story is really a story about rising up to a new life. As a child I constantly asked my mother about her life before, as she put it, "things changed." I listened carefully to her stories, and repeated them to myself. I also took to asking urgent questions of my father. I have an image of me standing outside the bathroom door calling in to him over the noise of the shower, "So what was your mother's name, and what was her mother's name?" But my

father's people do not live long, and he died when I was fifteen years old. So I never did get to ask him all my questions. After my mother Doris's death nearly thirty-five years later, I began to "dream" her, as Jamaicans say, and in those dreams I continued to ask her questions about her life before and after she came to Kingston. And then there was this one very vivid visitation when I dreamt that I went to see her in her new residence, a really palatial and splendid sewing room with high stained-glass windows, where she was now in charge of sewing gorgeous garments for top-ranking angels. She said they were paying her a lot for her sewing in this place, and that all her friends came to talk angelic big-woman business with her there as she sewed. She said she could not tell me more as she did not want me to stay with her too long, because the living should not mix-up too much with the dead. But as I was leaving the celestial workroom, she handed me a book. This is that book.

part one

The baby was plump and pretty as a ripe ox-heart tomato. Her mother, Margaret Wilson Harvey, gently squeezed the soft cheeks to open the tiny mouth and rubbed her little finger, which had been dipped in sugar, back and forth, over and under the small tongue to anoint the child with the gift of sweet speech. "Her name is Doris," she said to her husband, David.

In later years, my mother preferred to spell her name Dorice, although in actual fact she was christened Doris. But she was registered under a different name altogether – Clarabelle. This came about because of a disagreement between her parents as to what they should call their seventh child. Her father, David, was a romantic and a dreamer, a man who loved music and books, and an avid reader of lesser known nineteenth-century authors. He had read a story in which the heroine was called Clarabelle, and he found it to be a lovely and fitting name. He told his wife, Margaret, that that was to be the baby girl's name. Well, Margaret had her heart set on Doris, because it was the name of a school friend of hers, a real person, not some made-up somebody who lived in a book. Doris Louise, that was what the child would be called. They argued over it and after a while it became clear that Margaret was not going to let David best her this time. He had given their other children names like

Cleodine, Albertha, Edmund, and Flavius. Lofty-sounding names which were rapidly hacked down to size by the blunt tongues of Hanover people. Cleo, Berta, Eddie, and Flavy. That was what remained of those names when Hanover people were finished with them. Margaret had managed to name her first-born son Howard, and her father had named Rose. Simple names for real people.

There was nobody who could be as stubborn and hard-headed as Margaret when she set her mind to something. She was determined that her baby was not going to be called Clarabelle. "Sound like a blasted cow name," she said. David gave up arguing with his wife about the business of naming the pretty-faced, chubby little girl, especially after Margaret reminded him graphically of who exactly had endured the necessary hard and bloody labour to bring the child into the world. He dutifully accompanied her to church and christened the baby Doris, on the last Sunday in June 1910. Then the next day he rode into the town of Lucea and registered the child as Clarabelle Louise Harvey, and he never told anyone about this deed for fifteen years. As a matter of fact, he is not known to have ever told anyone about it, because the family only found this out when my mother tried to sit for her first Jamaica Local Exams, for which she needed her birth certificate. When she went to the Registrar of Births and Deaths, they told her that there was no Doris Louise Harvey on record, but that there *was* a Clarabelle Louise Harvey born to David and Margaret Harvey, née Wilson, of Harvey River, Hanover. She burst into tears when she heard what her legal name was. "Clarabelle go to hell" her brothers chanted when the terrible truth was revealed. Not one to take teasing lightly, she told them to go to hell their damn selves.

Eventually her name was converted by deed poll to Doris.

Thereafter, she signed her name Dorice, as if to distance herself from the whole Clarabelle/Doris business. Besides, Dorice, pronounced "Do-*reese*," conjured up images of a woman who was not ordinary; and to be ordinary, according to my mother's oldest sister, Cleodine, was just about the worst thing that a member of the Harvey family could be.

~

Cleodine was definitely not ordinary. She held the distinction of being the first child to be born alive to her parents, David and Margaret Harvey. She emerged into the world on January 6, 1896, as a tall, slender baby with a curious yellowish-alabaster complexion. The child Cleodine immediately opened her mouth and bellowed so loudly that the midwife nearly dropped her. Before her, not one of the five children conceived by Margaret had emerged from her body alive. Every one had turned back, manifesting themselves only as wrenching cramps, clotted blood, and deep disappointment.

This time around, her husband, David, had watched and prayed anxiously as Margaret's belly grew big with their sixth conception. Would this baby be the one to make it? Would it be the one to beat the curse of Margaret's seemingly inhospitable womb? The doctor had ordered her to bed the day it was confirmed that she was again pregnant, and once this happened, her mother, Leanna, had announced that she intended to mount upon her grey mule and gallop over to Harvey River each morning to take care of her daughter. Leanna forced her to lie still for most of the nine months, forbidding her to go outside, even to use the pit latrine. Instead she made her use a large porcelain chamber pot which she herself emptied. She bathed her daughter like a baby each morning and combed her

long hair into two plaits, pinning them across her head in a coronet. She prepared nourishing invalid food and fed her steamed egg custards and cornmeal porridge boiled for hours into creaminess and sweetened with rich cow's milk. She made her thyme-fragrant pumpkin soup and fresh carrot juice, because Margaret's cravings were all for golden-coloured foods, which she ate sitting up in her big four-poster mahogany marriage bed. Another reason for feeding her these soft foods was that Margaret had become afraid that any abrupt, jarring movement might dislodge the foetus. She chewed upon these soft foods slowly and gently, and later, to occupy herself she sat propped up in bed quietly stitching and embroidering every imaginable type of garment, except for baby clothes.

After Leanna departed each evening to return to the arms of her husband, John Bogle, David sat by Margaret's bedside and filled her in on what was happening in the village. He read to her from the newspapers or the Bible, and then he retired to the adjoining bedroom to sleep alone. Margaret and he had both agreed that nothing, not even their much-enjoyed conjugal lovemaking, should endanger the safe delivery of this child. David, who was an extremely private and modest man, had to bear with his mother-in-law, Leanna, saying the same thing to him each evening before she left: "Remember Mas D, no funny business tonight." And David, who believed that all such matters were truly private, would flush and say to his mother-in-law: "Don't worry about me and my wife's business."

For every one of those turned-back births, Margaret had prepared elaborate layettes. David had even bought an ornate, Spanish-style christening gown in Cuba the first time that she had become pregnant, a gown which they had given away in despair after they lost child after child. This time she was determined that she would prepare nothing for this baby just

8

in case. Just in case fate had decided to insult her once again, she was preparing to insult fate first. See, she would say to fate, I never expected any baby to be born alive, because I never even prepared any baby clothes. Not a small sheer poplin chemise or a soft white birdseye diaper. Not one woollen bootie did she knit or crochet, not one bootie the length of her index finger. No beribboned bonnet big enough to cover a head the size of a grapefruit; nothing. She had given away all the clothes she had made for her lost babies. Then one year later she found out she was pregnant again, but this time she was prepared for the worst. She would take to bed and chew gently, yes, but not one garment would she make in case she lost this baby too. Not one garment would she make, but every time she had such a thought, the foetus would deal her a swift kick from inside the womb. It was as if the baby Cleodine wanted to step out and occupy her place in the world immediately, because hers had been nearly a breech birth. However, the midwife succeeded in persuading her to come in headfirst, and she crowned promptly at 6 a.m., then shouldered her way out, announcing her presence with a commanding bawl.

"Oh my God, look Missus Queen," was what Margaret said when she saw her first-born, because the baby bore an amazing resemblance to Queen Victoria. When the news went out through the village that a baby girl had broken Margaret and David Harvey's bad-luck-with-children cycle, the Harvey relatives came calling. Many of the women arrived bearing beautiful garments they had sewn in secret because everyone in the village knew of Margaret's attempt to disarm fate by refusing to prepare for this baby. They brought exquisitely embroidered baby dresses, dozens of gleaming white birdseye napkins already washed clean in the Harvey River and dried near the field of lilies. They brought knitted woollen caps and booties,

mostly in white and yellow, not pink or blue, because nobody wanted to go so far as to predict the sex of the baby that the whole village all but fell down and worshipped. Born to rule, the little girl Cleodine was hailed as a "Duppy Conqueror," a mortal who triumphs over the baddest of ghosts, because she had cleared all the killing spirits out of her mother's way.

First-born children set the pace; they are the engine of the sibling train, the source of authority, inspiration, and energy for all the brothers and sisters who follow. The first child in a family must be raised to be bold, ambitious, strong and confident, the example for all the other children coming behind. Or so Margaret and David, like many parents of that time, believed — that the first child in a family was undoubtedly the most important one.

For the first year of her life, Cleodine's long narrow feet did not touch the ground because someone was always holding her aloft, showing her off to admiring strangers. Look she was born with two teeth, look she had nearly a full mouth of teeth before she was eight months old, look she is obviously bright, very bright. Look at her eyes, amber brown like a tiger's eyes, and those extraordinary fingers, like those of a piano player. The child often waved them like the conductor of an orchestra.

Maeve, Queen Maeve, was what Margaret's father, George O'Brian Wilson, had wanted to call his first female grandchild by his favourite child, Margaret. Queen Maeve the powerful mythical Celtic queen. But David said no, and put his foot down. He would name his first child, he and he alone. Yes, she would be named after a queen, for she was a queen and he toyed with the idea of calling her Victoria. But secretly he was hoping that the child would grow out of her resemblance to Queen Victoria, who, let's face it, was not a pretty woman.

Cleopatra, Queen of Egypt. A beautiful woman, powerful enough to mesmerize King Solomon. That would be the child's name. When he told Margaret that the baby's name was Cleopatra, he lowered his voice and said, "Cleopatra, we can call her Cleo; my Cleo, Cleo mine." Margaret looked at him and said, "Cleo Mine or Cleo Thine?" And they liked the sound of that and called the baby Cleodine, who proceeded to grow up and rule over everybody in Harvey River as long as she lived there.

Two years after the triumphant entry of Cleodine into the world of Harvey River, Margaret gave birth to another baby girl. In what would become an act of prescience, they named the girl Albertha. Having produced a healthy and intelligent child in the form of Cleodine, Margaret was a little more re-laxed about giving birth the second time around. She did not take to her bed as she had done when she was carrying Cleodine, but she was completely convinced that if she was going to bring this baby to full term she would have to behave as seriously as possible for the duration of this pregnancy. If, in her mind, hard-chewing had posed a danger to the safe delivery of Cleodine, then she decided that mirth, laughter, frivolity, these things would surely serve to place harm in her way. Again, she had not made any clothes for this baby, but this time it was not because she was trying to pre-empt fate, this time she had no need to prepare baby clothes because Cleodine had been showered with so many beautiful garments by the overjoyed people of Harvey River that this second baby would always be able to wear her big sister's gorgeous outgrown dresses.

Everybody called Albertha "Miss Jo" from the day that she was born. Perhaps they called the small girl "Miss Jo" because there was an absence of anything jovial about her grave, unsmiling little presence. The baby seemed to have absorbed her mother's fear of joy as a dangerous force while she was in the womb, the same fear that caused some Jamaicans to quote proverbs like "Chicken merry, Hawk near" to people who seemed overly happy. The truth was that Margaret and David had been hoping for a boy. Nothing would have made them happier than the birth of a male Harvey, so while there was some rejoicing at the safe delivery of this second child, alas, Miss Jo was not destined to be a star like Cleodine, who, when taken into her mother's room to view her sister, immediately said: "I big, you little." Albertha grew into a fair-skinned, always inclined-to-stoutness girl of medium height. Her outstanding features were her broad, high cheekbones, and her dark eyes, which could have been described as lovely if they did not perpetually seem so sad. From very early in her life she displayed certain prudish tendencies which made it quite clear that she did not enjoy the rude and rustic ways of country folk. She was pious and chaste and she never laughed at the smutty jokes involving the sex life of animals in which country children took delight. The rude, suggestive words of Jamaican folk songs did not cause her to giggle, like they did other small children.

> Gal inna school a study fi teacher
> bwoy outside a study fi breed her
> Rookumbine inna you santampee, rookumbine . . .

No, such songs did not cause her any amusement whatsoever. Her presence was a check on any loud-laughing, rude-joke-telling gathering. She was forever declaring that such and

such a person was "too out of order," forever complaining to her parents that one or the other of her siblings had transgressed in some way. All dancing, except maybe a stately waltz, was nothing but coarse slackness to her. She passed her time mostly reading and doing elaborate embroidery, for which she developed a great talent. This was the one area in which she grew to outstrip her older sister, a fact that greatly angered the competitive Cleodine, but which caused Miss Jo to ply her needle the more to scatter lazy daisies and raise up padded petals of roses across the surface of tray cloths and doilies, even as she looked with sadness and disapproval upon any coarseness and impropriety.

~

After Margaret had given birth to two daughters, she yearned deeply for a son, so when Howard was born, he was like a messenger sent from beyond to assure her that, yes, she was a complete woman. He looked just like a cherub, an angel baby. She breast-fed him until he could walk and talk. She rose at least seven times at night to check on the rise and fall of his breath as he lay asleep in his cot. Whenever he had a cold she would put her mouth to his tiny nostrils to draw the mucus down to clear his breathing; and in the rainy season, she warmed his clothes in her bosom before she dressed him. She did not go so far as to mark his limbs with the symbolic "no trespassing" hieroglyphics, like many mothers in the village who would draw ancient African symbols with laundry blue on the backs and bellies of their babies. This was done to warn away sucking spirits. Neither did she resort to pasting sickly-smelling asafetida around the tender, vulnerable fontanelle or "mole" as Jamaicans call it, throbbing at the top of his head, in

the hope that its acrid, medicinal smell would keep away ghosts and envious spirits. David, a staunch Anglican and the son of an English father, would not have had it. He did not hold with what his father called barbaric practices. Margaret, in any case, was not going to leave her son's care and protection to any random spirit guardians. She preferred to watch him herself. However, she did surreptitiously sweep his tiny feet with a soft broom when her husband was not looking. This was to prevent him from becoming a "baffan," or fool.

She never allowed any strangers to hold Howard. She rarely ever took him out in public until he was about three years old, because she didn't want people to "overlook" him, that is, to look at him too much with longing, envious eyes. She did not cut his luxuriant mass of black curls which cascaded down past his shoulders until he could speak clearly. And so, for the first few years of his life, he did indeed look like a beautiful, sexless angel. Margaret dressed him in sailor suits made from appropriate sharkskin. "You are a sailor like your grandfather," she would say as she transformed him into a nautical cherub, and her husband would say, "I don't want my son to take after your father." But even as Margaret dressed the boy in sailor suits, she harboured a deep fear that he would die from drowning. She had run through all the possible harm that could befall a child living in that village, and had identified the river as the thing that posed the most danger. "There was no child born in Harvey River at that time who could not swim," my mother would say. Everyone in the village used the river. They washed their clothes there, pounding them clean on the grey shale rocks. Everyone drew drinking water from the river, which ran clean and clear, coursing down always fresh from its secret source somewhere in the interior of the Dolphin Head Mountains. They all swam in it too. Mothers would take small babies

there for the ritual bathing and sopping and stretching of their limbs; they would release the babies into the river where they would instinctively kick their arms and legs.

All the children of Harvey River could swim, all except for Howard. Margaret had decided that the child should not bathe in the river, for that was where she would lose him, although no one in the village had ever drowned in it. Only once, a man from the nearby village of Chambers Pen had been stumbling home one night, drunk on john crow batty white rum, and while weaving a rummish path home in the dark turned right instead of left and fell in the river. "All the crayfish and janga must be drunk now," said the people of the village. David's father, William Harvey, had joked, "That man had only a little blood in his rum stream." William was especially proud of his joke because one of his ancestors, born in 1578 and also named William Harvey, had discovered the circulation of blood and had been physician to James I and Charles I.

For a time, David humoured Margaret's fear of the boy drowning. But when one day he came upon her bathing Howard in a wooden washtub, he grew angry and yanked the boy – who was tall for his age – out of the tub, took him down to the river, and taught him how to swim. After that there was no stopping Howard and the river. But every time he scampered away half-naked and gleeful, Margaret would worry until he returned damp and glowing like one of the Water Babies in Charles Kingsley's story. And those babies had all drowned.

The boy grew into the most handsome of young men. He became a sweet boy, a boonoonoonoos boy, a face man, eye-candy man, pretty-like-money, nice-like-a-pound-of-rice man. Lord, women loved him. Older women looked at him greedily, as if he were some sweet confection that they could eat slowly and then lick their fingers long afterwards. Young girls just

openly offered themselves to him. "Here I am, handsome Howard, pick me, choose me." They fought to get to sit beside him at school and in church, to have him sweep those long lashes up and down the contours of their trembling bodies, to call them by name. "Yes, it's you Cybil, you I talking to." "Me, you mean . . . Howard, me? Oh yes, oh joy!" They befriended his sisters in order to get a chance to visit the Harvey household and be near to him, to drink from the same teacups from which his lips had sipped, to peep into his room and see the bed that he slept in. He could have had any woman in the district. That is why he never married, he just had too many beautiful women to choose from. Why then did he follow a Jezebel clear to Lucea, there to meet his death?

"My Irish Rose" is what George O'Brian Wilson had said when he first saw his fourth grandchild. He also called her his Rose of Tralee and his Dark Rose, and the baby just smiled. David and Margaret agreed she just had to be called Rose because nobody had ever seen a more beautiful baby. Unlike Queen Victoria Cleodine, the unsmiling Miss Jo, and the almost-too-handsome Howard, Rose was perfectly beautiful inside and out. This baby was born smiling, causing her mother to wonder why, why was this baby smiling already, what was she smiling about? Perhaps she was smiling because everybody who ever laid eyes on her, loved her.

People liked being near the beautiful baby who hardly ever cried and who cooed like a little Barbary dove at the sight of sunbeams streaming in through the front window. More than ever the people of Harvey River began to find excuses to visit David and Margaret's house, because somehow being in the

presence of this child just made everyone feel better. First of all, no one could help noticing that even more than other babies she had an especially sweet body scent, as if she had been birthed in the bed of lilies that grew behind the Harvey house. Her flawless brown skin had a pinkish glow to it, and her soft black hair curled on her head like petals. She was born with an unusually sweet disposition, which could be credited to the fact that Margaret was never happier in her life than in the years after Howard was born.

Margaret had not entertained any strange no-hard-chewing, no staid no-smiling superstition when she carried Rose. The moment she had conceived Howard, she somehow knew that she was going to get her wish for a son. And she had made herself six blue dresses which she wore throughout the duration of her pregnancy. That was the only "strange" thing that she did. After the birth of Howard, she treated the rest of her pregnancies normally, as she went on to deliver up a new baby every two years.

"Three rinse waters, they must go through three separate rinse waters so they will be completely clean." Margaret, who was pregnant with Edmund at the time, had suspected that the girl who came to do the washing was only rinsing the family's white clothes twice, for they were looking a little dingy. So after she had walked the girl back to the river to perform the third rinsing, Margaret returned to the house, where she had left Rose napping on a blanket on the floor, to find the child missing. They searched under every bed, every chair, table, and wardrobe, under every bush in the yard, but there was no sign of Rose, and a great wailing came up from the Harvey house.

Just at that exact moment, David's half-brother, called Tata Edward, was taking his daily constitutional in the midday sun,

when he spotted the village crazy woman walking swiftly away from Harvey River with a small child held tightly in her arms. "My little girl, my little girl, look how she favour me, look how she favour me, I am taking her with me to Panama" was what she kept saying as Tata Edward dealt her a swift blow with his walking stick, causing her to let go of his beautiful niece. Being an excellent cricketer, he then swiftly flung himself sideways onto the grass and caught Rose before she fell to the ground. The poor woman, whom the villagers called Colun, had gone insane waiting for her lover to send for her to join him in Panama. Like everyone else, she had fallen in love with Rose, and for two years she had been peeping at the child through the hibiscus hedges surrounding the Harvey house. When she had made up her mind to steal Rose, she had spent days making a house of leaves and branches for the two of them to live in in the bushes outside Harvey River. The child just kept smiling while all the commotion was going on around her.

"Look how this damn blasted woman, who fool enough so make man mad her, come take way my child! Is me tell her to fret herself till her head start run over that idiot who fool her and gone a Panama? Why she come pitch pon my house and my child?" Margaret cried and cursed the poor woman and thanked God and Tata Edward. David prayed aloud from Psalm 91. "He that dwelleth in the secret place of the most High, shall abide in the shadow of the Almighty. I will say of the Lord He is my refuge and fortress: my God in him will I trust. Surely he shall deliver thee from the snare of the fowler, and from the noisesome pestilence. He shall cover thee with his feathers, and under his wings shall thou trust; his truth shall be thy shield and buckler, thou shall not be afraid of the terror by night; nor of the arrow that flieth by day." And the district constable came and arrested the poor woman for the

"crime" of being insane while the two-year-old Rose — who, for her part, seemed to have been born with some sweet secret — just kept smiling all the time.

As she grew, Rose's ability to keep a secret endeared her to her siblings and, later, to her school friends. If someone said, "Rose, I going tell you something and you mustn't tell anybody you hear?" the pretty little girl would just smile, shake her head, and use her thumb and forefinger to screw her lips shut. And her sibling or school friend might say, "swear to God." And Rose would just say, "not telling." And you could be sure that no matter what, Rose would never, ever reveal a secret or disclose anything told to her in confidence.

Because her belly had been more pointed than round, Margaret was happy to hear that everyone predicted her fifth baby would be a boy. There were only three things that caused her any discomfort during her pregnancy. First, she felt irritable all the time as opposed to just some of the time, and she found it disconcerting that she had suddenly lost her appetite for dry white Lucea yam, which was her favourite food. But the strangest thing of all was that she, who did not believe in ever going too far from her house, inexplicably developed a case of wanderlust and began to visit friends and neighbours in surrounding villages. Everyone in Harvey River began to remark on this. "Guess who mi buck up walking out a while ago? No, Mrs. Harvey! I never see her outta road yet, and make matters worse she big, big, soon have baby!" "David," Margaret would say, "I feel to go and visit my mother." "You sure, Meg? You are a lady that hardly ever leave your house. I can send to call your mother, she will ride come." "No, I want to go."

And so it went, all during her pregnancy stay-at-home Margaret became walkbout-Margaret, until the minute that Edmund was born, when she lost all interest in ever leaving the house. The baby Edmund was born in the middle of the night. "This baby born quick quick," said the midwife. "Him just slip out and slide right past me, like him want go walkbout already." Because he weighed just under six pounds, they had to pin him by his chemise to a pillow so Margaret could hold him to feed him properly. "Aye, he looks like a leprechaun, like one of the little people," said George O'Brian Wilson when he came to see his latest grandson. "Mind he doesn't get up in the night and make mischief on ye all." David and Margaret had had a good laugh when George Wilson said that. The little baby Edmund, who was also born with a short temper, howled.

It seems that all Edmund ever wanted to do was to leave Harvey River. As soon as he could talk, he would say, "Too dark." Then he would say, "Too damn dark." "What is too dark?" they would ask him, and he would say, "Here."

As he grew he also developed a dislike for bush. "Too much bush," he'd say, and everyone would say, "So what you expect, you live in the country." That did not stop Edmund from disliking his birthplace. All that bush. Everywhere he looked all he could see was bush, and under every bush the duppy of some godforsaken slave. The boy's heart did not sing out with joy as he beheld dawn rising pink and slow, moving like the folds of a woman's nightdress up over the Dolphin Head Mountains. His spirit did not rise and canter like a young horse over the verdant green pastures each day, because he hated all the macca, the thorns set there in the green grass to pierce his bare feet. The wicked cow-itch weed that itched you till your skin would bleed. The nasty white chiggoes that bored into your feet and

laid sickening mock-pearl parasite eggs. Grass lice, ticks, cow, goat, and horse shit, flies and mosquitoes.

"Jamaica is a blessed country, there are no fierce animals or poisonous snakes here, and Harvey River is like the Garden of Eden." David was always saying that. Edmund used to kiss his teeth when he heard it. Yes, but what about all those blasted insects, what about the thick darkness? He particularly hated the peenie wallies, fireflies, damn stupid little flies with that weak on and off light coming out of their backsides. He craved real lights. Street lights. He had heard that in Montego Bay and Kingston the streets were lit by tall gas lights. "Moon pan stick" country people called those lights.

And then there was the darkness of the people. Country people, always telling each other "mawning Miss this or Mas that." Who the hell wanted any mawning from them, thought Edmund. And the worst part was, if he did not answer them they would run and report him to his parents, who would chastise him for not having good manners. Good manners be damned. When he was thirteen years old he had actually asked his father one day where good manners ever got any black man and had his father ever noticed that massa and massa's sons and daughters—some of whom were famous for not having good manners—always seemed to reach very far. David had been appalled by that statement, and called Edmund a savage.

Edmund could not understand how he was so unlucky as to have been born in the country. From the first time that his father took him to Kingston when he was ten years old, he knew that the city was the place for him. There the streets had names, King Street and East and West Queen Street and Port Royal Street and Rum Lane. Not "outta road," like in the country.

Town had milk shops where he could go and order as much liver and light (light being what Jamaicans called the lungs of

the cow or goat) for breakfast as he wanted. Eat, belch, pay his money, and walk out like a big man. Also rum bars where a man could order his rum by the QQ (a quarter quart), by the flask or the tot, put a question to the barmaid, who was probably called Fattie, and take her home to his room that he had rented. His room where he could turn his own key and come in at any hour of the day or night he pleased because he was his own man. Town, where cars drive up and down day and night. Cars and buses and trucks and tramcars ran all the time. Not like this back-a-bush place with only donkey, mule, and horse. Who the hell said country nice? Not Edmund.

He considered it God's make mistake why he was born in Harvey River. He was Moses among the bulrushes. If only Pharaoh's daughter would just appear and carry him to town. As a child he would run outside to stare at any motor vehicle that managed to fight its way up to the village. He fashioned a steering wheel from an old pot cover and "drove" wherever he went, going "brrrum, brrruum" in imitation of the noise of motor vehicle engines, and he made hissing, screeching sounds whenever he stopped, like the boiling over hissing brakes of trucks.

David rode a horse and Margaret had a pretty, dainty-stepping donkey, but nobody who lived in the village owned a motor car. Edmund had been taken to Montego Bay as a child and had seen the taxi men driving tourists around. Even as a boy, he had been struck by the elite corps of smartly dressed men in starched white shirts and black pants, who all spoke "Yankee" and smoked cigarettes and had the prettiest women, because girls just loved a man who drove a car. Later, he would hear that tourist women — mostly rich Americans and English-women — would sometimes fall in love with a taxi man.

While Howard was being taught to become a saddler by his grandfather George Wilson, and his younger brother Flavius had expressed a desire to be apprenticed to the tailor in the next village, Edmund was expected to help his father with the cultivation of the coffee, cocoa, and yams, and if ever there was a man who hated agriculture that would be Edmund. As he explained to Flavius, who was a born farmer, what the hell would he, Edmund, be digging, digging in the ground for? The only thing he ever wanted to dig for was gold. Gold to make ring and chain and decorate his teeth and give as earring and brooch to women as presents. As far as he knew there was no gold to be found in Jamaica. He would much rather buy rice and bread from a shop than eat yam. As a matter of fact he refused to eat yams once he left Harvey River.

⁓

"Why the baby looking at me so?" said everyone who ever held my uncle Flavius in their arms when he was an infant. "Hey boy, if you see me again you will know me?" is what the children at the village school would ask him when he began to attend classes there at age seven. David and Margaret used to wonder when and if their sixth child ever slept because it seemed that no matter what hour of the night they checked on the children in their beds, the light of the Home Sweet Home lamp would reveal Flavius to be awake, alert, and staring hard into the darkness. Soon after he learned to walk, he armed himself with an old cooking spoon for a shovel and took to digging in the ground around the Harvey house. Then one day Flavius stopped staring so hard into people's faces and took to walking with his head held down, a habit which greatly

upset his parents. "Hold your head up, what do you have to be ashamed of, why you holding down your head so?" said his father, who had named him after a Roman nobleman in one of the books he had read. But Flavius was not ashamed; he was searching for something. Sometimes in his digs he found coins, and once somebody's gold ring which must have been very old because the gold was so thin it was almost translucent. Another time he found a pewter spoon and the head of a china doll. He kept his "treasures" in a pile beneath the house, and he always said that when he built his own house in Harvey River, he intended to transfer his things there because, unlike his brother Edmund, Flavius had no desire to leave Harvey River. He was sure that whatever he was searching for was to be found right there in the parish of Hanover — and that included a wife. But before he identified a prospective helpmate and mother for their children — he intended to have a large family — he decided that he should be sent to learn tailoring, for he was not one to put all his eggs in one basket. Everybody said the boy had a good hand for planting, and in his time he reaped quite a few prize yams. Flavius reasoned that while the yams were growing, he could just as well be stitching somebody's wedding suit. And as only madmen walked around without trousers, the men of Hanover would always need the services of a tailor. So he was sent off to learn how to "build" suits and trousers from tailor May of Grange, Westmoreland, whose father and grandfather before him had all been fine tailors. After being apprenticed to tailor May for a year, Flavius came back to Harvey River and began to sew for the men in the area. He grew to be quite proud of the fact that almost any man, even a struggling, ordinary-looking man from the country, could be mistaken for an important person when he put on one of Flavius's well-constructed suits. When he finally proposed to a young

woman named Arabella with whom he had gone to school in Chambers Pen, a petite girl with large soulful eyes and a still spirit, Flavius had his ducks all in a row.

~

Ann Rebeker Harvey was the last child or "washbelly" born to David and Margaret. The late pregnancy had come as a complete surprise to Margaret, who had naturally assumed that her child-bearing days were over after she gave birth to my mother, Doris, at age forty. Margaret was stunned when she discovered that she was going to be a mother for the eighth time, for frankly, she was tired of the whole giving birth business. The sickness, the bigness, the breast-feeding, the constant careful watching over the child till it was old enough to walk and talk. The never feeling tidy, the constant mother's perfume smell of baby powder and puke out-weighed the heartstopping beautiful moments, the sheer joy and pure delight that babies bring. She therefore elected to go through her last pregnancy with a fatalistic, what-is-to-be-must-be attitude.

Ann emerged into the world one June morning, looking like a chubby Hindu goddess made from milk chocolate. Her round little "head-cup," as Jamaican people call the skull, was covered by a cap of shiny blue-black hair, and instead of letting out a loud cry when the midwife gave her a welcome-to-the-world slap, the first sound that the baby Ann made was a cross between a laugh and a shout. She promptly proceeded to charm everyone around her when she opened her wide, heavily fringed dark eyes and proceeded to wink! Everyone instantly fell under her spell, everyone except her exhausted mother. Her siblings, even Cleodine, always treated her as if she was a

pretty doll who was born to amuse and delight them, and they all vied to take care of her, which suited Margaret just fine.

"One of you come and take this baby little, make me get to sleep, she is one fiery little thing, just want to laugh and play day and night. I'm a old woman I can't manage her." Her brothers and sisters were happy to oblige and from early on she developed into a very sociable being. Ann walked and talked before any of her siblings, and from the time she was small she was able to keep a roomful of people in stitches by doing her solemn wink and pulling ridiculous faces.

As soon as she could talk in sentences, she began to do funny, wicked imitations of everyone in the village, including the local Anglican minister. Her brothers and sisters would often put her to stand on a chair in the dining room of the Harvey house and say, "Go on Ann, preach like parson now," and the little girl would say, "Peeeple of Hawvy Rivah, heed the wohords of the a-passil Pawll . . ." catching the minister's affected preaching voice exactly. It was the same minister who had told her father, David, when he went to call upon him to welcome him to the parish, "Oh, I already met your half-brother Edward, whose mother was from England. Surely he is the king of the Harveys." "King to you," David had replied, "but not to me."

This same minister loved to preach from Ephesians 6:5, about how masters should be kind to their slaves and slaves were to be obedient to their masters. David had finally told the Englishman one morning after church that he would appreciate it if he stopped quoting from that passage in the Bible because slavery was fully abolished in Jamaica in 1838, and as the natives had it to say, "Massa day done!"

People soon began to beg the little girl Ann to do her imitations, especially the one of the village mendicant, who always

came by the Harvey house at the same time every day saying the same thing. "Morning mi massa, morning mi missus, beggin' you something to help poor me one." The "poor me one" was a bird whose low plaintive cry sounded to the ears of the Jamaicans as "Poor me one," and this man had adopted its name to aid him in his solicitation of alms. Everybody had forgotten his real name anyway, so they all called him "Poor me one."

But the man was not poor. He was a miser, and some people said that when he died they would probably find crocus bags of gold hidden under his banana trash mattress. The small child Ann had waited for him one morning, and as he drew up to the gate to sound his alms-begging request, the young girl borrowed the man's own voice and pre-empted him, calling out, "Morning mi kind massa, morning mi kind missus, beggin' you something to help poor me one." He never stopped at their gate ever again.

Unlike her siblings, Ann — the baby of the family, eighth child of David and Margaret, Ann with the blue-black hair, who grew to look like a girl in a Gauguin painting — did not fear her mother, Margaret. All the Harvey children humbled themselves under their mother's stern, often unsmiling gaze, and they tried to respect her oft-quoted edict, "No child of mine will ever rule me." No child, except Ann. It wasn't so much that the girl wanted to rule her mother, it was just that she was born free. The girl looked like a Gypsy. It was amazing how all the mixing of bloods produced people who looked like Indians and Gypsies. People who, if they were flowers, would be birds of paradise and Cataleya orchids. Ann, the last child of David and Margaret Harvey, looked like a bird of paradise. She radiated a kind of energy that was hard on her mother. "David, tell her that she cannot back-answer me."

"Just allow her, she is a good child, don't break her spirit."

"What, and make her rule me in my own house?"

People would call out to her, "Come here Ann Rebeker and give me a joke." And the child would do just that. It seemed as if she had been put on the earth to bring joy and happiness to everyone except Margaret.

"Show off bring disgrace, and high seat kill Miss Thomas' puss," she'd say.

"Lord, Margaret, just allow the child to prosper."

Where did this girl get this joy? This uncontainable, bubbling-over merriment that made her laugh and joke and giggle so much?

Unlike Margaret's other children, Ann never, ever appeared to be afraid of her. Once, when Margaret had quoted the Biblical injunction to her about honouring one's mother and father, the girl had reminded her that the same passage also said that parents should not provoke their children to wrath.

ow Harvey River became Harvey River. For all we know, the village of Harvey River used to have another name, but when my mother's paternal grandfather and his brother founded it in 1840, the old name was lost forever. The Harvey River was the source of life to everyone in the village. It was named by David's father, William Harvey, and his brother John, two of five brothers named Harvey who had come from England, sometime during the early half of the nineteenth century. They were related to one Thomas Harvey, a Quaker who had come to Jamaica in 1837, along with Joseph Sturge, the two men later writing a powerful and moving account of slavery in the British West Indies. The other Harvey brothers split up and went to live in different parishes in Jamaica after their arrival; only William and John stayed together. One version is that the two took up jobs as bookkeepers on the San Flebyn sugar estate, but one day soon after their arrival they witnessed something that made them decide to abandon all ideas about joining the plantocracy.

The estate overseer had hired two new Africans fresh off the boat in Lucea Harbour. Although slavery was officially abolished in 1838, some Africans were now being brought to Jamaica, along with East Indians and Chinese, to work as

indentured labourers on sugar plantations where production was severely affected by the loss of slave labour.

Among the new Africans was a set of twins from Sierra Leone, the great-grandchildren of fighting Maroons who had been transported there from Jamaica after the Maroon War in 1795. These fierce fighters had been banished to Nova Scotia in Canada, and had later settled in Sierra Leone. The twin boys had grown up hearing many tales of Jamaica and of the courage of their ancestors, runaway Africans who refused to accept the yoke of slavery. The twins even claimed to be related to the supreme warrior woman, Nanny of the Maroons. Grandy Nanny, as I have heard some Maroons call her, had led her people in a protracted guerrilla war against the British until they were forced to make peace with her, on her terms.

These two young men had chosen to travel to Jamaica from Liberia on a one-year contract as indentured labourers, mainly to see for themselves the green and mountainous land to which their foreparents always longed to return. Maroon Country, where places had sinister and coded names like "Me No Send, You No Come."

They stood like twin panthers on the docks at Lucea, with such a fierce, mesmerizing presence that the overseer of the San Flebyn estate, one Grant Elbridge, felt compelled to hire them as a matching pair. He did this partly with his own amusement in mind, for he and his wife often indulged in elaborate sex games with the Africans on the property. One week after he hired them, Elbridge announced that the twins had to be whipped, abolition of slavery or not, for who the hell were these goddamned twin savages to disobey and disrespect him? The night before, when he had summoned them to his overseer's quarters, and he and his wife had indicated to them that they wanted them to take off their clothes, the two, acting as

one, had spit in his face and stalked out into the dark night.

So Elbridge ordered the twins to take off their shirts again, this time in the middle of the cane field, and the twins obeyed at once. They tore off their shirts and bared their chests to him before the other labourers who now worked under conditions that were hardly better than before their emancipation. The huge, dark eyes of the twins locked onto Elbridge.

The Harvey brothers, who had been ordered by Elbridge to leave their bookkeeping and come down into the cane piece to watch him in his words "tan the hide off these heathen savages," stood close to each other and watched sick to their stomachs as the long, thick strip of cowhide lashed across the backs of the Maroons, raising raw, bloody welts. But they became truly terrified when they saw that it was Elbridge who bawled and bellowed in pain. The whip dropped from his hand and coiled loosely like a harmless yellow snake when he fell, face down, in the cane field. The Maroon twins seemed to have mastered the "bounce back" techniques of Nanny, who was able to make bullets ricochet off her body back at the British soldiers. Just as the bullets had bounced off Nanny's body into the flesh of the soldiers, so too did the twins redirect Elbridge's chastisement onto him. As Elbridge screamed and writhed in pain, the Harveys watched as the Liberian twins walked out of the cane piece and turned their faces in the direction of the Cockpit Country, knowing that no one would ever find them once they disappeared into Maroon territory. After witnessing this, the Harveys resigned their jobs as book-keeping clerks on the San Flebyn estate and decided to find some land to make a life for themselves.

In the spirit of true conquistadors, William and John Harvey had come across a small clearing up in the Hanover

Hills on a Sunday as they combed the area outside the estate in search of a place to settle themselves. It was not far from a place named Jericho and the entire area was cool and scented by pimento or "allspice" bushes. They did not know it then, but in the years to come, almost all the world's allspice would come from the island of Jamaica.

Tall bamboo trees bowed and bumped their feathery heads together to create flexible, swaying arches, and here and there solid dark blocks of shale jutted up from the ground in strange Stonehenge-like formations. On close examination, they saw that the rocks had bits of seashells embedded in them, so it is fair to say that at some point that area must have been under the sea. The clearing was verdant green and watered by a strong, coursing river. They had reached it by following one of the paths leading away from the estate. These paths had been created by the feet of men and women fleeing from the beatings and torture that was their only payment for making absentee landlords some of the richest men in the world. "Rich as a West Indian Planter" was a common saying when sugar was king during the eighteenth and nineteenth centuries.

Some of those paths led to small food plots often set on stony hillsides, which amazingly had been cultivated by the enslaved Africans to feed themselves. At the end of fourteen-hour working days cultivating cane, and on Sundays, their one day off, they had planted vegetables like pumpkins, okras, dasheens, plantains, and yams, the food of their native Africa. For some reason, the soil of the parish of Hanover produced the best yams known to the palate. The moon-white Lucea yam was surely the monarch of all yams, my mother always said. Every time she cooked and served Lucea yam, she would tell us the same story that Jamaica's first prime minister, Sir Alexander Bustamante, who was himself a native of Hanover

and a man who claimed to have been descended from Arawak Indians, would say that "Lucea yam is such a perfect food that it can be eaten alone, with no fish nor meat." She too subscribed to the belief that the Lucea yam needed nothing, no accompanying "salt ting," as the Africans referred to pickled pig or beef parts, dried, salted codfish, shad, and mackerel which was imported by estate owners as protein for their diet.

The clearing, which was later to become the village of Harvey River, was near the hillside plots farmed by some of the formerly enslaved Africans, many of whom now worked as hired labourers on nearby estates. The two Harvey brothers decided to "settle" the land, and, giddy at the prospect of imitating men like Christopher Columbus, Walter Raleigh, and Francis Drake, they named the river after themselves. They had spent the night sleeping on its banks, having come upon the place towards evening.

"Do you think this river has a name?" said William.

"Aye, it has one now," said John.

They had bathed in it, and caught fat river mullets and quick dark eels which they roasted on stones. Then they had fallen asleep to the sound of the rush of the waters they now called by their name.

The Harvey brothers built their first small house of wattles and daub. Later they built a larger house of mahogany, cedar, and stone. Then William had sent for his wife, Lily, and his six children whom he had left behind in London when he and his brother had come to Jamaica. Nobody knows where their money came from, but they were able to acquire considerable property in the area, and to live independently for the rest of their days.

In time the village grew. Grocery shops were established, there were at least two rum bars, a church, and a school. But no matter who came to live there, the Harveys were considered to

be the first family of the village. And when the government built a bridge over a section of the Harvey River and tried to name it after some minor colonial flunky, William Harvey himself went and took down the government's sign and erected a sign of his own saying Harvey Bridge.

He was a tall, big-boned man
the earth shuddered under his steps
but the caught-quiet at his centre
pulled peace to him like a magnet.

Whenever she spoke of her paternal grandfather, my mother would say that he was one of the biggest, tallest, quietest men that anybody had ever met. Actually, because she had a love for imagery, she would say something like, "When he walked, the ground would shake, but he was silent as a lamb, a giant of a man with a still spirit." True or not, there was something remarkable about the character of William Harvey, who was one of the few Englishmen in his time to legally marry a black Jamaican woman. By all accounts he was a very moral man who would not have countenanced living in sin with Frances Duhaney. He took her as his legal wife in the Lucea Parish Church, and none of his English neighbours attended the wedding. Some of them even cautioned him that black women were only fit to be concubines. William's response to that particular piece of advice was that any woman who was good enough to share his bed was good enough for him to marry.

He married her after his English wife died and left him with six children. He went on to have six more children with Frances Duhaney — Tom, Frances, George, James, Martha, and

my grandfather David — and from all accounts he cared for them all, from the blond, blue-eyed Edward born from his first wife to the dark, Indian-looking David and all the others of varying skin shades in between. He gave each of them equal amounts of land, which he surveyed himself, and he encouraged them to read and to love the books he had brought with him from England. He was known on occasion to chase outsiders from Harvey River, and if, as I suspect, those outsiders were dark-skinned like his own wife, then I'm not sure what that says about the very moral character of William Harvey except that he was deeply complicated and flawed like most people.

William had chosen Frances Ann Duhaney as his future wife when he went one day to the village of Jericho to purchase a pig and some chickens from her father. My great-grandfather seemed to have been a man of clear and unequivocal feelings. According to my mother, he identified my great-grandmother as his second wife from the first time that he laid eyes upon her.

Frances Ann Duhaney, called "Nana" as a sign of respect after her marriage, was a fine-featured woman with jet-black skin. Her surname, Duhaney, probably meant that her African grandfather had been owned by the Duhaney family, proprietors of the Point Estate at the eastern end of Hanover. The original form of their name was de Henin, from the descendants of Phillip de Henin of the Netherlands.

William Harvey had spotted the beautiful young girl moving efficiently about her father's yard. In the hour or two that it took William to buy the pig and some chickens from Mr. Duhaney, he noticed how lightly the young girl moved, how effortlessly she performed her tasks, feeding the chickens, sweeping up the yard, building a fire, disappearing and reappearing in no time bearing a pail of water drawn from the river, peeling yams and dasheens and feeding the peels to the pigs.

Her face was so serene throughout, her high smooth forehead never breaking a sweat. It seemed to him that she hummed a low and compelling tune all the time, like a worker bee. Her lips were a shade darker than the rest of her face, as though she had been suckled on the juice of some sweet, energizing black berry. He had asked her father for her hand in marriage.

Soon the young girl was moving swiftly, silently, and efficiently about the Harvey house on bare feet. She rarely wore shoes inside her house. It was as if she needed her soles to always be in touch with the powerful work energy issuing up from the Hanover ground through the floorboards, the same energy that enabled labourers to perform the ferocious, back-breaking tasks involved in the production of sugar cane; an endless cycle of digging, planting, weeding, cutting, grinding, and boiling under the ninety-six-degrees-in-the-shade sun, and the cut of the whip. Nana Frances pulled that same work energy up through the soles of her feet, and that allowed her to work tirelessly. William always said that it was not just her beauty, but her silence, devotion, loyalty, and capacity for hard work that drew him to her.

Nana Frances would get up early every morning, after only a few hours' sleep, to make big country breakfasts or "morning dinners" of roasted yams and breadfruit, bammies made from grated cassava, fried plantains, fried eggs, stewed liver, kidneys, and light, and escoveitched fish, washed down with quarts of coffee and chocolate tea. William was a big man who liked his food. She knew that, and she liked to cook for him and his trenchermen children. She would wash huge hampers of laundry in the river, beating the clothes clean on the river stones, washing linen as white as the proverbial Fullers soap. She kept the big wooden house clean, staining what seemed like acres of mahogany floors with red oxide and burnishing them

with a club-shaped coconut brush. She dusted and polished the heavy mahogany furniture with cedar oil, she cleaned the ornate silver cutlery with ashes taken from the belly of the iron stove, and she used the pulp of sour Seville oranges to shine the copper and brass utensils. Crouched on her hands and knees, she moved across the floors, her small calloused hands beating out a Johnny Cooper rhythm: Joh-nny Coo-per, Joh-nny Coo-per . . . that was the scansion and sound of the coconut brush beating out its domestic rhythm on the planks of the wooden floor. She starched and ironed clothes with small triangular-faced irons made by the local blacksmith, irons that were heated on wood or coal fires. She was forever bending over some source of heat or water, to iron, cook, set steaming plates of food before the big-boned Harvey men, proud of her reputation as a hard worker. She seemed to like it when people said, "She can work you see!" But she never encouraged her own daughters to work like that. She always told them, "I work enough for everybody already, you go and study your book." So when her son David married Margaret Wilson, Nana Frances advised the new bride to hire a maid to help her with her housework. Above all, she cautioned, "Don't go and wash clothes in the river. Get somebody to do that for you. Don't make these people think you are ordinary."

Her eldest son, Tom, took Nana's admonitions against ordinariness very seriously. He had been sent to Rusea's High School in Lucea, but growing bored with the dry curriculum that was imported without modification from English public schools, he took to skipping school and going to listen to the cases being tried in the Lucea courthouse. In time he persuaded his younger brother David to cut school and join him. At home they began to study the law books that their father had brought with him from England, and after a while they

both knew enough law to be able to give effective legal advice to the poor and defenceless of Hanover. David's talents lay more with civil cases. He was a gifted writer who wrote many letters on behalf of people unable to do so. He had a way of choosing appropriate phrases, for selecting the right words to express the plight of some poor, wronged person. Tom's talents lay more with criminal cases which he would "try" the night before the actual case, using his brothers and sisters as the accused, as witnesses, and as members of the jury.

"Go to my son Tom and my son David, they will tell you what to tell the judge." Nana, proud that her sons were not ordinary, was forever recommending her sons' village lawyer practice to any wronged person. Their reputation, no doubt helped by their mother's tireless word-of-mouth promotion, grew to the point where the local judges issued an order banning them from practising within a five-mile radius of the courthouse. So Tom and David set up office under a Lignum Vitae tree with its masses of lavender blossoms, exactly five miles from the Lucea courthouse. Dressed like most men of their time, in dark trousers and white shirts and wearing felt hats, they stationed themselves under the spreading branches of the national tree of Jamaica while poor people, many of them walking barefoot, came to them for help. Many is the time David Harvey gave his own clean shirt laundered by his mother, Nana Frances, to some poor man to enable him to stand with dignity before a hard-eyed judge. My mother's father and her uncle instructed hundreds of people how to defend themselves against the British colonial laws that valued the smallest piece of property over the life of any ex-slave, and David went home sometimes without his shirt because he knew how the law judged by appearances.

O to hear him sing the lake Isle of Innisfree,
now become Harvey River, near Lucea.

"Down by the Sally Gardens." My mother used to sing that song in a funny short-of-breath style, and looking back now I realize how many Irish words and phrases like "cute hooer," referring to a deceptive man or woman, were part of the language of the Harveys. They must have picked their Irishness up from the sailor who jumped ship in the Lucea Harbour and fathered my maternal grandmother with a woman of African descent who became the Guinea Woman in the poems and stories I would come to write.

The sailor was George O'Brian Wilson, who first saw Leanna Sinclair, mother of Margaret Wilson Harvey, when he went to call upon an Irish penkeeper on a sugar estate in the neighbouring parish of Westmoreland. He had jumped ship in the Lucca Harbour at the sight of the magnificent blue-green mountains of Western Jamaica. "The fairest isle that eyes ever beheld," is how Columbus had described this island. The intensely green landscape reminded George Wilson of parts of Ireland, but the weather here was much better, with its almost always hot, energizing sun and the warm clear blue seas with white sand beaches. Paradise. When he abandoned ship he took with him one thing, a woollen suit that had been woven and tailored by his own father. The wool had been dyed "rich black" by soaking it for a time in a boghole, then oiling it with goose grease before weaving it. That suit lasted him for his entire life, and he was buried in it.

George O'Brian Wilson was even more determined to stay in Jamaica once he landed and began to enjoy the rum bars and brothels of the small seaside town. This was the ideal place for

men like him, and every white person he met seemed to have come to Jamaica to run away from some dark secret. No man gave a straight answer to any questions about his past life. So he let the ship sail without him and set about trying to locate and form alliances with other Irishmen, who gave him this advice: find and marry the daughter of some local Creole.

Whites born in Jamaica were not considered white by the English, because by now there was so much mixing of white and black blood; with so many black women giving birth to "sailor pickney," light-skinned children and jet-black children walking around with "good hair," Aryan features, and eyes the colour of semi-precious stones. Creole families needed to find white husbands for their daughters, for one day they all hoped to escape this place where they were outnumbered by Negroes and return to "the mother country," which many of them had never seen but which they nonetheless regarded as home.

It was not difficult for the Irish sailor to find a wealthy bride from one of these "anxious-to-upgrade-their-colour" families. Less than six months after he let the ship return to Ireland without him, he became a married man with property, the dowry of his Creole bride. Not long after his marriage, he went to visit another Irishman who worked as a penkeeper on a sugar estate in Grange, Westmoreland. It was there that he first saw Leanna Sinclair.

She was sixteen years old, just over five feet tall, and her skin was the colour of onyx. She had wide, amazed-looking eyes and a dusting of tiny warts that looked like beads of jet along the top of her cheeks, which is why she was called a Guinea woman. She was standing sideways when he first saw her, her face turned in the direction of the sea, standing on one leg like a Masai warrior or an egret, her other leg tucked up behind her. Her thick hair was hidden under a white headker-

chief, and she gazed intently out to sea even as she served them. George Wilson began to fear that she would drop the tray with the glasses of planters' punch called sangaree, and grow wings and fly straight over their heads as they sat there in their leather-backed planters' chairs on the wide verandah. He grew afraid that she would fly back to Africa before he got a chance to clasp her strange, wild beauty to him, and in that instant he became completely convinced that she possessed something that he needed in order to live, some powerful life force which he had to catch and absorb into him to enable him to make his way in Jamaica. He needed to cover her and be ready to catch it when it escaped from her throat as an ellipse of light. His fellow Irishman laughed when Wilson told him about how affected he was by the sight of this girl. "And you a newly married man and all!"

George Wilson, who would always refer to Jamaica as being "behind God's back," enjoyed parallel honeymoons. His efforts eventually produced Margaret Aberdeen Wilson, as he named her — he insisted on the Aberdeen but never explained why — who was born with his fair complexion, grey-blue eyes, and long straight black hair; and another daughter, Mary, who was born a few months before Margaret to his lawfully wedded wife and looked like nobody he knew. George Wilson grew to love the child Margaret more than he ever loved any other human being in his life.

One day when Margaret was a small girl, her father had called her his "little neega," which was probably his Irish pronunciation of "negro," and the child told him, "If me a neega, you a neega too, for you is my father, you a white neega." And that was true. He was much more in tune with the ways of the poor black Jamaican people than he was with the imitation English manners of the Creole class into which he had

married. He had little or none of the graces of the well-to-do. As the head of his new family, he was expected to behave like a member of the colonial ruling class, having to sit at table at night with the local gentry of Lucea, who talked about the "lazy, dirty Negroes" in much the same way that they spoke about the "lazy, dirty Irish" in England. He was much more at ease drinking in the small, dark wattle-and-daub rum shops with the thatched roofs which looked like the thatched sod and stone huts of his native county Galway, and he loved the robust African rhythms of the native music. He himself played a wicked fiddle and could sing so that it brought tears to the eyes. He would tell Margaret stories about Ireland, about the little people and the leprechauns. In turn the child would tell him stories told to her by her mother, about the trickster spider man, Anancy, from West Africa, and duppy stories about rolling calves. Wilson grew to admire Anancy's wily ways and he told her that Buddam, the village ne'er-do-well who was always being arrested by the village pan-head (which is what Jamaicans called district constables) for beating up people, had the strength of the mythical Irish warrior, Cuchulain.

When he grew old, George Wilson abandoned his family in Lucea, and came to live with Margaret in Harvey River in the small house that she and David built for him. In Harvey River, he plied his trade as a shoemaker and saddler, and my mother loved to tell the story of how he once made a pair of boots for a woman from the nearby village of Jericho. When he delivered the boots to the woman, he told her that the leather was rather tough, and that she should oil the boots before she wore them in order to soften them. He said this in his rich Irish brogue, and to the woman's West African ears the advice to oil her boots came out sounding like "boil your boots."

She promptly went home, made up a roaring fire, put on a large cauldron of water, and boiled the boots until they shrank, so that they looked like footwear fit only for a small cloven-footed animal.

She returned to George Wilson in a great rage, insisting that he had told her to "bwile" her boots. He insisted that he had rightly told her to "aile" them, and then he probably told her that she should get her "bleddy eegnorant arse" the hell away from his shop before he shied his lapstone at her. The woman was thereafter called "Bwile boot, me tell you fi aile it, you bwile it" by the village children. My mother's people love beautiful shoes. In every photograph ever taken of the Harveys, they are wonderfully shod, no doubt a taste they acquired from George Wilson.

~

My great-grandmother was a Guinea woman. It seemed that, at best, Leanna Sinclair's feelings towards George O'Brian Wilson were mixed. While she was pleased by his attentions, she always felt as if her life's breath was being cut off when he covered her, and so she closed herself off tightly whenever he approached. She bore him two children, my mother's mother, Margaret, and a boy to whom he gave his own name, George, but who died when he was an infant. To capture her heart he tried flattery. "By Christ y'are the loveliest ting I've ever laid eye on."

"But you hate Jesus Christ, you tell me so youself, how you going swear by him and me believe you?"

He gave her gifts.

"I bought some ting for you, a fine red dress."

"I don't wear red. Plenty African get catch because them was wearing red and that is how them see them to catch them."

"Shut your focking mout and just do what I tell you."

George Wilson never did get to ingest that part of Leanna's soul which he visualized as a rim of light, no matter how hard he tried to make her cry out so that it would detach itself from her soul-case and float through her open throat into his mouth. He never did get to possess Leanna because she could always see far and she knew that George O'Brian Wilson was not her true love. If she appeared to be looking out to sea the first time that George Wilson saw her, it was because she was seeing a ship, perhaps it might even have been the one that was bringing those twin brothers to Jamaica. Leanna was able to recognize other people who could see far in this way, they always looked past you. Mostly they looked up to the sky. If they looked into your eyes, they often looked quickly away because they could see things about you that they did not want to have to see. Who wanted to be seeing people with perfectly good-looking faces change into animals when you looked at them? Or hear greedy people grunting, when to the ears of others they were speaking in dulcet tones?

One night when she was twelve years old, Leanna dreamt that she was one of the Africans packed into the hold of a slaver. In her dream, she was crouched and chained, wedged tightly against the bodies of other Africans squatting in their own excrement. The smell and the thick darkness in the hold was like no other darkness or smell in creation. It was shit and sulphur and the raw and rancid sweat of human fear, and aloes and bitters and the vile essence of degradation. The foul stinking air was rent by the hoarse cries of people calling out to different gods in many different tongues, calling upon ogun and shango and damballah, gods of iron and lightning and war, to

fling down ancient curses upon their captors. Curses as old as the world itself. Curses employed by the first man and the first woman who suffered at the hands of other crazed beings who had flown past their nests, transgressors of the sacred law: do unto others as you would have them do unto you. Curses invoked by King Rameses and King David against their enemies. "Tear them from limb to limb, dash them against the rocks, smite them hip and thigh, maim and blind them, may their tongues cleave to the roofs of their mouths. May their own children suck out their eyes, their life breath, may dogs eat their entrails . . ."

And one or two more pious ones amongst them were praying to more compassionate gods to send mercy rain to soften the hearts of their captors, men who would reduce human beings to beast-state for the sake of gold and silver shekels and Cain's profit. Suddenly, in the midst of this terrible place, the people gradually became conscious of music being played. A music which took its rhythm from the waves on which the ship of darkness rode, a rhythm which rocked out and returned to its centre, conducting in its wake and movements the peace that passeth understanding. And for what seemed like an eternity, but was in fact only a few minutes, silence settled over the slaver. In later years, Jamaicans would call this beat Rocksteady.

Leanna had started to see the man who would become the love of her life just about the time that she entered puberty, and in her visions he was always walking towards her. Sometimes she would not see him for months and then she would be doing her domestic work up at the Irish penkeeper's house, polishing a mahogany table, and she would see an image of a young black man, not too tall, but with strong legs and big hands, appear up through the wood grain of the table. For years she saw his image. Sometimes he would be walking across

high blue mountains with people who looked like his mother and father, another time he would be making his way through cane fields, and sometimes he was walking by the sea. Once, he was lying down on the cold ground, looking up at the stars, gazing up at the constellation which looked like a big gourd in the sky, wishing for a drink of star water. Sometimes the young man was crouched down with the people who looked like his parents, hiding from someone or something in the bushes. But one thing was certain, he was coming towards her. And because Leanna knew this man was coming, she kept her heart tightly closed whenever George Wilson was near, so that he eventually grew tired of trying to make her yield up her essence to him.

⁓

After the trouble,
some with the name Bogle
catch fraid like sickness
and take panic for the cure.

John Bogle's people had found their way to the parish of Westmoreland after the Morant Bay Uprising, in 1865, when John's relative Paul Bogle — to whom he bore a remarkable resemblance — was hanged. Paul Bogle preached and he walked to petition the representatives of the British Colonial government on behalf of the starving people who were turned loose after emancipation and given nothing. No land, no money, no forty acres, not even one mule. The planters were compensated for loss of human property, but the men and women who had worked to build the great wealth of the British ruling class received not one farthing. On August 1, 1838, their first morning of full freedom, many of them had walked away from

the estates carrying not even a simple hoe with which to till the ground. The ones who chose to stay worked for the lowest possible wages, out of which they then had to pay the estate owners for their keep. Then the sugar industry collapsed. Money was scarce and taxes high. Disease and famine, cholera and smallpox, claimed more than fifty thousand lives and then, like an additional Biblical plague, came drought. Domestic food crops began to fail year after year. Add to that a justice system that as a rule dispensed no justice to the majority of Jamaicans, a system administered by the estate owners and managers who were full of vengeance and wrath over the loss of their human property.

Paul Bogle, a child of enslaved parents, was a prosperous small farmer from Stony Gut in the parish of St. Thomas. Deacon Paul could speak with the tongues of men and of angels, but he was also a man of deeds. He led a delegation on a forty-five-mile walk from Stony Gut to Spanish Town to see Governor John Eyre, and draw his attention to the suffering, but the Governor refused to meet with them. George William Gordon was among the men of property who sympathized with the people's suffering. The son of a slave woman and a Scottish planter, he had worked hard to educate himself and had been elected to the Legislative Assembly in 1844. Bogle and Gordon, Baptists both, tried to petition the Colonial government on behalf of the beleaguered people. They tried and tried the peaceful way. They walked, they wrote petitions, even to the Queen herself. For their efforts they got a letter from Queen Victoria, which recommended the starving landless Jamaican people practise industry, thrift, hard work, and obedience.

Governor Eyre ordered Paul Bogle and George William Gordon to be hanged for leading the uprising that we were

taught in school was the "Morant Bay Rebellion." Some four hundred desperate people stormed the courthouse in Morant Bay and clashed with the local volunteer guards. Twenty-one men, mostly white, were killed. More than six hundred ex-slaves were executed and as many flogged in response to the uprising. A dispatch from Col. J.H.F. Elkington to the commander in the field went as follows. "Hole is doing splendid service all about Manchioneal and shooting every black man who cannot account for himself. Nelson at Port Antonio is hanging like fun by court martial. I hope that you will not send any black prisoners. Do punish the blackguards well." One month after, the Morant Bay River in St. Thomas was still stinking, polluted from the number of corpses floating in it.

After the Morant Bay Uprising, to say that your name was Bogle was to sign your own death warrant. Some of the surviving Bogles coined protective variations of their great name, such as Bogues, Boggis, and Bogey. John Bogle and his parents had walked across the island from St. Thomas to Hanover, removing themselves as much as was possible from what happened in St. Thomas. As far as the east is from the west, John's family travelled to the parish of Hanover, trying to keep their lives and to keep the great name of Bogle alive. But ironically they ended up being called Buddle instead of Bogle by many Hanover people. And one Sunday in 1875, as sure as fate, Leanna was walking towards the town of Savanna la Mar, and walking towards her on the main road was the same man she had been seeing in her dreams, leading a big grey mule. She began to laugh as she recognized him, and he began to laugh even louder. They met in the middle of the road, and he said to her, "If you was *my* missus, I wouldn't make you walk. I would give you this nice grey mule." From that day, they never lived apart, until John Bogle died. They lived, farmed, and

flourished in Grange, Westmoreland, and Leanna rode her grey mule, wore her money jewellery, necklaces and bracelets fashioned from silver coins soldered together, and lived a happy, prosperous life. When her mother married John Bogle, Margaret, who was six years old, told him, "You not my father." He said, "I know, but I am the man who will honour your mother."

"Me meet the man who intend to put him ring pon mi finger."

That is how Leanna Sinclair announced to George O'Brian Wilson that she was ending their relationship.

George Wilson, who had by then lost all interest in getting Leanna to surrender completely to him, said:

"Fock! So you're to be married then . . . well, way you go, just you have my Meg dressed, ready and waiting outside every Sattiday morning, for I'll not be setting foot in your goddamn yard ever again. I'll bring her back by nightfall . . . Oh, don't imagine tis you who's leaving me, truth is, I've no further use for you!" When he said this, Leanna kissed her teeth loudly and fanned the hem of her dress back and forth as she turned and stepped away from the Irishman. George Wilson never spoke directly to Leanna again. He did not feel any need to. She had given him what he needed to make his way in Jamaica. She had given him Margaret.

\mathcal{M}argaret Aberdeen Wilson met David Harvey when they were schoolchildren. The fact that they both had black mothers and white fathers meant that they had a lot in common, and as long as they lived, they never ran out of things to say to each other. Their childhood friendship blossomed into romance, and when they became teenagers, David began to court Margaret. Leanna and her husband, John Bogle, would stay up in the small sitting room to make sure that the couple outside on the verandah "behaved themselves," so Margaret and David would sit on the verandah, which was lit with a smoky kerosene lamp, and they would talk about their friends, about what was happening in the village. She would tell him what her father had told her about Ireland, and he would tell her what his father had told him about England, all the while aching to fall into each other's arms. When it began to grow late, Leanna would rock her mahogany chair vigorously on the floorboards to signal to David that he should go home. David was a sensitive young man. He always took the hint, and he used this rocking-chair signal as his cue to perform a farewell suite of songs on his harmonica. Out of sheer mischief he would blow, "Nobody's Business but My Own," the anthem of the "don't-care."

If me married to a nayga man
turn round change him
fi one coolie man
nobody's business
but me own

Then he would play what became his and Margaret's sig-
nature song, "Beautiful Dreamer." He would raise the silver
harmonica to his lips, and it would flash in the half-darkness
of the verandah, where the small kerosene lamp rested on a
wicker table. He would play "Beautiful Dreamer," accompa-
nied by the high alto chirping chorus of crickets, the bass calls
of bullfrogs, and the croaking lizard's response. His inspired
performance was illuminated by stage lights of peenie wallies,
or fireflies, and the thick country darkness formed an opaque
black fire cloth behind him. He would depart playing that
song, which Margaret would hear growing fainter as he rode
away on his horse, back to Harvey River, where he took her to
live after he married her when she was eighteen and he was
nineteen years old.

David's father, William Harvey, had given them twenty
acres of land and helped the new marrieds build their first
house. Margaret's father, George O'Brian Wilson, handcrafted
fine leather shoes for the bride and groom and insisted on
giving away his daughter despite the protests from his legal
wife and children in Lucea, to whom he was forced to say:
"There is not yet born the focking man or woman who is the
boss of me." He and Leanna Bogle did not exchange one word
at the wedding of their daughter, and John Bogle stood silently
by Leanna's side as the young bride, Margaret, who was dressed
in a long satin gown trimmed with wide bands of Irish lace
that George Wilson had specially ordered from England, walked

grim-faced – as was the custom of the time – under her sheer veil up the aisle of the Lucea Parish Church.

At the wedding reception, held at William and Frances Harvey's home in Harvey River, George Wilson played the fiddle and sang "Peg O My Heart," changing the words to "Meg O My Heart," for Meg was what he sometimes called his beloved Margaret. She and David danced while her father fiddled, and she blushed and tried to pull away when David danced up close to her. But he had smiled and insisted, saying, "We are now husband and wife, we can do whatever we please."

\mathscr{B}efore the children came into their lives, days in Margaret and David Harvey's household always began well before daybreak in the cool Hanover mornings. "Before night take off him black trousers, before cock crow, before the sun show it clean face behind the Dolphin Head Mountain." Margaret, like her mother, Leanna, was always the first person up in her household. She would put on one of David's old jackets over her long nightgown and walk barefoot through the sleeping house. When she reached the back door, she would slip her feet into a pair of his old boots and step out into the backyard and rap loudly on the window of the small outroom where the domestic helper slept. "Wake from thy slumber, Miss Lazy, arise and shine and catch up the fire." The fire that the sleepy-eyed girl would wake and start at 5 a.m. in the big iron stove would not be put out until evening. "The first thing that a good woman do when she wake up in the morning is to put on a kettle of water to make coffee for her husband and tea for her children." Margaret, like her mother, Leanna, lived by that rule. She always brought a cup of hot coffee to David first thing in the morning. He would drink it and then set off for his field. If it was a day when he conducted his village lawyer practice, he would rise with Margaret and study from his law

books by lamplight before he set off to meet his brother, Tom, outside the town of Lucea.

Each day, David Harvey headed off into the world fuelled by large mugs of coffee, fried bammies or dumplings with codfish and ackee, cornmeal or hominy porridge, and thick white slabs of harddough bread. By mid-morning, a second breakfast was prepared and packed in straw baskets called "cutacu," and sent to him as he worked in the fields. Other men in surrounding villages took the remains of their first breakfast to the fields with them to eat at mid-morning, but in Margaret Harvey's household, second breakfasts were always delivered to David in the fields by a young boy from the village who ran errands for them. He was told to "run, run quick before the food cold, Mr. Harvey don't like cold food."

At midday when David returned from the fields, or in the afternoon if he had gone to his village lawyer practice, there was "dinner," the main meal of the day. From the start of their married life, David and Margaret's kitchen boasted some of the largest pots in Hanover, and as there were always relatives and friends visiting, the deep-bottomed pots swelled with rice, the smoke-stained pots boiled "junks" of yams, sweet potatoes, and dozens of green bananas with pieces of salt pork. There were huge cast-iron dutch pots in which slabs of mutton, beef, or pork, fresh from slaughter, were fried or stewed with garlic, onions, peppers, and salt. Midday dinners often lasted until early afternoon and filled the belly till supper, which was served at sundown, always with mugs of hot cocoa or "chocolate tea" and harddough bread and fried fish, or sardines and big, thick, sweet cornmeal puddings. A place was always set at the table for David as head of the house, and Margaret usually sat with him when he ate.

As more and more children were born to David and

Margaret, they ate in shifts, or they ate anytime they wanted to, using a variety of mismatched dishes. Fine china left over from Margaret's wedding set, pieces of which were broken by various helpers and children, were set out alongside ordinary "ware" plates, bought in Lucea. They used an assortment of cutlery. Some heavy, ornate silver knives and forks brought back from Cuba by David, bone-handled knives and forks brought from England by William Harvey, and more ordinary tin knives and forks bought from merchants in Lucea at various times. Except for Sundays after church, when the entire family always sat down to eat their Sunday dinner of rice and peas and chicken together, Margaret had no time for "frippery" like damask tablecloths. Raising eight children and feeding a steady stream of visitors did not make for "dainty living." "My children eat good food, plenty good food, as much as they want, no child of mine ever know hungry," Margaret would say. This no-frippery attitude was endorsed by her father, George O'Brian Wilson, when he came to live at Harvey River. He would tell Margaret about his days as a boy growing up in County Galway, where his family shared their small thatched stone cottage with the animals, and how the window taxes meant that his parents could only afford to have one small window and a half-door in their dark little house. Because of these conditions, one of his siblings had died of typhus.

Later in life, Cleodine tried to impose more "refined" ways of dining on the Harvey household. She would cook at home dishes that Mrs. Marston, the Englishwoman who ran a small private school for Hanover girls, had taught to her pupils as part of their training in the domestic sciences. Cleodine's attempts to improve the Harvey family cuisine was, however, not a success. "Look how she take the good piece a beef and stew it down to nothing, then cover it up with crush pitata as

if she shame a it," was the verdict on her shepherd's pie from her brothers. "Country bumpkins, bungoes, you will never amount to anything," Cleodine said. Margaret and David, who usually let their first-born have her way, pretended that they liked the shepherd's pie, but they made no move to incorporate it and other English-style fare into their lives. "When I have my own house," Cleodine would say, "I will not be serving any of this coarse hard food." And Margaret, who drew the line at being "ruled" by any of her children, would answer, "When you get your own house you can do any damn thing you want, but don't forget that this is my house and I am the only big woman under this roof."

Margaret liked to think of herself as the undisputed boss of her house, and David made very few decisions without consulting her. The ones he did manage to make without her approval all had to do with him lending money or standing surety for some poor person, who invariably did not repay him. Margaret never let him forget these lapses. "If you did ask me, I could tell you that that man is a liar and a thief, and that any money you lend him would be a dead story, but no, you and you soft heart, you make everybody take you for a fool."

Her area of special concern, however, was the welfare of her daughters. Whenever some story of an unfortunate girl who had "fallen" reached her ears, Margaret would immediately blame the mother of the girl. "You see me? I watch my girl children like hawk! There is nothing that any of them do that I don't know about. I don't understand how a woman could say that her own daughter fall and she never know for months! I know how every one of my girl children stay at all times." When the Harvey girls reached puberty, they all received the same lecture from her, a lecture that was really a short threat: "What this means is that you can have baby now, and God see and

know I will kill you if . . ." Margaret did not even have to finish her threat. The Harvey girls referred to the region below a woman's waistline as their "Bottoms."

Apart from witnessing the rough mating of farm animals, and blushing at the little rude jokes and songs of schoolchildren who were not above converting a hymn into a dirty ditty — "At the cross at the cross where I first met my boy and the burden of my drawers rolled away" — and the whispering about some village girl who "fall," the Harvey girls did not talk about sex. They were charged to remain virgins till they married, and to defend their virtues to the death. A charge which they all took very, very seriously.

\mathcal{L} ate one afternoon Doris had gone to bathe in the river by herself. The riverbed was deserted of all the village women by the time she got there. Some had come early, after dispatching the men to the fields, bearing their dirty clothes in big bundles on their heads. Some went to the fields themselves and then did their laundry later in the day, but they all washed their clothes in the same way. Soaping them with iron-hard wedges of brown soap, making loud, strong rubbing sounds with their knuckles as they scrubbed the clothes clean. Young girls were told: "You have to rub the collar, the armholes, and the sleeves and make sure you turn the clothes wrongside, wash it clean, and rinse it at least two time."

White clothes were spread on rocks to bleach in the morning sun, while the coloured clothes were being rinsed in the swift moving water, then laid out on the rocks to dry. After doing the laundry, the women bathed themselves and bathed the children, often using the same wedges of brown soap on their skin, along with slippery green aloes to wash and condition their hair. That was the more open washing of clothes. There was a more secret "small clothes" washing that took place there too, small clothes being the term for menstrual cloths. This washing was done in pails of water drawn from

the river, off to the side, under the shade of the bamboo which screened the river. Young women were told not to pour this "small clothes" water back into the river, so they used it to water the roots of the flowers growing on the riverbank. The bright red hibiscus and the red water grass seemed to benefit from this, and in turn they became useful, nurturing plants. The pulp of the hibiscus can be used to blacken shoes and to make ink for poor schoolchildren. The red water grass became a medicinal herb, good for bad fresh colds.

My mother never did say why she went to bathe alone in the river that day; maybe she wanted to do her own private washing in private and as it happened there was no one else there when she reached the river, so she took off her dress under which she was wearing her bathing costume and dived into the river. She was a beautiful diver, who never made a splash when she entered the water although she was a tall, plump girl. The water just seemed to part for her and to let her in. She swam bank to bank and dived deep once or twice to investigate what was under the rocks in her family river. She came up with a small crayfish but she threw it back. "Grow some more," she said aloud to the underweight crayfish.

"Who you talking to?" said a voice, and Doris looked up to see a strange boy standing across from her on the riverbank. He had to be a stranger, for normal river protocol dictated that if a village boy came across a Harvey girl bathing, he would leave immediately. Instead, this one stood on the riverbank, big and bold, staring at my mother, who had buried herself in the water up to her neck the moment that she realized that she was not alone. "Go away," she said. But the boy just stood there, grinning and staring. "You don't hear me say you must move, go'on, go 'way from here?" she said. The bold-faced boy, who was from Kingston and was visiting with relatives in nearby

Chambers Pen, had never seen a river before, much less a river with a pretty young girl bathing in it. He stood his ground, looking right at her, smiling an impudent, pleased-puss smile and refused to budge an inch.

The news reached Margaret and David before Doris got home. How she had been overheard cursing terrible badwords down by the river, "expressions" as she and her sisters called them. For my mother, taking the charge to defend her virtue seriously, had summoned up every curse word she had ever heard used by anybody in Harvey River, or on the streets of the seaport town of Lucea, and had flung them across the water at the leering town boy, who was so surprised by the stream of invective issuing from the mouth of the sweet-faced bather that he did exactly what my mother had been trying to get him to do, he fled.

"That's right, my daughter, I am proud of you." To her surprise, instead of scolding her for cursing badwords, that is what her father, David, said to her as he held her in his arms when she reached home.

"You do well, Doris," said Margaret.

"She did not have to stoop so low as to curse expressions," said Cleodine.

"Any port in a storm," said David, who then sent his sons to find the visiting town boy and to explain to him just how men were expected to behave when Harvey women were swimming in their river.

"Doris is not the prettiest one, but she is the one that everyone loves," her brother Flavius would say. "Dear Dor" they called her, for if Cleodine was pristine and as perfectly designed as an anthurium, Albertha a lily above reproach, Rose a fragrant damask rose by name and nature, and Ann gorgeous and intense

as a bird of paradise, my mother could be described as a mixed bouquet. She was a little of all those flowers, with a good spray of common wildflowers like buttercups and ramgoat roses bundled in with hardy perennials and quick-growing impatiens, and she learned how to send her roots down deep when storm-time came.

Storm-time was the furthest thing from Doris's mind while she grew up as a daughter of the first family of Harvey River. She was an easy-going child who from an early age displayed signs of a quick intelligence and a love of hyperbole. Once, when her brother Edmund hid in a bush and jumped out at her, a frightened Doris declared: "Only Almighty God alone knows how my poor, poor, trembling, fearful little heart could stand such a great fright . . ." This she said with her eyes raised to heaven and one small hand covering her little palpitating heart. She had a way with words, words being one of the things she learned from her village lawyer father, David, from the vituperative Irish eloquence of her maternal grandfather, George O'Brian Wilson, and from the West African Guinea woman griot-style of her grandmother Leanna.

"Doris is really Mas David daughter." In the same way that her father literally gave the shirt off his back to people going to Court, and constantly loaned them money to pay fines, my mother was known as a "come to help us." Much as she loved her dresses, she would give them away to her cousins who admired them. She was the one you went to if you wanted to borrow anything. If you needed somebody to keep your baby while you went on an errand or if you were feeling sick, she was an excellent nurse. Once her sister Albertha's fingers had become so swollen and infected from excessive embroidering that she could do nothing for herself. It was my mother who

bathed her and dressed her until her hands healed, and Albertha always spoke about her sister's ministrations with tears in her eyes. Everybody in Harvey River loved Doris; so on that September morning in 1920, after Margaret Wilson Harvey's husband and children had left the house, and she noticed a line of red ants marching along her clothesline – a sure portent of trouble – she did not expect trouble to do with Doris. In the late morning, she glanced across the valley, up to the hilltop, in the direction of the village school and saw what looked like a group of school girls in navy blue uniforms fluttering down the hillside like a flock of grass quits. Minutes later, when she heard the girls burst into the village with a great warbling commotion, Margaret hurried out into the square only to behold her daughter Doris at the head of the crowd bearing her long black plait in her clenched fist.

Back up the hill they went, this time with Margaret at the head of the crowd, carrying her daughter's once waist-length braid flung over her left shoulder. As they climbed the hill, she cried "this is like murder" and swore to personally punish the culprit who in a fit of adolescent concupiscence had sliced off my mother's hair as she sat in front of him with her head bent forward, concentrating on the rules of proper speech in her *Nestfield's Grammar*.

So devastated was Doris that she refused to go to school for weeks, staying close to home with her chopped-off hair hidden under a mob cap and bursting into tears anytime anybody said something like: "You *hear* what happened" or "*Here* is some money, go and buy a bread for supper," or "Didn't you *hear* me calling you?"

Harvey relatives came from far and near, bringing Doris little gifts, a nice ripe mango, a coconut cake, a shilling, gifts to help ease the misery of the loss of her plait, which Margaret

kept, lying in state, on a table in the centre of the drawing room.

"Why these things always happen to me? Look how that nasty boy spy on me and make me curse those expressions and embarrass myself, and Almighty God, who seeth and knoweth all things, knows that I was innocently, innocently studying my book and that wicked wretch come and cut off my hair, why me? O Lord? Why me?" And then she cried out something that she had read in a novel: "My life is over, for a woman's beauty is her hair."

Margaret could not let that pass. "A woman's beauty? So you a woman now? The only woman in this house is me, your mother, so you better put this hat on you head and go on to school."

Eventually David dug a hole in the yard and buried the severed plait, saying, "It is only hair, it will grow back, it is not as if the boy took her life." "Yes, that is true," said her mother, "but it look like she have bad luck. Look how that renking little boy from town was peeping on her and now look this . . . her lovely head of hair shorn like a sheep."

For months after the boy cut off her hair, my mother wore a broad leghorn straw hat whenever she went shopping in Lucea with her sisters. For these trips they would debate for days beforehand about what to wear in order to "cut a dash" when they entered the town. They favoured linen, crepe, and georgette dresses in cool pastel colours or romantic florals. Never dark colours; dark colours were for older, married women. Sooner or later they each would have decided on an outfit, always ones with skirts that buttoned up the side so they could undo the bottom buttons when they rode, two to a horse, into Lucea. But my mother would be changing her clothes up until the eleventh hour. Sometimes she would change into as many as ten complete outfits before her sisters threatened to leave without her as they rode the five miles into the town of Lucea. "Yes, Match-Me Doris, those black shoes go with that powder-blue dress and you don't have time to change them," says Albertha. And Doris, who did not like to be hurried, and was liable to become short-tempered if pressured, would certainly have told them, "Go on, go on and leave me behind, for I am not going into town looking like a poppyshow today. Furthermore my clothes are mine. I sew them, I can change them as much as I like." "You think you are

the only one who can change clothes?" They would have argued, but once they got there they would become the five ladylike Harvey girls.

Lucea, the capital of Hanover, is situated on the western side of a horseshoe-shaped harbour that is approximately one mile wide. With the exception of the parish of Kingston and St. Andrew, Hanover is the smallest of the fourteen parishes in Jamaica. Hanover was almost named St. Sophia, in honour of the mother of King George I, but this name was voted down by the Legislative council in favour of Hanover, originally spelled Hannover. The name was chosen with reference to the German domain of the reigning family of England.

When the Harvey girls descended from their home in the hilly interior of Harvey River and rode into the town of Lucea, they never failed to look up in wonder at the Lucea Clock Tower, which held a red clock that looked like the high-domed helmet worn by German royal guards. Everyone in the town knew that the clock in the tower was brought to Lucea by mistake, that it had been destined for the island of St. Lucia, and that the captain of the ship which was transporting it had mistaken the Port of Lucea for the island of St. Lucia, and delivered it there in 1817. As it so happened, Lucea's town fathers had already ordered a new clock built, but it was of a more modern design, and not anything as grand as this German helmet. They decided forthwith that they could not and would not let the red helmet clock go and so they laid claim to it. It has remained there ever since.

After noting the time by the clock tower, the girls would dismount and leave the horses in the care of one of their relatives in Lucea, after which they would sometimes go to visit the Lucea Parish Church and pay their respects to some of their

relatives who were buried in the churchyard. They would go by the Lucea Hospital at Fort Charlotte (named after George III's queen) and Rusea's High School, built towards the end of the eighteenth century with money left by a Frenchman, Martin Rusea, in thankfulness for the safe harbour and hospitality that he had found in Lucea. These were the town's main landmarks, situated fairly close together on the promontory overlooking the harbour. With the imposing Dolphin Head Mountains rising as high as two thousand feet, and an abundance of cabbage palms and tall coconut trees forming a lush backdrop to the azure harbour, the town of Lucea was a small but steady source of light.

The eligible young men of Lucea gathered to feast their eyes on the Harvey girls whenever they came to town. These included the young men who worked as clerks at the courthouse and as civil servants in the few colonial government offices in existence at that time, such as the Collector of Taxes. Some of them were apprenticed as surveyors in the Lands Department, and a few were members of Her Majesty's Jamaica Constabulary Force, but the Harvey girls would not consider giving the time of day to a policeman. For some reason (probably to do with their Irish grandfather, George O'Brian Wilson) their mother, Margaret, had a fierce prejudice against policemen and soldiers. Another of her edicts, in addition to "No child of mine will ever rule me," was "No policeman or soldier will ever sit in one of my chairs."

Dressed to the nines to come shopping for yet more fabric, the girls would go directly to Mr. Jim Reid's store on the Lucea main street. Mr. Reid, a slender, well-dressed, and soft-spoken man, was known for his exquisite taste. He stocked the finest cloths, lace, buttons, buckles, belting and trimmings, accessories, lingerie, and millinery, as he referred to his hats. Mr. Reid was

unmarried. Such a pity, for any woman would have been glad to have him dress her every day. He adored the beautiful Rose. "Look Miss Rose, I ordered this blush pink crepe de chine with you in mind, and these carioca kid shoes are perfect, just perfect." Mr. Reid smelled nicely of Florida water. On Sundays he wore a crisp white drill suit and an expertly blocked Panama hat. He had a friend, Mr. Dixon, who owned a bicycle built for two. On Sunday afternoons, Mr. Reid and Mr. Dixon would go bicycling along the coast road, their well-seamed trouser legs secured by matching bicycle clips.

Shagoury's was the other store frequented by the Harvey girls. The goods there were not of the same quality as those stocked by Mr. Reid. Doris used the first one-pound pay-cheque from her job as a pupil-teacher to buy a pair of pumps from Shagoury's. Mr. Shagoury, who was not too long from Lebanon, recommended the shoes highly, saying, "these shoes strong, you wear them till they bark." Maybe that was a popular saying in his native country. But the shoes fell apart after a few weeks. The uppers and the sole separated, creating a flapping, gaping space in the front of the shoes when she walked. Her brother Howard said that was what Mr. Shagoury meant when he referred to the shoes "barking," for they now looked as if they had open mouths.

They would also shop at Emmanuel's Haberdashery, some-times for special linens and lingerie, for each Harvey girl expected to be married, and they each had a bottom drawer. After shopping, they would visit their Aunt Fanny's bakery on what was called Back Lane, to buy fresh breads and pastries to take back to Harvey River. The girls had a particular fondness for the small, flat buttery loaves called *gratto*, a word which was probably a corruption of the French *gâteau* in the same way that other French words crept into the language and had been

reshaped by the tongues of Jamaicans. For example, Château Vert, a village in Hanover, was now called, *Shotover*, and the bunch of assorted vegetables – the legumes – that could now be bought in the local market for the Saturday soup were called *leggins*.

Aunt Fanny was their father David's sister, and she ran the bakery with her husband, a silent man who had travelled to Panama and there learned the art of baking. In his case, he had learned the *secret* art of baking, for he refused to share his recipes with anyone, including his wife. He insisted on being alone when he prepared the dough for the buttery gratto and French bread, the meltingly delicious cashew and molasses biscuits, and the fancy pastries. All Aunt Fanny and their children were required to do was to place the privately prepared dough in the oven. The man died with his recipes unrevealed, and Hanover people claim that since his death there has not been baked a gratto as delicious as his.

Aunt Fanny had stood at his deathbed, accompanied by a few of her children bearing exercise books and pencils, saying, "Baker, Baker." She would have said that, for by now no one referred to him by his real name, and everyone called him "Baker" as if he alone had the right to this title. No other baker in Jamaica was as deserving of this name, not even "Nayga Bun," the cunning baker Bennett from Spanish Town who had invented the hot cross bun with the cheese hidden in its belly. Long ago at Easter time, some generous Christian masters would sometimes let their slaves have a hot cross bun as a treat, but they considered cheese to be too good for them, so Bennett hid the cheese inside the bun and marked those buns specially. Maybe he made them odd-shaped and thick-faced so that the aesthetic sensibilities of the mistress of the house would cause her to reject them (and allow the enslaved

to have them). Maybe he made the rugged crosses on them with heavier dough. But whatever the case, he and they both came to be known as "Nayga Bun."

"Baker, do, I am begging you as your wife, to tell me how you make the gratto. How many eggs do you use to make a baker's dozen, Baker? How much flour and salt and so, what else you put in them to make them so nice?" The children stood ready with pens, pencils, and paper, poised to take down this precious recipe for the golden gratto. No answer. "All right Baker, since you won't tell me how to make the gratto, what about the biscuits? How much molasses? How much ginger and flour and other things you use in the biscuits, tell me nuh, Baker? Please, I am begging you as your wife, the mother of your children, who are going to starve if the bakery closes down." And Baker, who just could not bear to share his special knowledge with anyone, turned one jaundiced eye in the direction of his wife and children, then turned his face to the wall and swallowed hard. In this way he committed to his knotted bowels all his knowledge of the efficacy of egg whites, the cloudlike consistency of thrice-sifted flour, appropriate measures of leaven, and just how high dough should be allowed to rise before you punched it in the face for being too puffed up.

After his death, the bakery had to be closed down, for no one could replicate the secretive baker's creations. Poor Aunt Fanny had to move to Kingston, where one of her sons died from falling out of a tree at the Kingston Race Course, when the great Paul Robeson was giving a free concert there.

On their way past the blacksmith's forge, the Harvey girls would often have to push their way through gangs of schoolchildren

who loved to stand outside the door and chant rude words in time to the ring of the blacksmith's hammer on the anvil:

Lulu Bing
Sally Bing
Sally Bing
Lulu Bing
Morning Lulu Bing
Morning Sally Bing
Look up under Lulu Bing
Look up under Sally Bing.

The Bing sisters were two spinster ladies from England, and this coarse jingle must have been a source of mortification for them, as no doubt they had never consented to having anyone look up under their modest cotton dresses. Now they had to put up with having their good names being bawled out in the streets by bands of dirty, uncouth ruffians, who had even added a second verse to their vulgar ditty:

Lulu Bing
Sally Bing
Lulu Bing
Sally Bing
Me love Lulu Bing
You love Sally Bing
Me we married Lulu Bing
You can married Sally Bing.

The Bing sisters were almost as famous in the town as the Mares, the Steers, and the Hoggs, three families who lived as neighbours in a section of town the locals called Animal Hill.

After spending a Saturday morning shopping, the Harvey girls would pass by Animal Hill to have lunch with one of their relatives. Maybe their cousin Lily Musson, who was the daughter of one of their father David's half-brothers. On their way to her house they would go by a house called Glenmore, at the corner of Cressley Lane. This spot was once the site of the Jewish burial ground, and in the yard there could still be seen some scattered tombstones, one of which bore an inscription to Mr. Moses Levy, who died in Lucea but was born in New York.

Sometimes the girls would see the Englishman Walter Jekyll parading through the streets of Lucea. Jekyll, called "Jake Hell" by the Hanoverians, was a flamboyant figure given to wearing sheer white diaphanous costumes when he went for his baths in the warm Caribbean sea. He carried his notebooks and pens in a type of straw basket favoured by the peasants, and he was often accompanied by one or two beautiful local lads. What was known about him was that he was born into the British upper class and educated at Cambridge University, and had been a minister of religion who had renounced holy orders and moved to Jamaica, where he developed a strong interest in Jamaican peasant culture. In 1907, he published "Jamaican Song and Story," based on the Anancy stories and folk songs he had heard from African Jamaicans during his travels throughout the island. He lived for a while in Hanover at Riverside, in the same village where Cleodine would later live as a married woman.

This character Jekyll was the mentor of Claude McKay, the great Jamaican poet and novelist, who would sometimes list Jekyll as his father on the forms he had to fill out while he lived in the United States. McKay became a leading figure in the Harlem Renaissance, and he wrote the sonnet "If We Must

Die," an anthem of black resistance that Sir Winston Churchill quoted in a speech to rally the people of England during the Second World War.

> If we must die let it not be like dogs
> hunted and penned in this inglorious spot
> while round us bark their maddened dogs
> making their mock at our accursed lot.

~

At the end of a day's shopping in Lucea, the Harvey girls were always met outside of the town by a family helper who would have been sent to assist them with carrying their parcels back to Harvey River. The girls would ride home full of the latest news from Lucea and laden with purchases – from lengths of fabric, stockings, hats, and lingerie to bottles of Lydia E Pinkham's Vegetable Compound for "female" complaint. They always brought back some small gift for David and Margaret, usually a bag of cakes and pastries from Aunt Fanny's bakery that were more "refined" than the substantial cornmeal and potato puddings that were baked every weekend in the Harvey household.

Many years later, my mother and her sisters would continue to fall into their fabulous-Harvey-girls-get-dressed-to-go-to-town routine whenever they were together. Even when they were old women, they were still the fabulous Harvey girls.

fter she had reached sixth class, the highest class at the village school, my mother's oldest sister, Cleodine, was sent to Mrs. Marston's special school for young ladies, the closest thing to a finishing school that David and Margaret could afford. Her siblings watched in awe each morning as their big sister unbuttoned the five buttons — from hem to mid-calf — of her long skirt, mounted upon one of her father's horses and rode off sidesaddle to go and learn how to become a proper young lady. Cleodine liked it when they waved to her.

In no time, Cleodine began to affect a perfectly upright walk, because she was made to wear a backboard. This being early in the twentieth century, the Englishwoman instilled in the handful of elite village girls who attended her school good Victorian principles. She taught reading and writing, with great stress on proper penmanship, along with art, music, religious studies, and domestic science. Cleodine excelled in all these subjects to such an extent that, years later, she was able to perfectly hand-letter her wedding invitations, design and sew her own gorgeous wedding gown, demonstrate to the organist just how she wanted the wedding march to be played with loud flourishes, and supervise the craftsmen in the renovation of

her marital home, which her husband had named "Dunrovin'." After Cleodine directed the remodelling, she re-christened the house "Rose Cottage" and filled it with the finest mahogany furniture of her own designs as she became the wife of a man she did not love.

Cleodine was dressed in her long, white crepe de chine gown. It was fitted all the way down to her hips and then it flared out so that she looked like an inverted lily. Her veil of illusion tulle frothed out from her face and then rose and fell behind her. Her head was ringed by a circlet of orange blossoms. Her face glowed as she wept, "I do not love this man that I am about to marry." A little voice rose up inside her, asking, "Was there ever a sadder bride?" "No," Cleodine answered the voice. "No," she said out loud, "I am the saddest of all brides."

They are preparing the wedding feast. The aroma of good country cooking hangs like a spice canopy over the village. The domestic perfume of seasoning: top notes of curry; sharper notes of garlic, onions, and pimento; base notes of black pepper and thyme, which flavour the flesh of cows, goats, and chickens. Feast food is being prepared in big, black three-legged pots. In kerosene tins they are boiling a fierce pepper soup, made with the rubbery genitals of bulls, a cow cod soup to make the groom potent and virile. At the thought of this, Cleodine wants to vomit.

Over the front gate they have arranged an arch of June roses intertwined with asters and arum lilies. In the centre they have hung two silver bells, from whose mute clappers stream white and silver ribbons. Under the arch the bride will pass, going out of her parents' house a virgin. She will go to the parish church and return, passing under it again, as a wife, a married woman. She does not love this man Clement Campbell,

this man who is fifteen years older than she and who has been travelling and working in Cuba and Panama, who has come back to the neighbouring village and bought land and built a big house with a sign on the gatepost that said, "Dunrovin'."

This man had come to her father and asked him for her hand before he ever had a conversation with her. At first she outright refused to marry him, but in the end her mother, Margaret, insisted, saying that Cleodine had always had her own way from birth and that she thought she was better than everybody else, and that it was her father, David, not she, Margaret, who had encouraged her to think like this. "You mark my words, you will pick and pick till you pick shit," said Margaret, sounding exactly like her father, George O'Brian Wilson. "Who do you want for a husband, the king of England? This man is a good man, a fine-looking man, he will be a good provider, what the hell more could you want?" It was all well and fine for her to be doing pupil-teaching up at that Englishwoman's school, but it was really high time for her to get a husband who could support her queenly tastes and show the way for her sisters.

When he came to call on her, he brought gifts that he had bought during his travels: three yards of pink silk cloth, three scented white soaps in a box marked *Muguet du bois*, two pairs of silk stockings, kid gloves, and then the diamond-and-opal ring. Cleodine had read in a book that it was bad luck to wear opals if they are not your birthstone, that opals should be worn only by people born in October under the sign of the scales. The stone in the ring reminds her of her mother's left eye when a spark leapt from the fire on which the workers were boiling sugar and put out the life in it, leaving a white cloud over the pupil for the rest of her life. This is what the stone in this ring reminds her of, and it sets her to remembering other things, other times, another man.

• • •

I have imagined that there was a man named Alex Marston, and when he was brought home from England, in 1915, nobody in the village saw him for weeks. They said that he was kept sedated with laudanum to see if sleep and rest could knit up his ravelled nerves, which had become shell-shocked during the war. Every time he woke up they fed him on soup made from one whole pigeon with the neck wrung, not severed, so that the blood did not drain out but stayed inside the body to be boiled down into the soup. When the bird was cooked so that its flesh fell away from its bones, they added red wine to the soup and his mother fed it to him herself.

One afternoon the eight girls who attended Mrs. Marston's school were sitting outside on the front verandah doing embroidery, cross-stitch, faggoting, drawn-thread, and the stitch called hardanga. Once, the hardanga stitch was lost for years and it did not resurface until an old seamstress from Westmoreland dreamt how to do it again. After that dream she woke in great excitement early on a Sunday morning, applied her needle to the bodice of a plain blue linen dress, and drew up the hardanga from oblivion, where it had languished for more than seventy years in the land of lost stitches. It had slipped off every seamstress's needle at exactly the same time and date in the same way that other stitches were lost by ancient Indian tribes, Inuit peoples, and Celtic craft workers. Every once in a while, when the culture of a people undergoes great stress, stitches drop out of existence, out of memory. The hardanga had disappeared when the great Jamaican freedom fighter Sam Sharpe was executed in 1832. Perhaps the women who had stitched his flowing white garments had hidden the hardanga stitch in the seams. These women, who had washed

the clothes whiter than any Biblical Fullers soap with the foaming suds of blood-red ackee pods, had ironed the hardanga into the seams of Daddy Sharpe's robes, causing the stitch to be shut up there for three-score years and ten.

The girls were sitting on the verandah embroidering away while Mrs. Marston read to them from Jane Austen's *Sense and Sensibility*. Mrs. Marston always reminded them of how kind she was to start this school, to teach a select handful of girls how to become proper young ladies. Mrs. Marston also needed the money that their parents paid her, because her husband had taken up drinking in a serious way.

Alex appeared at the doorway in his pyjamas and dressing gown and stood there watching his mother reading to the girls. Cleodine, who was now a pupil-teacher at the school, was supervising the embroidering done by the younger girls, and looked up and saw him. His uncombed dark hair and wild eyes made him look like Heathcliff in *Wuthering Heights*. Mrs. Marston got up hurriedly and led her son back inside the house. After a few weeks he seemed to be much better, because Cleodine saw him exercising the horses in the pasture. One afternoon she was walking home alone, having stayed behind to help Mrs. Marston finish a dress. She was a better seamstress than Mrs. Marston any day, but the Englishwoman always tried to make her feel as if she was conferring a great honour upon her by allowing her to help. There were still things she wanted to learn from the Englishwoman before she stopped coming to help with the teaching of the younger pupils, so Cleodine fixed her face in a wry half-smile whenever the woman said things like "It is not often that I allow anyone from the village into my private quarters, but I'll make an exception in your case, Cleodine."

When she had walked down the hill leading her horse after

helping Mrs. Marston with her dress, the style of which she thinks is utterly unsuited to Mrs. Marston's short thick body, she finds Alex waiting for her at the end of the long driveway.

"Hello, Cleodine."

"How do you know my name?"

"I asked who was the tall, slender girl with the legs like a colt."

She knew how to heal him. He said that whenever the battle erupted inside his head with gunshots and sirens and death screams, if he heard her singing, the noises would go into retreat. He would often pass her notes which read: "Sing for me and push back the enemy, my precious Cleodine," and she would find a reason to say to Mrs. Marston, "I need to practise a song that I'd like the younger girls to learn." Then she'd go to the school piano and play and sing, ostensibly for the younger pupils, but she and Alex knew who the songs were for. Once he wrote a song for her, using words like *anodyne* and *columbine* and *adamantine* and *love-divine* to rhyme with her name. She helped his mother with the school for two years, two years in which she saw him almost every day until the noises in his head got worse and they sent him back to England.

She did not love this other man whose hands were rough and calloused from years of hard manual labour in Panama and Cuba, who affected the manners of a Spanish gentleman and peppered his talk with Spanish words. His "aie Cara and aie chica" meant nothing to her, but she will never settle for becoming an old maid, never.

They came into the room and found Cleodine alone, staring at her image in the mirror. She had ordered everybody to leave her alone for a few minutes before the wedding, but they came barging in anyway, the wedding bessies, Tinnette and

Marie, two sisters who looked after every bride of consequence in this village. They themselves had never married, but they knew every single thing that a bride is supposed to do or not to do on her wedding day.

"You must never let your groom see you in your wedding dress before the wedding."

"The bride should always carry money in her shoes or in her bosom on her wedding day, to make sure that she has a prosperous marriage."

Marie begins to fire questions at her. "What do you have on that is old?"

Her grandmother Frances's pure silk slip, given to her by her husband, William, who imported it from England. It was embroidered with raised roses on a vine trellis. It had been kept wrapped in a piece of tissue paper with white roots of fragrant khus khus grass and mothballs in a big brass-sided trunk for the wedding day of her son's first daughter.

"What do you have on that is new?"

Her crepe de chine and Brussels lace wedding dress, which she had made herself with the help of her mother and her sisters. They beaded it with rhinestones like false diamonds and more than three hundred teardrop pearls.

"What do you have on that is borrowed?"

The mother-of-pearl buckles on her shoes given to her by her godmother who lived in Falmouth, in the parish of Trelawny. Cleodine had thought of running away and going to tell her godmother that she could not go through with this wedding because she did not love this man. They say the man she loved is crazy, and now they have sent him away to England; but her godmother sent her those buckles with a letter that said she could not be happier that she was making such a good marriage.

"What do you have on that is blue?"

"Don't ask that. Just don't ask."

Marie stood up and faced her with a glass of dark red wine in her hand. The wine was so red that it looked like pigeon's blood. She told Cleodine to drink it. Cleodine tries to find her commanding voice, the one that made her siblings shudder and hurry to do her bidding, but she cannot.

Marie advanced towards Cleodine, holding out the pigeon-blood red wine, then she made as if to throw the wine all over the wedding dress, and Cleodine thought "if she throws the wine on my dress, then there can be no wedding," but how could she give these common Hanover people reason to drag her name from one corner of the parish to the other? In any case, she now had no one else to marry. She would drown herself in the sea before she gives these ignorant people reason to laugh at her.

So Cleodine took the wine and swallowed it down, beginning to feel as if she was floating on her veil of illusion tulle.

*A*lbertha, or Miss Jo, made only one friend at school: a girl who also came from a large family from the nearby village of Mount Peace. The girl's name was Pamela Samuels and the two became good friends because they had two things in common: they were both skilled embroiderers and they took life very seriously. They sat together in school and walked home together, swapping embroidery patterns and shaking their heads at the crude, ignorant ways, the out-of-orderness of the other children. They embroidered, embroidered, embroidered. Tablecloths and pillowcases and sheets and doilies by the dozen, which they stored in their respective bottom drawers because they both hoped one day to marry cultured, refined, and serious men. By the time they finished sixth class, Pamela Samuels and Miss Jo both became worried about what the future held for them in the little parish of Hanover, on the small island of Jamaica, with none of the men around refined enough for them. Together they made a pact to rise up early one Easter morning to do what young girls all over the world, anxious to know what the future held for them, did. They agreed to break eggs into white saucers and to stand outside under the slowly rising Easter sun, studying the shadows cast

by the sun in the egg yolk and albumen. They both saw the same thing – ships.

Before the end of that year Pamela immigrated to Montreal, a move which may have had to do with her being a Presbyterian. The Harveys were devout Anglicans, pillars of the Church of England. David was the catechist at the Eton church and each Sunday the entire family attended worship there, to recite appropriate creeds and collects from the Book of Common Prayer, and raise the great hymns penned by masterful English wordsmiths like George Herbert and John Keble. The Harveys delighted in filing up to the lace-and-flower-decorated altar, where they would kneel and take thin white wafers on their tongues and wash them down with wine dispensed from ornate brass chalices. Pamela Samuels's people went to dour Presbyterian meetings. No altar, no incense, no solemn bows and crossings of self. The Harveys did not want Miss Jo to become a Presbyterian. "My God, she is grim enough already," said her father. So they were relieved when Pamela Samuels immigrated, possibly at the invitation of a Canadian Presbyterian minister known by her parents and his family, who had suggested that she should come to Canada where she could become a sort of governess to the minister's nine children. But Pamela Samuels missed her friend and soon she wrote, encouraging Miss Jo to come and join her in Montreal. True, she explained, it was bitterly cold and most people spoke not English but French, but a refined, well-spoken, and serious person like Miss Jo could easily find work in the homes of well-to-do Canadians. Perhaps she could earn a living sewing and embroidering for chic French-Canadian women and in that way she could enjoy a more cultured and refined lifestyle, far removed from the "rookumbine" and "gal a wey you go a gully for?" culture of rural Jamaica.

David and Margaret were not sure at first that it was right for their daughter to go off and live in Montreal, Canada, but eventually they concluded that she just might become even more dolorous and grim if she were not allowed to travel, and even if she did go to Montreal, at least they would never have to witness her turning her back on their beloved Church of England, so they gave her their blessings and she departed by steamer to Montreal, from where she later sent for her sister Rose.

Albertha's solemn, almost stoic nature was to stand her in good stead during those early days in Montreal. In her letters back to Harvey River, she never told how she looked forward to her days off from doing domestic work in the houses of wealthy people in Outremont and Mount Royal. She did not reveal how hard it was for her, someone who had grown up in a house with domestic help, to have to do housework for strange people. Keeping strangers' large mansions clean, and looking after their demanding children who would call her not "Miss Jo" but Albertha. Come here Albertha, do this do that Albertha. How hard it was to work and live in the houses of people who were not interested in who she really was, or where she came from.

She would write only to tell her family about the wonders of snow, about the church services she attended at St. James Anglican Church, because, contrary to David's fears that she would become a Presbyterian, Albertha had in fact gone in the other direction and become completely taken with the liturgy in Latin, incense burning, High Anglican, almost Roman Catholic services held at St. James, situated in downtown Montreal. Once she mentioned a bus trip that she and Pamela and a few other young women who also worked in service had taken to the Laurentian Mountains, but, for the most part, her

letters were short, contained not one word of complaint, and always had Canadian dollars folded into them.

When she was forty years old, Albertha was introduced at a church social held at the Christchurch Anglican Cathedral to a Barbadian man named Geoffrey Seal, and to the horror of her sister Rose, who by then had joined her in Montreal, she began to walk out with him on her days off. Rose could not believe the change that would come over her older sister whenever the portly Barbadian appeared. Miss Jo would become animated and talkative and would often gaze affectionately at the man who was almost as wide as he was high. She even took to repeating his little gems of wisdom: "You know, Mr. Seal told me something this evening when we were having dinner in the restaurant at the Hudson's Bay store, he said that Montreal is the Paris of Canada," this said as if everybody, even the smallest child in Canada, did not know this for a fact.

Mr. Seal and Miss Jo were married within the year. None of Miss Jo's friends or relations could understand how she who had held to such high standards all her life could have married a man who fell so woefully short of their youthful ideals. An unkind person could have said "Seal by name and nature" when they saw a photograph of Miss Jo's groom. In addition to not being blessed with fine looks, Mr. Seal did not even have a great sense of humour. He, like Miss Jo, probably had never once cracked a smile at a rude folk song or laughed out loud at the slack wine-up way of country people. He was, by all accounts, dour and dull, but he was completely besotted by Miss Jo and she with him. His life was made complete when on their wedding night he discovered that Miss Jo, at age forty-one, was completely chaste and unspoiled. He proceeded thereafter to tenderly love and care for his virgin bride so that the serious,

unsmiling Miss Jo became the placid and contented Miss Jo who did not give one row of pins about the disapproval of her family. Her sister Doris was the only one of her siblings who did not condemn her marriage, saying she was happy that Miss Jo had finally found love, after so long.

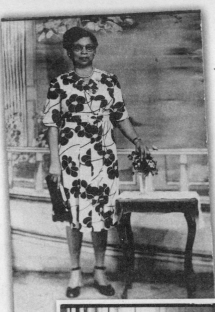

Cleodine

Albertha

Rose

The Fabulous

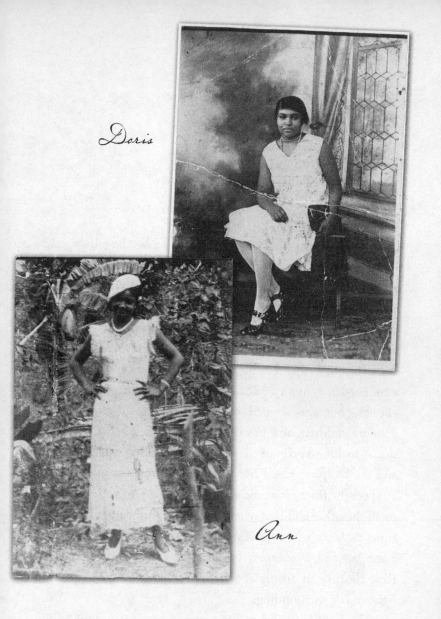

Doris

Ann

Harney Girls —

From the day that Rose was abducted by the village mad-woman, everybody in Harvey River watched carefully over her, and David and Margaret insisted that she should always be accompanied by one of her siblings at all times. Whenever this job fell to Cleodine, she would respond to the admiring cries directed at Rose by saying, "She is pretty, yes, but she is not as bright as me." Unlike Cleodine, Rose did not grow to be a brilliant or even a very competent student. She was intelligent enough, but she seemed to always prefer the company of younger children, and in classes at the village school, she was prone to long spells of daydreaming, looking out at the sky and the Dolphin Head Mountains with that sweet half-smile. And yet the teachers would never take a strap to her as they did to all the other children when she did not remember her twelve times table, or when she did not know how to spell words like *supercilious* and *peradventure*. It was as if it was understood that Rose functioned mainly as an icon, bringing joy, goodness, and light to her surroundings.

The true love of her life was a young man named John Clare, the son of a poor sugar estate worker, who had gone to school with her in the village. Intelligent and ambitious, he

wanted to study to be a teacher; but his painful shyness always reduced him to silence in the presence of Rose's luminous beauty. He never could get up the courage to confess his love to her. How could someone so radiant love a quiet, knock-softly kind of man like him? She, for her part, kept wondering how come he never flirted with her or sent her mash notes, or invited her to go in a group to dances in Lucea and Montego Bay like the other young men. Could he not see that she saved her best smiles and warmest greetings for him? She did not care if he was poor, she would have worked with him to make a life, she would have borne him beautiful children. But all he ever did was stare at her and tremble, nervously brushing his hair back from his forehead, so she concluded that he did not care.

On the day she left the village for Montreal, to join her sister Miss Jo, he just stood in the square with hot tears running down his face, one hand pressing on his windpipe, as if he were trying to force out the necessary words to make her stay. He stood like this, watching her leave his life forever, all because he did not have the words. He did not know it, but he was the namesake and descendant of a great poet, John Clare, who had enjoyed some success in England in the eighteenth century, and then, because of his struggles with ill health and poverty, spent the latter years of his life in terrible misery. He wrote a poem called "Secret Love," and if only Aunt Rose's silent suitor had known it, he could have asked his poet forefather to speak to her for him.

> I dare not gaze upon her face
> But left her memory in each place:
> Where'er I saw a wild flower lie
> I kissed and bade my love goodbye.

When she had gone to apply for her passport, the officer processing Rose's papers had fallen in love with her, and tried all kinds of delaying tactics to discourage her from travelling to Montreal. He mislaid her application. He found fault with the way in which the forms were filled out, so that she missed the boat which sailed from Kingston to Montreal only every few months. It brought Canadian codfish, sardines, and wheat flour, and loaded up in Kingston with sugar, bananas, and rum. As there were not many people travelling to Canada from the West Indies at that time, berths were limited to a few on every cargo ship and Miss Jo, knowing of this, had gone to great trouble to secure her sister a place. Eventually the man did process Rose's passport, but only after her father accompanied her to the passport office and threatened to report the man to his superior officer, making him realize that Rose was not just a beautiful, inexperienced young girl from the country who had nobody to look out for her. And so Rose took the next ship from Kingston to join her sister Albertha in Montreal, and there she found work babysitting for a French-Canadian boy named Billy Lefèvre, whose alcoholic parents would often abandon him for weeks at a time. Invariably they would not have the money to pay for her services, so she would end up feeding and caring for the boy, who called her "Tanti." She would take him home to stay with her until his drunken parents resurfaced, and would often have to take him along with her on the other babysitting jobs she took in order to get money to feed them both. Eventually, after several such jobs turned out badly for her, she had to leave the Lefèvre boy behind with his unfortunate parents, and she found a job working in the household of a Mr. and Mrs. Lord. Mr. Lord was a newspaper magnate and Mrs. Lord was a patron of the arts. The entire family fell in love with Rose and they all became

fiercely protective of her because every time she stepped outside their mansion, someone tried to take advantage of her luminous beauty.

Wherever she went in Montreal, men would pursue her — always the wrong men. On the bus some bank clerk or a graduate student attending McGill University would sit beside her and get off at the wrong stop just to follow her home, calling out after her, "You are the most beautiful woman I have ever seen, I will die if I do not see you again." Her doctor fell in love with her, and kept arranging for her to come and be examined for sundry suspected illnesses. As a result of this unfortunate experience, she lost faith in the medical profession and pursued alternative forms of healing. She ate healthy foods and exercised every day and grew more and more beautiful and attracted more and more unsuitable men. Men who would threaten to commit suicide if she did not return their love, then end up sending her notes that read: "My Beautiful Rose. You are too good for me, you deserve someone much better."

Perhaps the father of the son born to Rose when she was in her early forties wrote such a letter to her before he disappeared from her life. There was talk of an engagement; but nobody ever knew what really happened, for Rose carried the secret of his identity with her to the grave. But in 1951, Rose gave birth to a beautiful, healthy boy child, whom she christened David after his grandfather. When everyone saw a photograph of the boy, they all said he looked like an angel that had been sent to make Rose happy. Here was one man who would surely love her and stay with her as long as she lived.

It could be said that uncle Flavius spent his life trying to find and keep God. His true quest began one Friday night in the village square, when he, being at a loss to find suitable amusement for himself in quiet, peaceful Harvey River, decided at the urging of his brother Edmund and other locals boys to accompany a band of mockers on a mission to harass a group of Salvation Army evangelists. This was the best that they could do to provide themselves with some form of Friday-night entertainment.

When they got to the meeting, the Salvation Army band was in full swing; the trumpets were blasting and the kettle drums were booming as the white uniforms of the Army members gleamed under the light of bottle torches. The band of mockers gathered and started singing along with the Salvation Army chorus, dragging out the words of the hymns. "I weeeel cleeeeeeeeg to theeee oooooole ruggeeeeed crooooooosss," they sung, clinging to each other, shaking their heads and twitching their bodies as if convulsed by the Holy Spirit.

Flavius, like all other members of the Harvey family, was a talented actor, and he began wowing the crowd with a spirited virtuoso performance, causing his scoffer friends to laugh uproariously, ridiculing the efforts of the valiant band of

Salvationists who had walked miles across rocky roads to bring the word of God's army to the Hanover people. The leader of the Salvationists was a tall, indigo-skinned man with a powerful baritone voice. He wore steel-rimmed glasses that gleamed in the night. He had a shock of white hair and he played the big kettle drum. When the boys started their heckling, his response was to beat the drum hard. Harder and harder he hit the stretched goat skin until the drumbeat began to overpower the heartbeats of many of the people gathered in the square.

People stopped laughing at the mockers and stood transfixed by the power of the drum sound being pounded out by the man with the hair that stood out in the darkness like a halo around his head. The lenses of the man's glasses were throwing back reflections from the blazing bottle torches, so that his eyes looked as if they were on fire. He began to stare straight at Flavius, and the next thing you know, Flavius fell down, calling out, "Jesus, Jesus, O Lord Jesus." At first everyone thought that he was joking, still mocking the Salvationists, and then they all fell silent.

"Flavy, stop form fool now, the joke gone too far, come make we leave and go home before them lock we out," said his brother.

Flavius lay silent on the ground, unmoving, not responding to Edmund's voice or his gentle, then not so gentle, shaking.

"Lord have mercy, what is this pon me now. Flavy, gittup."

Eventually Flavius did stir, but this was only after people in the crowd doused his face with water and passed a bottle of white rum back and forth under his nostrils.

"Duppy box him. Me tell you say duppy box him, see how him rally when we sprinkle the white rum, everybody know say duppy fraid a white rum."

Flavius rose up and walked over to the band of Salvation-ists and asked if he could join them. He marched off singing with them into the dark Hanover night, returning late to his father's house. From that fateful night he spent the rest of his life seeking the Almighty with great zeal and fervour. During the course of his life he held membership in every known church in Jamaica, except for the Church of Rome and the African-based Myal, Revival, and Pocomania sects. Over and over again, he recreated that conversion experience as he joined one church after the other, each time convinced that he had found the perfect one to suit his spiritual needs. After much searching, he finally found a home in the Christadelphian Church, having fallen out over doctrinal differences with the Anglicans, Salvation Army, Baptists, Wesleyans, Moravians, Seventh-day Adventists, Jehovah's Witnesses, Pentecostals, and Brethren – Open and Closed.

His father, David, blamed Edmund for what happened to Flavius. "It's because of you why Flavius now has no abiding city, he would never go and tease any Salvation Army people if you did not put that idea in his head. Flavy is a respectful boy, he was perfectly happy in the Anglican Church, where he was born and raised. It is you, you Mr. Edmund, who encourage him in that mischief, now look at him walking up and down shaking tambourine – because he has no other musical ability – in a Salvation Army band!"

~

Although his father's anger at Flavius's conversion really made Edmund want to leave Harvey River – which Edmund had never liked in the first place – even more, his reasons for

leaving soon became more urgent. It had to do with a girl from Chambers Pen.

"Fall her, your son fall my daughter, Mr. Harvey."

That is what the girl's father had said when he came to report his daughter's condition to David, who confronted Edmund about the matter when he came in late that night.

"You are going to do what is decent and honourable, as befits a son of mine."

Two weeks before the wedding, Edmund ran away to Kingston. Margaret accused David of chasing away her son. She wept and cursed her husband for days. "How you know if this child really belong to Eddie? What I was saying was we should wait till it born and see if it have the Harvey little toe, every Harvey child have the same shape little toe, if the child don't have it, it is not a Harvey, if it have it, then of course, Eddie must face up to his responsibility, now as it stands, you threaten him, him catch him fraid, and now him run gone and I might never see my boy child again!"

After Edmund fled Harvey River, it would be three whole years before they heard from him. He eventually wrote to his mother from Kingston, telling her he was now driving a big Ford taxi. Thereafter he would send her letters containing a few pound notes and the occasional photograph of himself standing with one foot on the running board of his taxi. But as they say in Jamaica, "what is fi you, cannot be un-fi you." Seven or so years after Edmund fled by night from Harvey River to avoid a shotgun wedding, he saw the woman who was to have been his bride walking up East Queen Street in the city of Kingston, where she had come on a shopping trip. And he could not do it, he could not just drive his taxi past her. He stopped and offered the mother of his son a drive.

He had been sending money to support the boy Neville, who was indeed born with the Harvey little toe, and who from his photographs one could tell was big for his age, bright, and well-mannered. Edmund begged the mother of his son a thousand pardons. He told her that people had told him things about her to turn his mind from her and that had made him confused. He apologized for the fact that she had been humiliated, shamed, and mashed-up by his desertion. She told him that she had read certain psalms for him in order for bad things to happen to him. She cursed him like a dog as she sat there in the front seat of his taxi and he kept saying that he was sorry. Then he asked her if she wanted something to eat. "My God, you must be hungry after you curse me so." And when he said this she had laughed. He took her for a meal at Arlington House Hotel, where Alexander Bustamante, who had come back from his stint in the Spanish Foreign Legion and who would later become the first prime minister of independent Jamaica, used to take his meals. She went home with Edmund that night and two months later he married her and a year later they had another son, Roy.

But the marriage did not last. Taxi men just do not make good husbands. They are always on the go, they don't thrive in normal domestic situations. Eventually, Edmund's wife immigrated to England and sent for their two sons. He never spoke of their brief marriage again.

All the river water could not cool
the fatal furnace within

*W*hen the soles of his feet remained behind on the floor-
boards as he tried to walk to the front verandah, it was as if
my uncle Howard had shed the last of the attachments that
bound him to the earth. They were lying there on the polished
mahogany as if he had traced his feet on cardboard and cut
them out to send to Canada for his sisters Albertha and Rose
to buy him new shoes. For weeks his skin had begun to appear
more and more translucent, parchment-like and luminous.
Then all his soft black curls fell off, and later his teeth and his
fingernails came out. He died one January, after the feast of the
Epiphany. When the three wise men were coming, he was going.

Except for my uncle Howard and, later, my aunt Albertha,
the eight living children born to David and Margaret Harvey
all died in the exact order in which they came into the world
and they lived to be well over eighty years old. My uncle
Howard died after a mysterious accident involving a woman
and a stone flung one dark night by a jealous man. The stone

broke his forehead open and let in fevers, confusion, and sickness so wasting that he became the first Harvey to jump the queue and disturb the order in which they all came into and departed the world.

"Mas Howie, don't bother to go to Lucea today. Today is Sunday, heavy rain might fall and you know how bad the road is when the rain fall." Margaret had told her first son this as he prepared to leave the house on that late October afternoon. He was whistling as he stood at the mirror in the hall, combing his slick black curls that were still wet from his bath in the Harvey River. Her heart "rose up" whenever she looked at him, so tall and slim-bodied, his skin the colour of a perfectly baked biscuit, his nose straight as a knife blade, and those brown eyes with the long sweeping lashes. None of her daughters had such lashes. Everybody said that he was the most handsome young man that anyone had ever seen, that he looked like God had made him personally with no help from assistant angels, so well put together was he. Margaret's grey eyes welled up every time she saw him. Imagine, that she could have brought such perfection into the world.

He had nice ways too. Affectionate, kind like his father, David. He was always funning and making jokes. He was the only one who could make such jokes with agate-eyed Margaret, who did not run jokes for spite. "Mummah," he would say, "come and dance with me," and he would hold her at the waist and waltz with her in circles as she protested, around the room. "Come and do the Lambeth walk with me, my sweet Mummah." "Boy, go away and find somebody your own size to play with," she would pretend to scold, but she actually did waltz with him, even as she swore that the only time she had ever danced was on the day of her wedding, and where did this boy come from, harassing his own mother so? "David," she

would call out to her husband, "come and talk to your son." And David would stand there in the doorway and laugh as he watched his wife, who was not given to overmuch gaiety, being spun around the floor by their son who had grown taller than his father. He had the height of his English grandfather, William Harvey.

"Why you have to go to Lucea today, a Sunday, Howard?"

"Aye, Mother, I can't tell you my business."

He didn't have to tell her his business, for his business surely involved that woman, that red-head girl who had come from Lucea to attend a wedding in the village last week. The girl's skin caught fire from the time she saw Howard, best man for the groom, who was one of his cousins. All during the wedding reception, which was held at David and Margaret's house, the young woman was burning like a fire lantern. Her hair was coir red and her skin like burnished copper. She was a vamp from Montego Bay, who was now living in Lucea. Dressed in her orange voile dress, she looked like fire itself when she moved, her tiered skirt fanning out like flames around her as she insisted on dancing with him. "Come Howie, let me show you this move, I'm sure this step don't reach to country yet." Anyone could see she was just dying to lay herself careless before the first son of the first family of Harvey River, and he was like a rain-fly drawn to her flame.

When the red-head girl sat down to eat a huge plate heaped with curried goat, Margaret had stared in disbelief when the girl pronounced that the goat was not hot enough. The tender goat mutton had been seasoned and cooked by an East Indian man by the name of Gangalee, from the neighbouring parish of Westmoreland. Gangalee's skin was almost as black as that of the Africans. He was originally from Madras. "Me Madrassi," he would say. "You a coolie," said the African

Jamaicans. The night before, Margaret had watched him rub the curry powder into the pieces of fresh goat meat, curry that he had blended himself using turmeric, called tambrik by the African Jamaicans, coriander or curriana as the Jamaicans called it, cumin, sage, and his own secret special ingredients that the Jamaicans did not know, so they had no name for them. He had cut up onions, garlic, and what looked like dozens of hot country peppers and added this to the meat which had been left overnight to soak up the seasonings. The next day it was browned in iron pots of fragrant coconut oil and cooked down in big kerosene tins. You could smell the strength of the curry for miles. Gangalee was known to cook the best and hottest curry in the western end of Jamaica. Maybe it was the selfsame Gangalee who was immortalized in what became a popular Jamaican folk song:

> There was a coolie man by the name of Gangalee
> married to a coolie gal, them call her Cookie
> send her to go boil rice and ackee
> She disobey the order and boil rice and bajee
> Now bajee is a thing that take plenty water
> Bajee is a thing that take plenty fire
> Get you curry, get you curriana, get you mussy
> Get you mussiana, get piece a stick
> Put it pan the kibba, hinder bajee from boiling over
> Bamma beejee bajee, bajee o.

The girl demanded a Scotch bonnet pepper, which Howard brought to her. The pepper pieces fell from her fingers like burning sparks as she calmly sliced them into the already highly seasoned meat. Margaret watched in horror as the girl ate the red-hot flesh of one of the hottest peppers known to

man, without calling for water to cool her tongue. Not a tear came to her eyes as she chewed the vicious hot capsicum. "Scotch bonnet pepper, you know, the girl eat one whole Scotch bonnet pepper!" Margaret had remarked to David afterwards. David had laughed and said, "She is a better man than me." For of all peppers, there are few as hot as the pepper shaped like a Scotsman's tam-o'-shanter; not the small deceptive little bird pepper, nor the hot finger pepper or jalapeno; maybe not even the wicked one called the habanero. It was this Scotch-bonnet eater that was causing Howard to go into Lucea that Sunday.

David and Margaret had warred over the way in which she was raising Howard. But he was not a child any more. "Leave him to be a man, what are you trying to do, turn him down? Keep him under your petticoat for the rest of your life?" David had also cautioned her against what everyone saw as her blatant favouritism. "How do you think the other children feel? They all think that you love Howard more than them."

If only she could have hidden him under her petticoat that day. That morning she had again seen a line of red ants marching along her clothesline and knew that something terrible was going to happen.

She watched her son leave, dressed in his dark trousers and a gleaming white shirt that she herself had washed and ironed. He was wearing a felt hat, rakishly skeeted to one side, and he was stepping smartly in an almost-dance as he made his way down the path to the main road to catch the truck going into Lucea. When he got to the gate he turned and threw her a kiss. It floated across the hibiscus hedge, skipped on the flat white river stones which paved the pathway up to the front door, and hopped over the windowsill into Margaret's lap. She picked it up, knotted it into a corner of her handkerchief, and tucked it into her bosom. As she did this she found herself singing

one of her father's songs, "Down by the Sally Gardens, she bid me take love easy as leaves grow on a tree, but I was young and foolish and with her did not agree." Over and over she sung those lines.

When they brought Howard in, bleeding from the head that night so that the inside of his felt hat was lined with thick blood and his white shirt was now mostly dark under the light of the lamps, she was moaning, "But I was young and foolish and now I'm full of tears." They cleaned the wound with alcohol or overproof white rum, which caused him to cry out as it stung him even in his half-conscious state, and they bound the wound tightly with a clean cloth, torn from good white linen sheets, to try and staunch the head injury that was bleeding so profusely. How could one head contain so much blood?

All around the house on the acres and acres of land around them grew different herbs for bush medicine, a bush for every sickness, for every complaint. There was even a bush called "fresh cut" for new wounds. But who could find such herbs in the dark? Throughout the night they tried to doctor his head, to force teaspoons of sweet sugar and water down his throat to replace the vital energy draining away from him. They washed down his limbs with aromatic bay rum to quell the fever that was now rising through his pores, and David read psalms at the foot of the sickbed. Psalm after psalm, all except Psalm 90, which is the funeral psalm.

The nearest doctor was miles away, and Howard was in no condition to make the journey to the doctor's house along the rough, unpaved roads. It was best not to move him. All night they just kept staunching the wound and cooling his limbs until dawn broke. Now there was no choice. David went and found someone with a buggy who took his son, fevered and delirious, back into the town of Lucea to the hospital.

When he was brought back to Harvey River five weeks later, Howard was a shadow of himself. Margaret and David's handsome son had become a thin, gaunt, sad-eyed man who stepped tentatively from the back of the hired car that brought him home. Leaning on David's arm, he slowly made his way up the path to the front door, where he stopped, looked back, and gave a wan smile to all the friends and relatives gathered in the yard to welcome him. He raised his right hand in a feeble gesture of acknowledgement to them and then he went into the house, passed through the living room and into his bedroom, where he lingered for two months. Then one morning as he made his way towards the front door of the house, he stepped onto the floorboards and left the soles of his feet behind. Everyone knew that he would die before the day was over.

"Only a borrows, Miss Meg, you only got a borrows of him. He was God's own angel that God lend to you for a time." "You think that I don't know that? Nobody know that more than me," Margaret said to the woman.

David planted cinnamon and aloes near the grave of his first-born son. Cinnamon and aloes because they spoke of them in the Bible, in Proverbs 7:17: "I have sprinkled my bed with myrrh, aloes and cinnamon. Let us enjoy the delights of love." These words were spoken by loose women who sought to entice callow youths to their destruction. It was as if the words of the Bible had come to pass in David and Margaret's own lives. Their son had been killed by a man jealous over his red-haired woman, a man who was never caught and punished, for he fled and vanished into the thick country darkness the minute that Howard fell "like a wounded ox on the way to the slaughter house" (Proverbs). When Albertha and Rose returned from Montreal for a visit in the 1940s, they brought with them

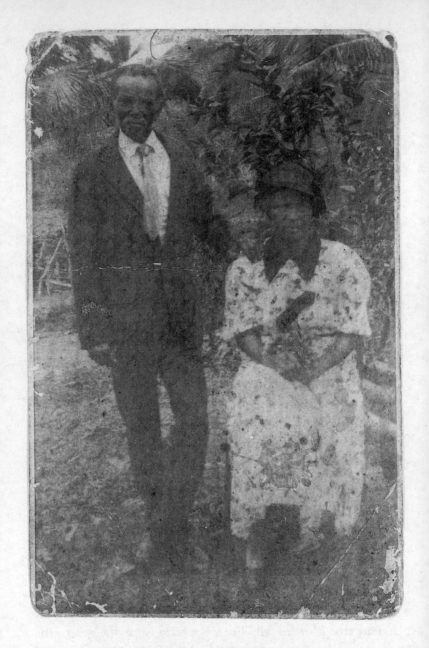

David and Margaret Harvey in Harvey River,
on the occasion of their fortieth wedding anniversary.

bulbs of irises which they planted around Howard's tomb. The irises bloomed only as long as David and Margaret and their children lived in Harvey River.

~

For months after Howard's death, my mother's mother, Margaret, could be found sitting in her big bentwood mahogany rocking chair by the window in the front room of the house. She wanted the man who had flung the stone to see her. To see her terrible agony. Maybe if she sat by the window which faced the street, he would pass by and see her, pass by and be moved to confess by the sight of her raw grief. At night, she railed at her husband to use his village lawyer skills to find the murderer, but try as they might David and his brother, Tom, could not find him. Some people believed that he stowed away that same night on a ship docked in Montego Bay.

Margaret wanted no one to forget about the terrible injustice done to her. Day after day she sat by the window through which she last saw him fully alive, walking his young man's bopping walk, throwing her that last kiss. For hours she would sit by the window and rock and stare, sometimes moaning her father's Irish songs. "She bid me take love easy as the grass grows on the weirs, but I was young and foolish and now I'm full of tears." Sometimes she would imagine the body of the man who took her son's life hanging from a tree. Sometimes she would imagine her hands tight around his throat. Everyone passing by would comment on how hard Margaret was taking the loss of her son. Some would try to call out to her, sincere words of encouragement directed up the stone-paved path down which her son had gone forever. "Nuh mine, Mrs. Harvey. God knows best. The Lord giveth and the Lord taketh away."

These words, intended to comfort, did not reach her. She just sat there locked into her grief, rocking, moaning out across the yard and into the bushes, where her grief notes came to rest in the trees and became indigo-winged solitaires, making low piping loss sounds.

It was Margaret's father, George O'Brian Wilson, who eventually put an end to her public demonstration of grief. He appeared outside her window early one morning, having walked up from the small cottage that David had built for him near the main house. He waited outside in the front yard for his daughter's household to stir. When Margaret took her seat by the front window, her face drawn and contorted from her night's crying, she saw her slim, dark-haired father, who by then sported a long pepper-and-salt beard, standing in the front yard like a stern Old Testament prophet. "Get the fock up, get up out of that blasted chair, and get on with your god-damned life. Your poor husband says he's tired of talking to you about just sitting there because you don't countenance a word he says. Get the hell up, I never raised you to be a weakling, to have these eedjits jabbering about you as if you were the village lunatic, sitting there like Our Lady of Perpetual Weeping by the window with your house all going to hell. Because of you that assistant Queen Victoria Cleodine has become the boss of all, coming here every day from her Castle Rose Cottage to order us all around. Telling them at the bar to stop selling me my white rum, as if my drinking is her god-damn business, all because you are no longer present. The boy is gone, get on with your life. Get the fock up, or I'll take a whip to your backside."

That was the day that Margaret stopped sitting by the window and told Cleodine that it was too much work for her

to run two houses and that she did not have to come to Harvey River every day any more. Everyone agreed that George Wilson was the only one who could have made her get up from that window, reminding her that she had his Irish blood in her and that nobody, not even her grief, was going to be the boss of her.

George O'Brian Wilson, shoemaker and saddler, of
Lucea, Hanover, late occupation, bruk sailor.

*E*very year on the seventeenth of March after Margaret's
father came to live with her, the people of Harvey River would
congregate in the road to witness the annual St. Patrick's Day
party given by George O'Brian Wilson, for himself and for
other Irishmen in the area. He made it clear that this party was
not for anybody but the Irish, who would dress all in green and
gather from early afternoon at the Harvey house to drink, play
the fife, drink, play the fiddle, drink, sing, and drink.

With his half-Irish daughter Margaret as his assistant,
George Wilson would cook a creolized Irish stew, substituting
goat meat for mutton and adding turnips, onions, carrots, and
potatoes. As he added herbs like fresh thyme, he would lament
his separation from Ireland, often breaking into song as he
stirred. He served the stew to his guests before they got down
to the serious business of singing and drinking. Their Irish airs
and reels would issue across the Hanover cane fields as they
celebrated the day of their beloved saint, who, like most of the

people in Jamaica, had once been a slave. It is certain that some of these airs inserted themselves into the music of the Africans who were keeping the continent alive, "yerri yerri Congo," in the hills of Hanover and all over Jamaica. So every seventeenth of March, George Wilson and his friends would rise up and praise St. Patrick in sweet spiritual tongues until they fell down senseless. The morning after, everyone in the Harvey household would wake to find so many green men sprawled, stale-drunk and damp with dew, in the front yard, coiled at the roots of breadfruit and mango trees, flat out in the grass, or blissfully resting under flowering shrubs after their annual tear down.

A man who feared neither God nor man, George Wilson would sometimes stand outside the door of his small house in thunderstorms and fire off shots from his rifle into the heavens, answering each thunderclap with a gunshot, screaming, "God above, god below."

When he lay dying, George Wilson told his daughter that he was being plagued by the devil. Margaret asked him to describe in detail exactly how the devil was plaguing him. Always a practical woman, she intended to devise some drastic and appropriate strategy to defeat the horned one. George Wilson said that the devil was showing him two roads and advising him to take the shorter one. Margaret told him to tell the devil to go to hell because everybody knew that the road to heaven was the longer one. He thought it over and he seemed to accept this counsel. But a while later he asked the yardman to chop him some wood. When Margaret asked what he wanted it for, her father, being a man who was not averse to having a backup plan, said, "I'm going to build a fire and burn the devil's arse."

When George O'Brian Wilson died, my grandmother Margaret sent a message to his Creole family in Lucea to tell

them of his passing. The family always made a point to never acknowledge Margaret or her mother, Leanna, and they did not acknowledge the message. So Margaret made arrangements to bury her father, whom she had tenderly taken care of in the last years of his life. On the day of the funeral, the entire village came out to pay their respects to the "white neega." There was a certain tension in the church, because in life George Wilson and church were like the devil and holy water. "When a man dead him just dead. Look how him just lie down there in the coffin and make them call up Jesus name over him and he don't get up and curse them," said the people of Harvey River. All through the funeral service there had been no sign of his legal wife and children. But at the burying ground, as they were nailing the coffin shut, Mrs. Wilson and her children drew up in a hired car and demanded that the coffin be opened so that they could pay their respects. Margaret remembered all the years they had refused to recognize her existence. She grabbed the hammer from her husband and drove the long ten-penny nails deeply and securely into the coffin lid, nailing it shut, and ordered that it be lowered into the grave at once.

part two

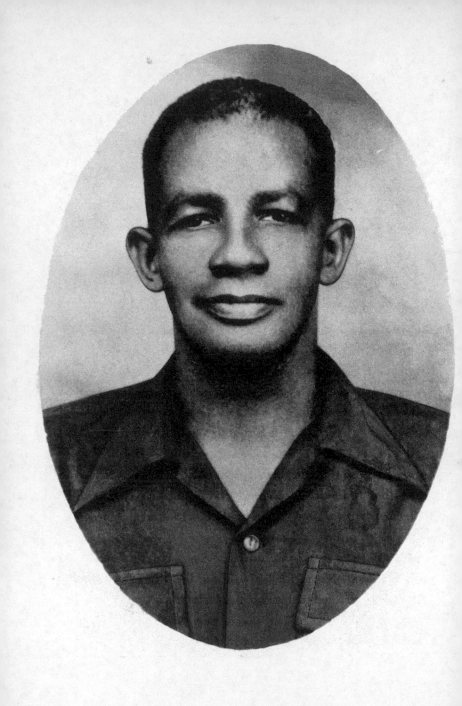

*I*t was a cricket match that first brought Vivian Marcus Goodison to Harvey River, where he fell instantly in love with my mother, Doris Louise Harvey.

All important events that occurred in the village of Harvey River took place at the Harvey home, and on this Sunday my mother's parents were hosts to a visiting cricket team. Slim and of medium height with rich copper-coloured skin, Marcus Goodison had a movie-star smile and a wonderfully engaging manner. He had driven the cricket team from Malvern in the parish of St. Elizabeth to Harvey River, where he immediately took note of the fact that in the Harvey household there were some very attractive young women. Upon seeing this, he surrendered his place on the team and never played the cricket match. He just gave up his turn as the star batsman to some aspiring hanger-on who would never ordinarily get a turn at bat, a reserve member of the team who was only chosen to make up numbers, a batsman prone to making "agricultural" strokes, a "yamlikker" who used the fine linseed-oiled willow like a crude hoe. Unlike Marcus, who did everything with finesse, whose strokes were poetry in motion. On that fateful day in 1930, Marcus had no time for cricket, for he had sighted Doris.

He had begun at first to sweet talk Ann. Then he looked to the far side of the yard and saw Doris, who was watering some of Margaret's special plants with cold tea left over from their breakfast. He had gone up to her and asked her for a drink of water, then he had set about charming her and her parents, and by the time he was due to drive back to St. Elizabeth he had succeeded. He explained to them that he was employed as chauffeur to the manager of Barclays Dominion Colonial and Overseas Bank just so they would know he was a responsible man; and to make sure that Doris wouldn't forget him when he was gone, he left behind his maroon-coloured beret, which completed his outfit. That outfit consisted of cream serge pants and a maroon blazer, worn with a white shirt and a pair of two-tone brown and white shoes. The next Sunday he drove from St. Elizabeth to Harvey River ostensibly to collect his beret, and maybe he left something else that day too because he soon became a regular visitor. In between visits he wrote her passionate letters.

> I went to town last week and I stood up on King Street and looked, Dor, but not one woman in the whole Kingston was lovely as you.

> Dor, I hope and pray that you will consent to be my bride. If you say no, I don't know what I will do. Please don't hand me a left hand ticket.

Marcus, as always appropriately dressed, arrived one Sunday to formally ask for Doris's hand in marriage. David and Margaret had been expecting this day for months. The young man was so obviously in love with their daughter. I mean you had to be in love to drive from Malvern, St. Elizabeth,

to Harvey River, Hanover, almost every two weeks for a year. Driving over those rough, mostly unpaved roads, just to come and see a girl who was so shy that she never looked in your face when her parents were around for fear they might think her too bold.

David sees the car drive up and when he sees Marcus step out fully dressed in a navy blue suit and white shirt and tie, he tells Margaret,

"Mr. Man is here for your daughter's hand."

"Then she is just my daughter all of a sudden?"

David goes to the door to meet him. He stands in the doorway and calls out to Marcus, whom he has never seen look nervous before.

"Mr. Man, where are you going so dressed up today?"

He loved the young man. He was a well put-together person, he made a good living, he was charming and possessed of a deep self-assurance, but at the same time kind-hearted. He was always trying to make the people around him happy. He would do his best to make his daughter happy, David felt that. But he couldn't just allow him to come in here and walk off so easily with his Clarabelle.

Marcus hears the serious tone in David's "Mr. Man" question. He is a little surprised because he has come to regard him as a friend and ally. He has become deeply attached to this man he hopes will become his father-in-law, because he never grew up with his own father.

Marcus dressed like a dandy because all he knew of his own father were the stories of the young man who changed his shirts two or three times a day, who always smelled of "4711" gentleman's cologne, and who favoured two-tone "John White" shoes, imported specially for his size nine feet. Marcus played the guitar like his father, Uriel; from him he got the gift of

music. My nightingale-throat father could sing too, and all wind and stringed instruments obeyed him. He was able to play virtually any musical instrument. He was glad of that gift from his father. So this is the Marcus who stands on the first of the three steps at the front door of the Harvey house.

"I have come to ask you an important question, Mr. Harvey."

"Yes, what kind of important question you have to ask me, Mr. Marcus Goodison?"

Marcus takes one step up and says, "I would like to have your daughter's hand in marriage."

"Which daughter would that be, Mr. Man. I have many daughters, you know."

"Your daughter Doris, sir. Doris is who I want to be my wife."

"You think that she will want you as a husband?"

"I hope and pray so, sir, because I . . . ," and here he almost breaks down crying, "because I have never met a nicer, kinder young lady in all my life, and my life will be worth nothing if she won't consent to be my wife, sir."

And these last words he says in a low hoarse voice, looking up into David's face, begging with his brown eyes for him to accept him, to intercede for him to Doris, because for a man who lost his mother when he was a teenager, his heart tells him that this is the woman he needs to show him what kindness and caring are. He knows that if and when he lays down to sleep beside her he will rest as he has never rested before, that his absent father, who was named for one of the archangels, will come to him in dreams and say, "My own boy, you have chosen well."

"Just know one thing, Mr. Man. If you form the fool you will have me to deal with."

"I would take my own life before I hurt her."

Marcus climbs up onto the top step and stands next to David, who then says, "Come my son, let us sit inside and talk."

Marcus's own father, Uriel, was the second son of the wealthy Goodison family, who owned acres and acres of red lands in St. Elizabeth, lands that were eventually sold to bauxite mining companies. Some say the first Goodisons were two English buccaneers who settled in Jamaica and married Creole women, so Marcus's father was one of the playboy sons descended from a line of retired buccaneers. Some say that the Goodisons were Jewish merchants and that the family name means "Son of God."

Marcus's mother, Hannah, had copper-coloured skin, blue-black hair, and deep tranquility. She looked like a painting of an Arawak Indian. She, like the Arawak Indians, had died early. Uriel, his father, also died young, and St. Elizabeth people said that his entire estate was meant to go to Marcus, who as far as anybody knew was his only child. But people also said it was squandered by Uriel's brother, an even bigger playboy than him, who hurried on his own end through riotous living in night clubs and brothels from London to Kingston and Havana. My father had received just enough money from his father's estate to buy himself a house in Malvern and a second-hand Model T Ford car. He was considered by the women of St. Elizabeth to be a good catch.

With her parents' consent, Marcus presented Doris with a diamond ring. My mother told me that for days after her engagement, all the young women in the village would come to the house and ask to see her diamond ring. However, not all of them were happy for her. At least one woman in Harvey River

was overcome by jealousy, and envied the love that had found Doris. This woman was a distant cousin who wanted to be married more than she wanted anything else in life. Someone swore that they once heard her say that she would give her life to be married just for one day. Well this young woman had looked at the engagement ring and had not been able to say anything except to ask how did they know if the diamond was real. She was overheard saying how unfair life was, that imagine, instead of herself "this little gal" was going to be the one to become a married woman.

My mother says that she fell asleep one afternoon wearing her ring, which did not fit tightly. When she awoke, the ring was gone. Such a commotion followed, with her bawling like a baby at the loss of her brilliant diamond engagement ring. Memories of her "bad luck" persona came back to her, the Clarabelle persona who cursed expressions and embarrassed herself, the girl whose long hair was chopped off had now lost her diamond engagement ring, she had come back to displace lucky, happy Doris, who was in love with and loved by a hand-some young man named Marcus. Everyone searched the house and the yard, to see if it had slipped off while she did her chores. My mother kept crying, and insisting that she was wearing the ring up to when she fell asleep. She was sure of this because she had been staring into its centre, and had dreamt that she was bathing in a crystalline pool of water. But the ring was nowhere to be found. Doris was inconsolable. What kind of cross was this, what kind of sign, for sure this was a terrible omen!

But Margaret told her that she was not to think such thoughts. "What this is, is envy and bad mind," she said, "and my dead father is going to see about it." That was all she said; but she said it loudly enough for everyone who had come to

help search for the ring to hear, and those who heard told those who had not heard. Doris found her ring at her front door the next morning. They say that the woman who was possessed by envy flung the ring, knotted in the corner of a handkerchief, onto the verandah of the Harvey house that night. Somebody said they saw her run past the house at great speed and throw something that arced like a white bird across the night sky, as she ran without stopping out of the village.

The task of preparing Doris for life as a refined married woman had been given over to Cleodine at Rose Cottage, where white damask tablecloths, bone-handled knives and forks, and monogrammed sheets were in everyday use. My mother had approached her sister's house with a very heavy heart. Once before, she had been sent to Rose Cottage to undergo "finishing" by Cleodine. That earlier visit had ended with Doris packing her bags after one week, and walking back to Harvey River in tears. When she reached home, tired, miserable, and covered with dust, she had entered the Harvey house sobbing. "She want to kill me. She make me wake up at five o'clock every morning, she make me knead dough till my hand want to drop off, because she have to have fresh bread every day. She make me draw her a hot bath every evening, because cold water cannot touch her skin. She make me iron about a thousand crochet doily to put on her chair and tables. 'Antimacassars, Doris, have you ironed the antimacassars?' Then she have to tell me again that an antimacassar is to keep hair oil from rubbing off on the chair upholstery, as if I care.

"Every time I try to sit down she say, 'There is nothing worse than a slothful woman,' and she find something else for me to do. 'Make me a cup of tea. The water must be boiling, and you must rinse the teapot in hot water before you put in

the tea leaves. Not more than three minutes, the tea must not steep for more than three minutes and then you are to pour it through a strainer, I am not a tea-leaf reader, so don't bring any cup full of tea leaves to me.' Stew guava and orange to make jam and marmalade. Learn to steam fish just the way she like it, because she don't eat meat. She read in some book that she have, how people who don't eat red meat live long, so every day all she cook is fresh fish, fresh fish and so-so fresh fish and stew peas without meat. She say that white bread is like poison. 'Brown bread has roughage, Doris, roughage!' Every day she telling me how I must eat roughage, so she ordering me to cut up cabbage and eat it like rabbit. But is when she order me to iron one of her husband drill suits that I pack my bag and come back home. I tell her, 'He is your husband, you should iron his clothes,' and she box me, so I leave, Mummah and Puppah, please, don't make me go back to Rose Cottage.'"

But it was there that my mother was sent to stay before she married my father.

Rose Cottage was set on five acres of land in a rolling valley in the village of King's Vale. "Castle Rose Cottage," as George O'Brian Wilson often referred to his granddaughter's house, could not be seen from the main road, and visitors had to make their way down a set of steps cut neatly into the hillside, until they came to the large white-painted, three-bedroom house built high on stilts. The house was called Rose Cottage because the entire garden was planted with fragrant pink, white, and cream rose bushes which bloomed in profusion from their neat, rectangular beds. Along the verandah, in special round clay pots made by a woman in the district called Congo Lou, Cleodine cultivated African violets. Indigo and purple and scarlet, brooding intense violets that were so strongly coloured you could stain your fingers by touching one

of the petals. Cleodine tended these herself, and all the brides-to-be were given strict orders by the yardman, as they sat there on the side verandah waiting to be shown into Cleodine's presence, never to "touch Miss Cleo's roses," meaning the violets. Like many Jamaicans, he called all flowers roses.

By the time of my mother's marriage, Cleodine had become one of the most famous makers of brides in western Jamaica. Women came from as far as Montego Bay, Savanna la Mar, and Falmouth to be transformed into fabulous brides by Cleodine. The brides-to-be were rarely young. By the time they made their way to Rose Cottage they were usually "big women," grown women who had lived for years with a man or with a series of men and had raised their children (who would then become attendants at the wedding) and worked and worked, and saved and made a life, all the time looking forward to their glorious wedding day. While they planted ground provisions and vegetables in a field, they would sometimes pause and look tenderly at bright potato flowers or garlands of yam vines and imagine their own bridal bouquets. As they slept on mats in the market, they imagined honeymoon beds, where all things would be made new again. When they put up with a man's wandering ways, wearing his hats and his shoes to show his other women who was the woman-a-yard, they heard themselves saying, "I have the talk, for I have the ring." Every Sunday when they cooked rice and peas and chicken and watched family and friends gather round to eat and enjoy the taste of a good woman's hand, they visioned the day when friends and family, bearing presents, would come to raise a glass to "Mrs. Bride and Mr. Bridegroom." And thereafter they would wave with their left hand to all, and watch their ring finger grow proud and stick out from the others on the left hand, for it was now weighted with gold. When the time finally came for the

women to make their way to Rose Cottage, they were ready to be born again into beautiful virginal brides, and there was nothing that Cleodine liked more than being completely in charge of a wedding.

"Take a seat on the side verandah" the brides-to-be were told by Cleodine or by one of her maids. Never the front, for only specially invited guests were ever allowed in through her front door. "No, I will not be making that dress for you, that style is utterly unsuitable for you," she would say to some woman who had the temerity to come to her bearing a picture of a dress she had torn from a magazine. "All right Miss Cleo, anything you say, mam." "You are not trying on this dress until you go and take a bath," she was known to say to women come hot from the market to try on their wedding dress. "Here is a piece of soap and a towel, go and take a bath in the river before you try on this bridal gown," she would say. And surprisingly, big, independent women who were older than Cleodine, who ran their own households like tyrants, would go meekly to the river and cleanse themselves just as Cleodine had ordered them to do. Once or twice she was heard to say, "I don't cast my pearls before swine" or "I will not waste powder on a black-bird," as some rejected and dejected woman made her way from Rose Cottage, never to know the magic of being transformed by one of Cleodine's creations, for Cleodine on occasion would flatly refuse to take the custom of someone and she never would give any further explanation other than the one about the swine and blackbirds.

The centre of Rose Cottage was a large, high-ceilinged drawing room furnished with the elaborate furniture Cleodine had designed herself, and in pride of place, a pipe organ that she had ordered and had had shipped from England. Above the organ, just where she could raise her eyes to it as she pumped

away, was a large gilt-framed photograph of John Wesley. Cleodine, in a gesture of modernity and independence, had upon her marriage formally embraced the Wesleyan Church, forsaking the Anglican religion of her forefathers.

"Well, Doris, I hope you realize that a married woman's life is not just a bed of roses," said Cleodine. They were sitting together in the gathering dusk on the front verandah of Rose Cottage. This time around, Cleodine had not ordered my mother about as she did on that disastrous first visit. She instead invited Doris to observe what she, the perfect example of a married woman, did with her days. "Everything must be done decently and in good order," Cleodine lived by these words. She rose early, because the Bible said that is what good women did. She washed herself in warm water which was brought to her by the maid, applied cold cream to her face and neck in upward strokes, dressed herself in garments that were demoted church dresses, and put on her high-heeled pumps. She was always the tallest person in her house, always. Thus prepared, she would emerge from her room and order everyone under her roof to participate in morning prayers and the singing of hymns before partaking of a healthy breakfast. None of those oily saltfish and hard food, morning-dinner type breakfasts were ever served in her house, ever. Only fresh brown bread baked the day before, new-laid brown eggs, New Zealand butter, wholewheat or oats porridge, homemade preserves and tea, lots of good black tea brewed in a warmed pot and served with milk and brown sugar.

"This is how you do it," she instructed as she showed my mother how to make a bed with the wrong side of the top sheet turned out so that the smoother right side is what touched you and your husband's skin when you lay down to rest. It is best to plan your meals in advance. You start the midday meal right

after breakfast, so your husband never, ever has to wait on his food. Always make sure your husband's clothes are in good order. A badly turned out husband reflects poorly on a wife. Always tidy yourself to greet your husband at the end of the day and make sure his supper is ready and that he has clean pyjamas to sleep in each night. And on and on, everything done perfectly, just so, right from morning till evening when the household was called to evening prayers, the lamps extinguished, and Rose Cottage put to bed.

My mother had turned red when her sister said that a married woman's life was not a bed of roses. Just the word *bed* made her embarrassed. Then her sister dropped her voice, as if she was sharing a terrible secret. "You cannot imagine what a terrible thing is going to happen to you," Cleodine said, shaking her head from side to side and making clucking sounds in the back of her throat. "If you ever know what is before you," she whispered. What was before her was of course her wedding night. Her sister continued, "If you ever know, the pain that a man puts a woman through, in order to get his pleasure!" My mother burst into tears sitting there in the dark on the burnished front verandah. Cleodine had left the "what was before you" discussion until last. For the seven days that my mother had spent at Rose Cottage, being groomed for her life as a "proper married woman," Cleodine had made no mention of sex. She and her husband had separate bedrooms, and he was often "away" on business. Cleodine had shown her how to bake bread, how to spread a table for company, how to make perfect corners on a sheet, and how to iron a man's clothes. The proper ironing of a man's white shirt took an entire morning, with Cleodine sending my mother back to the ironing board three or four times until the perfectly ironed garment was produced. "No, the sleeves must not be seamed, the collar must

have no creases, iron it first on the wrong side, open up the inside seams, then iron it on the right side." The ironing of a starched, white drill suit — with no creases in the sleeves of the jacket and perfectly straight seams in the trousers, and no creases on the fly — took almost one entire day. But there was no mention of sex.

Because the house was set in a valley, nightfall at Rose Cottage came early. Dusk then dark seemed to come to rest there before it reached Harvey River, and often, the Tilley lamps had to be lit from as early as 5 p.m. With dusk, an air of quiet melancholy often settled over Rose Cottage, with its shining floorboards, beautifully polished furniture, and everything in its right place. A heavy perfume of nightblooming jasmine, honey-suckle, and roses would waft in from the garden as Cleodine took her place at the pipe organ under the watchful eye of John Wesley, to play a selection of evensong hymns. It was after the organ recital that she would order all under her roof to take part in evening prayers before turning in for a long dark night.

The mahogany table in the dining room was always set with a place for Cleodine's husband, but often, when morning came, the place setting was undisturbed. "If it is too late, my husband sleeps in the room behind his businessplace," explained Cleodine, although my mother had asked nothing about the undisturbed place setting. After a long pause, she said, "At this time of the year, business is brisk, he is probably not coming home again tonight."

Except for the servants sleeping in the two rooms behind the house, my mother and her eldest sister were alone in Rose Cottage. By the light of the lamp that sat on the polished verandah table between them, my mother could make out her sister's profile that was growing to look more and more like Queen Victoria's. But on these nights, Cleodine looked like a

very sad queen. By day, her strong face was set like stone under her upswept hairdo, and no one, especially not her "subordinates," dared to look directly into her amber brown eyes behind her gold-rimmed glasses. The tip of her middle finger, capped by a steel thimble, would drum steadily on the lid of her sewing machine as she issued brisk orders to the servants, "Go — tap tap — and fetch me — tap tap — a cup of tea." "My husband is a hard-working man, I am proud that he will do whatever is necessary to succeed," she said, then she was quiet for a moment, as if brooding upon exactly what her husband was doing in order to succeed. My mother knew enough about her sister to understand that this statement about her hard-working husband was one that was meant to stand by itself. One that did not invite any response from her, one that she was not welcome to comment upon.

My mother wanted to say something like "poor you." She always said "poor you," but she meant it as a genuine expression of solidarity and sympathy. She would have loved to have said to her sister, "Poor you, I hope that you are not too lonely," but she knew that her sister would have considered it an impertinent remark, so she just kept silent. She wanted to ask her, "Since you are the only one of us Harvey girls who is married, and since you have shown me everything about how to keep a good house, what can you tell me about what is before me?" and Cleodine must have read her mind, because she then said, "I think it best that you read this book to acquaint yourself with what is before you." In the semi-darkness of the verandah, she handed her a book entitled *Safe Counsel*. My mother, who always preferred a teaching story to any dry, fact-laden book, later said that she was too embarrassed to read it.

Marcus and Doris were married in the Lucea Parish Church on August 2, 1931. My mother frowned and wept during the entire wedding ceremony, because brides at that time were not supposed to look joyful. The worst thing a decent young woman could do was to look happy on her wedding day, for surely that meant that she was looking forward to the sensual pleasures of the honeymoon bed and only a bad woman would enjoy that. My mother wept copious tears. My father smiled broadly throughout. Albertha and Rose sent her a trousseau from Montreal. Included in this wardrobe for a new life were silk and satin nightdresses, some with matching bed jackets and nightcaps. Her flowing wedding gown of crepe de chine with silk godets and her chantilly lace train, fifteen yards long, was the talk of the parish for years.

The couple went off to live in St. Elizabeth, attended by Doris's personal helper, Ina, and laden down with trunks full of fabulous clothes and housewares. As was the custom then, my mother wore an elaborate hat and a long duster coat as she drove away with my father in his Model T Ford.

ow that all her other children had left the house, Ann became the object of her mother Margaret's homilies on how sorrow followed closely to joy as surely as the night followed the day, therefore one should not be so laughy-laughy, so quick to pop story and want to go to fairs and concerts and dances with unsuitable friends. She, Margaret Wilson Harvey, as everyone knew, always had a deep mistrust for anything resembling excess happiness, and just to prove herself right, look how she herself had gone and forgotten and been so happy over her son Howard, and had not God taken him from her? Had her other son Edmund not run away to Kingston, never to return to Harvey River? Had God not allowed a spark from the cane-boiling fire to cool into a cloud in her left eye? Had not George O'Brian Wilson's legal family been allowed to cut her out of his will, rob her of the house and land in Lucea that he had specifically willed to her after she had cared for him in the last years of his life?

Her daughter Ann needed to learn from her mother's misfortunes; and if she did not want to learn from her mother's misfortunes, she should at least learn from that cautionary tale about an own-way girl who had come to a bad end in a village near Harvey River. The girl, it was said, suffered from

a powerful case of "don't care." She never listened to a word that her mother said, and she liked to laugh loudly and to "sit down bad"; that is, she would not sit with her legs closed and crossed at the ankles, preferably slanted to the side, so that others would not be able to look up under her dress. This girl loved to dance and she ignored her school work and took to sneaking out of her parents' house at night and going to dances in the company of some other no-good giggling Don't-Care girls from neighbouring villages, loud-laughing common girls. Well, one night she slipped out, and there it was she met her fate. The girl danced till near morning to the titillating beat of the "Merry Wang" and the frowsy rub-up "Mento." No doubt she danced to "Penny Reel O," a very slack song with lyrics like, "Long time me never see you, and you owe me little money. I beg you turn your belly gimme, make me rub out me money, penny reel O."

The dawn was rising over Hanover when she finally returned to her parents' house, but they had locked and bolted the doors and windows. So she sat outside in the yard on a stone, shivering in her long satin dance dress, with the back plunged low. As she sat there, it came to her that she should go and have an early morning bath in the river. She went down to the cool river, which in the dawn hours was a light jade green, the colour of young jimbelins. The water was deliciously cold and surprisingly warm in some spots, and she swam and swam until the sun came up fully over the village. She had no towel, so she rose out of the water and put on her dance dress over her wet skin, and to the eternal disgrace of her family, she walked home with her wet satin dress clinging to her voluptuous form, her hair long and dripping wet across her shoulders in thick ringlets. Cool and relaxed, she walked towards her parents' home and met them coming down the one street in the village,

dressed in their church clothes. They passed each other in the square and never exchanged a word. But the entire village witnessed this shocking scene and by the time her parents reached the church, the parson had put together a fiery impromptu sermon about harlots and loose women. This incident was in fact a blessing for him, because he had planned to preach one of his old stale standbys about the prodigal son. Well, you know that terrible Don't-Care girl died soon thereafter, probably from pneumonia or TB which, according to Hanover people, she had contracted by wearing low-cut dresses which exposed her lungs.

But some other people claimed that the Don't-Care girl had met a mermaid when she went for her early morning swim in the river. They said that she had made friends with this "River Mummah," who had combed the girl's hair with her golden comb and taken her down to the deepest parts of the river. Down there, River Mummah had shown her where her golden table was spread with delicious things to eat, delicacies rescued from the holds of sunken galleons which had come from faraway lands, laden with spices like saffron and coriander. She had fed her on cured saddles of mutton and haunches of venison and special breads and light cakes which never went stale and never grew soggy underwater. She had introduced her to many water souls, some of whom had met aqueous deaths for love. Some had run away and chosen to drown themselves and live as restless water spirits rather than as wretched slaves. People said that the Don't-Care girl had not died from pneumonia or TB but that the mermaid had come for her and that she was living under the river, forever dancing now in its restless currents. Some people even claimed that on some Sunday mornings she could be seen walking through the village, dressed in her wet satin dance dress.

And do you know that even after Ann was told this story the girl still clung stubbornly to her joy, to her sense of humour and her dreams? She announced that she wanted to go to Rusea's High School to study, maybe to become a lawyer. Her mother pointed out that this was impossible because David had succeeded in giving away almost everything they ever had to people in need. Besides, she knew David did not believe that girls should be educated. Like many men of his time, he thought that it was a waste of money to educate girls, who anyway would just end up getting married and having children. All that they had left was some land which Margaret was not going to sell to finance Ann's dreams, so she had better do what her sisters Cleodine and Doris had done and find herself a husband.

or the rest of her life, my mother would compare any woman who was inclined to be stingy and controlling to my father's grandmother Dorcas, with whom they lived during the first few weeks of their marriage. Those early weeks of marriage had proven to be difficult for Doris and Marcus. The one-bedroom cottage in which he had lived his bachelor life was being made into a house fit for a married couple who expected to have children, and that is why they were staying with Dorcas. A tall, dark, brooding, silent woman on whose land flourished a variety of fruit trees, she forbade anyone to ever pick so much as one lime without her permission. The sweetsops, soursops, naseberries, starapples, oranges, and mangoes sometimes rotted under the trees because she did not feel like giving her permission for anyone to pick them. Sometimes she would gather baskets of fruit and hang them from the ceiling in her kitchen, where they would over-ripen, dripping their sour nectar down. Bees would buzz around these laden baskets of spite-fruit, mice would nibble on them, and fruit bats would slap their leathery wings against them, but she would not give them away if she didn't feel like it. My mother, who loved nothing more than feeding people, was stunned and appalled by Dorcas's miserliness. "Nobody in Hanover would

ever do something like that," she would say, "these St. Elizabeth people are very peculiar."

On the day of Doris and Marcus's arrival in Malvern, the trustees of the Munro and Dickinson Trust were holding their monthly meeting, and the square was alive with horse-drawn carriages and several brand new Ford Motor cars. Doris did not fail to take note of the fine store that sold beautiful imported fabrics, and another dry goods store run by Cleve Tomlinson, who was Marcus's friend, and the fine courthouse building which, if anything, was even more impressive than the one in Lucea.

Marcus had many friends in the town of Malvern. Among them were teachers from the Bethlehem Teachers' College, and some were like the lively Gertie Holness, who ran the shop and bar situated on the main road and who was to become one of my mother's best friends. These friendships proved invaluable to her as she spent the first few weeks of her marriage enduring the tight-fisted ways of Dorcas, who considered Doris at twenty-three to be a mere girl.

The newlyweds attended church in Malvern on the first Sunday after their wedding to "turn thanks." It was and remains the custom in rural Jamaica that the bride and groom should always go back to church on the Sunday after their wedding to show themselves to God and the community and give thanks for the blessings of their new life. Doris took great care with her "turn thanks" outfit. She always described it in exactly the same words, the outfit she wore on this important occasion.

"I wore a dress of smoke-coloured Brussels lace with matching leather shoes that my grandfather George O'Brian Wilson made from my own last and a dusty pink cloche hat festooned with one blush pink rose."

All the marriageable women of Malvern had come out to see the stranger woman whom Marcus had chosen as his wife,

the woman he had gone to Hanover and picked out over all of them. "They came to see a show that day," said Doris, "and they did see one." They returned to their homes defeated. Marcus had married a princess. Which woman in St. Elizabeth could dress like that? And her walk, that straight-backed upright walk which she had learned from her sister Cleodine, who had learned it by wearing a backboard. Many of the women who came prepared to hate her for stealing their most eligible bachelor now wanted to befriend her so that she could help them to look fabulous, sophisticated, and uncountrified.

All the women except for Patsy and Ramona O'Riley, sisters who had both had their eyes on Marcus as a prospective husband. "If I don't get him, then it must be Ramona," Patsy would often say. Marcus was easily one of the most attractive men in Malvern. He owned his own house and had a good job, and he could make anyone, even the dour Dorcas, laugh with his outrageous jokes. Marcus was the friend you needed to have if you were ever in a jam. He was the friend you could tell a secret to and you would never, ever, in a million years, hear it back. He would lend you money and forget it. He would over-look your worst faults. "We are all human," he would always say. "If Patsy don't get him then it must be me," Ramona said.

In those first weeks of living with Dorcas, Doris suffered greatly from homesickness. She missed her mother and her father, her sisters and brothers, more than words could say. Sometimes at the dinner table, sitting down to one of Dorcas's frugal repasts, she would cry softly and lament out loud some-thing like, "I wonder, oh I wonder what they are having for dinner today."

Marcus became anxious, but he was doing everything to make sure his bride was happy. They were putting the final touches on their house, which was now redesigned with the

rooms situated one behind the other like the boxcars of a train, a house with high ceilings, separate living and dining rooms in the centre, and four bedrooms, two joined to the living room, two to the dining room, and the kitchen and bathroom behind. A big well-fruited yard with flowerbeds and its own water tank. Everything was being put into place in their new home. He so wanted Doris to be happy.

"How is Mrs. Goodison?" asks Marcus's best friend, Stanley Parsons.

"She not so bright today, I think she a little low. Miss her people, you know."

Stanley was secretly relieved that Marcus had not married Patsy or Ramona. He was hoping to land one of the sisters himself and he did not stand a chance if Marcus was around. He had a good reason to call upon them.

"Patsy gal, it look like that stranger woman that Marcus go and find clear a Hanover, head not so right you know. I hear the big woman just bawling like a child night and day for her mother and father."

The next week Doris and Marcus go to church, and after the service people come up to ask her if she was feeling any better.

"I am fine," says Doris.

"Oh, I thought I hear that you are suffering from melancholy."

And so it went on. Any little personal thing that Marcus told Stanley made the rounds via the bush telegram operated by Patsy and Ramona.

"What kind of mixed marriage that is anyway. Marcus should never married outside this parish. I hear the wedding had all kind of people mix up, whole heap of big shots siddown beside poor nayga." This was true, thanks to David

Harvey's egalitarian thinking, but some snobbish St. Elizabeth people who attended the wedding had not liked it.

One night my mother dreamed that she and Marcus were sitting down to dinner and that someone was cutting away the floorboards under her chair. She screamed loudly and the cutting stopped, then began again. This time they were trying to saw away the floorboards from under the entire dining room.

"Marcus, you don't see what they are doing?" she said as she related the dream to him. And much as he didn't want to admit it, Marcus soon realized that it was probably someone close to him who was behind all this, maybe even Stanley trying to destroy his new life before it had time to take root.

"So Marcus, how the Missus getting on?" Stanley asks him.

"That is she and the Mister's business."

After a while when their source of information dried up and more and more people began to speak highly of Doris's legendary good nature and kindness, Patsy and Ramona found other people to savage. For the rest of his life Marcus was careful to watch his words around certain people. In later years he would always tell his children, "The only person who can harm you is somebody close to you. Be careful who you choose to be your friend."

~

The parish of St. Elizabeth was supposedly named for Elizabeth, Lady Modyford, wife of the Governor of Jamaica from 1664 to 1671. On old maps of Jamaica the area was marked as "Elizabeth," and it is not certain exactly when Elizabeth became a saint. Before Columbus encountered the island of Jamaica, the parish was the site of significant Arawak and Taino settlements, where the peaceful native inhabitants

lived planting cassava and corn and going far out in the Caribbean sea to fish in large, long canoes hollowed out from the trunks of tall trees.

Apart from shopping expeditions into Lucea, and one or two visits to Montego Bay and Savanna la Mar, my mother had not travelled far from Harvey River before she married and moved to Malvern. Whenever Marcus, who was referred to as "Doris's intended" after their engagement, described Malvern to her, she would try to picture the place that was said to have one of the most salubrious climates in the world. A place that was almost always cool and where the air was clear and clean. She took to reading any story in the *Gleaner* newspaper that had anything at all to do with her intended's place of birth. "Shakespeare donates silver pattern and chalice to Black River Parish Church" ran the caption under a photograph of a man handing over an ornate box to another man dressed in a bishop's robes. But even if it turned out that the donor of the pattern and chalice was only a very distant relative of the great William Shakespeare, the newspaper report was proof that Malvern could not be an ordinary place if one of Shakespeare's relatives lived there.

Over time my mother collected a great number of odd facts about the parish of St. Elizabeth, facts that she would feed to her children for the rest of her life. "Santa Cruz," she would say if she saw or heard the name of that town mentioned anywhere, "Santa Cruz is a Spanish name meaning Holy Cross." Other Spanish names that intrigued her were "Hato De Pereda," which was what the Spaniards called the Pedro Plains; and "Lacoban," what they first called the Black River.

"When I moved to Malvern, in St. Elizabeth, I really missed the Harvey River," she would say, "for it is a parish that sometimes suffers from drought. Still, there are rivers and

ponds there, and the Spaniards called one of those ponds 'Laguno Suco,' which means 'dirty lagoon,' but St. Elizabeth people call it 'Wallywash.'"

Cockpit Country, Accompong, Cuffie Pen, and the Land of Look Behind. This was Maroon land, bush domain of Maroon leaders like Captain Cudjoe, who along with Accompong signed a peace treaty with the British in 1738. German Town, called "Jahman town," is where blond, blue-eyed men and women, the descendants of German immigrants, many of whom came to join the constabulary force, live and talk deeply dyed Jamaican patois.

Any mention of pirates would cause my mother to relate how southeast St. Elizabeth used to be home to many bucca-neers. "Yes," she would say, "when Henry Morgan, who was a wicked old pirate, converted from his sinful ways and became Governor of Jamaica, he laid down the law to all the other buc-caneers that they were to follow his example and settle down too. He gave them a lot of land in St. Elizabeth for them to turn 'gentleman farmers.' Some people say the Goodisons were descended from such men."

"'Labour in Vain Savannah' is what St. Elizabeth people called a place where the red soil was so tough and water so scarce that no cultivation could possibly thrive. Speaking of farmers," she would continue, "St. Elizabeth farmers are some of the most hard-working and industrious people in the world, for dry as that parish is, they still manage to grow so much of the food that feeds Jamaica. You know those people will even set down straw at the root of the plants to catch dew water when rain is scarce! They grow the nicest Irish potatoes and sweet potatoes in Jamaica and the best peas, pumpkin, and cassava.

"The Arawaks were the ones who first cultivated cassava,

you know, and there were Arawaks living in St. Elizabeth before Columbus came," she would say. "People who saw your father Marcus's mother always said she had Arawak blood in her. She resembled your father's cousin Estelle, the two of them had that same copper-coloured skin and that jet-black hair."

~

It was the arrival of her sister Ann that completely cured Doris of her homesickness. "Doris, I long to see you till I short." "Ann, you was always short," replied my mother, as they hugged and giggled in the front yard of the house in Malvern. Ann's talent as a mimic immediately found fresh material in the miserly character of Dorcas and the vicious troublemaking of Patsy and Ramona, whom she christened the cerassee sisters, cerassee being a local bitter herb. It was Marcus who had suggested that they invite Ann to come and spend time with them in Malvern when their own house was ready, for he knew that there was no one who could make my mother laugh like Ann. "Doris," she would say, "you remember 'Steevin, yu see mi drawers?'" and my mother would begin to laugh till long eyewater ran down her face, until she began to gasp for air, and her laughter and lack of breath became a series of whoops. Ann did not even have to finish the rest of that "Steevin, yu see mi drawers," a joke they had laughed about from the time they were small children, when on their way to church one day they overheard an exchange between an elderly couple who lived in a little house right on the main road:

Old woman: "Steevin, yu see mi drawers, the one with the crochet round the foot?"

Old man: "But now now Jemima, yu no tink yu damn fast, wha me know bout yu drawers?"

The compelling presence of the fabulous Ann drew all the eligible bachelors of Malvern to their house like a magnet. Suddenly all the young men in St. Elizabeth seemed to be "just passing by" the Goodison house from the time that Ann arrived. She flirted with, and made fun of, the best of them and she and my mother giggled like Don't-Care girls as they fixed up the newly renovated house. In between the giggling, Ann confided in Doris about the difficulties of being the last child left at home, how Margaret and herself were now always at war, especially since their father, David, was now confined to bed. He had nearly drowned when the small boat that was ferrying people from Havana, Cuba, to Lucea, capsized one Saturday night a mile outside the Lucea Harbour. David was a skilled swimmer and would have easily made it to shore but for one of the passengers, a large, loud-mouthed woman who could not swim. She kept holding on to him, and David just could not leave her to drown as all the other passengers had done, but laboured with her clinging to him like a massive remora that long water mile, giving her his strength, hauling her great weight through the dark Caribbean sea.

Most people agreed that my mother and father were not, as her father, David, would have said, "unevenly yoked." That they were a good match. That she was lucky to find such a kind and charming husband who was a good provider, and that he was lucky to find such a caring, industrious, and gifted wife. Her siblings all seemed to be happy to welcome Marcus into the Harvey clan. Everyone with maybe the exception of Cleodine. For if any one of David and Margaret's children was going to have an outstanding marriage surely it would have to be her, no, she could not, would not cede that honour to Doris.

Ann, in her later years, once referred to Cleodine as "Cleopatra Queen of Denial." For Cleodine had found that the way to cope with the disappointments in her own life was to simply deny that they existed. She solved the problem of ever witnessing my mother's happiness first-hand by never paying her a visit in her new home in Malvern. She would sometimes write to my parents, usually to inform them of some new piece of property her husband had acquired or of some important addition they had made to his place of business or to Rose Cottage, but she never came to visit. Ann and Flavius, however, would often over the years come and stay with their sister Doris in Malvern, and would always keep her abreast of the latest news in Harvey River. Once, Rose and Albertha came back on a visit from Canada, and they all had a big happy family gathering up in Malvern, without their older sister Cleodine.

Shortly after they were married, my mother had gone with my father to visit the capital city of Kingston, where he often went to the Kingston Industrial Garage on Darling Street, to buy parts for his garage business. He had taken her with him, because he said he wanted to show her something. He had driven past KIG down to a squatter settlement near the garage. "I know how you like an unusual sight, Doris, so look there."

My father pointed at a sprawling village built entirely from wooden packing crates. Everywhere as far as the eyes could see was the word FORD FORD FORD FORD FORD FORD FORD stencilled on the sides of the little wooden shacks.

"Ford ship the Model T in parts in one big wooden packing crate, and when the dealers assemble it, they use one side of the crate to form the floorboard of the car, and the

rest of it the Henriqueses give away to whoever asks for it." My mother's eyes filled with tears when she thought of their nice comfortable house in Malvern and her family home in Harvey River. "Oh Marcus, God bless them," she said. "You have to give our people credit for being enterprising."

It was on that occasion that he had taken her to the Ward Theatre, where my mother for the first time in her life saw a moving picture. As she sat in a plush, velvet-covered seat in the balcony of the cool, dark theatre, sipping a cream soda that tasted like water from some sweet invisible fountain, she was as happy as she had ever been in her twenty-six years on earth. There in the dark, she kept glancing over at the profile of her handsome husband. Even in the dark, she was aware of his distinctive profile, his high forehead, his "Roman" nose, his smile, oh his wonderful smile. She still experienced that little shiver of excitement when she saw him smile. His smile and the smell of his 4711 cologne. She was immensely proud of the way he sat there perfectly groomed, wearing a white shirt that she herself had ironed. She admired the way his fingernails and toenails were always clean and well-trimmed. "A clean man," she always said to her children, "your father is such a clean man." There in the Ward Theatre, looking by turns at the screen where the grainy black-and-white film rolled, then back at her husband, her future, without a doubt, was bright. A woman with a high upsweep hairdo that trembled when she struck the keys sat in the orchestra pit and pounded out accompaniment to the movie on an upright piano. My mother leaned over close to my father and whispered that the woman was good at her job, for she knew how to play fast when one of the actors was running for a train, and to play slow and soft when the lovers on the screen were kissing. When she said that, my father kissed her.

My Lord, if only everybody in Harvey River could see her now. "What a token," her father, David, would have said about moving pictures, using the word that the King James Bible used to describe signs and wonders. That day in the theatre she felt certain that she could live happily anywhere on this earth as long as she had her husband beside her. She, who had frowned and wept all throughout their wedding ceremony because, as she always used to say, "It was a brazen bride in those days who smiled," was freely returning her husband's love, there in the dark.

The next day as she dressed, she changed her outfits over and over, asking him, "How you like this?" "How about these shoes with this dress?" and unlike her sisters, he never lost his temper with her, he just sat on the bed in the guest house and smiled and smiled and told her naughty things like, "Yes I like that blue dress, it shows off your nice bosom, and every man on King Street is going to grudge me if you wear it." She had changed outfits until she had come up with the perfect look to go shopping with him on King Street, with its rows of sophisticated department stores, stocked with every imported luxury item imaginable. "Cleo, Miss Jo, Rose, and Ann should be here today," she kept saying, when she saw the top-quality fabrics, shoes, hats, handbags, housewares, and toiletries sold by elegantly turned-out salesmen and women over genuine marble counters. On the arm of her handsome husband she had ascended the wide staircases to the upper level of Issa's department store and had lunched on the balcony of what was then probably the finest department store in the Caribbean. This outing had made her shopping trips into the town of Lucea seem small. The streets of the bustling big city had made my country-girl mother nervous. Although she had stepped jauntily in her fine wine-coloured pumps, which complemented

her cream-coloured linen dress with just a touch of hand-embroidery in the form of a wine-red rose on her left shoulder, she was happy to cling tightly to my father's arm on that visit as the great crowds swept them along, up and down King Street, happy that he was such a fine and reliable husband who would always protect her from any harm.

\mathcal{M}y father did not consider his job as a chauffeur for the English manager of the Black River branch of Barclays Bank as a destination in life. His intention was to open his own garage, and along with Doris to run a fine guest house.

My parents were married in the month of August, but when December came around they realized that my father was going to have to spend his first Christmas away from his new bride, because the bank manager was a bachelor who always spent his Christmas holidays at the Liguanea Club in Kingston. The Liguanea Club was then an exclusive members club which did not admit black people. The only black Jamaicans who set foot on those grounds were the waiters, maids, and gardeners. The club's membership was comprised almost exclusively of expatriates, mostly Englishmen, who ran the affairs of the country when Jamaica was still a colony of Britain.

With a sad heart, Marcus left his new bride in the care of his grandmother and drove the bank manager into Kingston, depositing him at the Liguanea Club. He found accommodation for himself somewhere in downtown Kingston, and he spent all of that Christmas and New Year in the city driving his employer to various functions, waiting all night out in the car until the manager was sufficiently soused and ready to

return to the club. He had celebrated Christmases like this before driving for the bank manager, but as a bachelor himself he had not minded hanging out with the other chauffeurs while their bosses drank and bad-mouthed the natives, who were usually outside bad-mouthing the expatriates. But that year he felt different. He was now a married man, and a married man belonged in his house with his family at Christmas. When he returned from Kingston, he promptly resigned from his job and went into partnership with his cousin Charley. Together, they opened a garage, something my father had always dreamed of doing. Like all young men born early in the twentieth century, they shared the same passion, a love of motor cars. Unfortunately, the business did not last.

Charley had been born in Africa, where his father had been posted as a member of the West India Regiment. His wife had accompanied him, and their only child, Charley, was born in Liberia. The first time that my mother met Charley was when Marcus invited him and his wife, Minnie, to dinner in their newly refurbished house to meet his new bride. Doris had prepared a sumptuous Sunday dinner of rice and peas and chicken and pot roast. Using all her new bride things, she had spread the table with a snow-white damask cloth and used her dishes decorated with a bird-on-a-flowering-branch pattern called "Pareek," made in England by the Johnson Brothers. For years to come my family would talk about this meal. They had barely said grace when Charley fell upon the food. "Piece more meat, man," "more rice and peas," "put the gravy on the rice . . . the rice!" he would say. Then he would bend his head again over the mountain of food before him and work away at it, swiftly and deftly levelling it while tapping his feet in a craven, gormandizing dance.

Out of embarrassment, Minnie began to kick her husband

under the table. Only then did he stop eating to demand loudly of her, "What the hell are you kicking me under the table for?" Close to tears, the embarrassed Minnie pleaded with him. "Charley, please, look at Marcus, he is such a gentleman." To which Charley, lowering his head once again to work away at the mountain of food, replied, "Marcus does not know how to eat food."

The first time my father saw a motor car, he had been blinded by the light. It was just after dark, and the light came from a lantern that was illuminated by burning carbide and carried on a pole by a proud young boy who walked ahead of the vehicle. The Leyden brothers, three wealthy planters from Black River, St. Elizabeth, were said to have imported the first motor car into Jamaica in 1903, a four-cylinder "New Orleans," manufactured in Twickenham, England. Perhaps this was the same car that was now making its way through the streets of Malvern, and my father, like the little boy in the nursery rhyme, "stood in his shoes and wondered" at the sight of the magnificent horseless carriage.

My father never forgot how, years before, he had seen his first car, he had been sent as a small boy on an errand by his mother to deliver freshly laundered vestments and altar cloths to the home of the local Anglican minister. All over St. Elizabeth, horse-drawn carriages were a common sight, and to accommodate them there were huge wooden drinking troughs in almost every town square. Marcus's mother, Hannah, who had a gift for washing and ironing white clothes into pristine cleanness, had undertaken to launder the vestments and altar cloths without payment as a kind of temple service from the time that she was a young girl. The job of delivering the clothes to the manse on Saturday evenings soon fell to the child Marcus.

It had been a scorching hot Saturday morning, St. Elizabeth was in the grip of a long and hard drought, as a thirsty, sweating little Marcus trudged through the town square bearing a basket full of holy laundry. Suddenly he heard a great commotion, and when he looked he beheld a group of boys who had stripped themselves naked and were splashing gleefully in the waters of the horse trough:

"Hey Marcus, come bathe wid we."

He didn't think twice; he just put down the basket and, taking off his shirt and short pants, jumped into the cooling waters of the horse trough. He was having such a good time that he did not see his grandmother Dorcas approaching. She snatched him out of the horse trough, slapped his bottom right there before everybody, and made him put on his clothes, retrieve the basket of laundry, and walk before her to the manse, where to his terrible shame, she reported to the minister that he was a wayward and sinful child. The minister then proceeded to give him a long, long lecture and concluded by saying: "My son, do not be like the horse or the mule which need to be bridled." My father never felt warmly towards anything to do with horses after that.

But when he saw the car, he knew that his life was somehow bound up with this machine, which was powered by a noisy motor, instead of with an animal that ate grass, produced stinking manure, and needed to drink from a water trough. Marcus had joined the band of youngsters following the boy who held the lantern to light the way for the car, and when the car stopped he watched in awe as the driver descended and handed a tin can with a long spout to the boy, who gave the lantern to another boy to hold while he went in search of water. My father stood there, gazing intently as the driver took out a set of tools, knelt down, jacked up the car, and

unscrewed one of the wheels to change the thin narrow tire that had suffered a puncture. The boy with the lantern held the light high so the man could see to do his work. The first boy returned with the tin can filled with water, took back his lantern-bearing job, and the driver lifted the bonnet of the car, poured water into the engine, and closed it. Then he did something else, he took his leather belt from his waist and used it as a replacement for the fan belt which had snapped. When all these repairs were done, the driver swiftly turned the crank handle to restart the car, jumped in, and departed with the light-bearing boy running ahead of him into the night. My father would have followed them to the other end of the island had he not feared his grandmother's wrath.

So he went home instead and dreamt of the horseless carriage; and he knew that one day he would, like the driver, know how to give it water and to change the tires and replace broken parts and keep it going, for to him the car was more beautiful than any horse he had ever seen. So when big people asked him, "What you want to be when you grow big, Marcus?" he would reply, "I want to be a driver."

Cars were brought to the island of Jamaica by wealthy estate owners who imported the luxurious machines along with great steel drums of gasoline to power them. For years after, the great steel drums that had contained gasoline could be seen, abandoned, in open fields, gleaming under the hot sun, defying nature to break them down.

Because Marcus was so determined to become a driver, his mother had sent him to one of her relatives to learn how to drive a truck. By the end of one week, just by observing what his cousin did, my father was able to drive. His cousin was amazed when he, partly in jest, said to him, "Show me how you woulda drive, if you coulda drive," and the thirteen-year-old

Marcus got behind the wheel — half-sitting, half-standing, because he was not that tall — and with a smile of pure joy, drove the big old truck until it reached a steep incline.

"All right, all right driver," said his cousin, "gimme back mi truck, for me can barely manage this hill, what says a new driver like you."

Driver. He had called him *driver*, and the word fell like a benediction on the young Marcus's ears. After that my father set out to learn everything about cars and trucks. He would walk from Malvern into the town of Black River to seek out the company of the older men who had been trained to maintain the island's first motor car. Men who were happy to share their knowledge, to explain what made the horseless carriage run and how to keep it running.

Life was good for my parents in those early years. Unlike her mother, my mother had no difficulty conceiving, and went on to have nine children in all, one every two years from the time she was in her mid-twenties until she was in her early forties. After a year and a half of marriage, she gave birth to the beautiful and intelligent Barbara; two years later a son was born and named Howard, after her beloved brother; and then came Carmen Rose, whom we called Betty; and then Vaughn, who did not like his name, so he christened himself Bunny. (The five remaining children were born in Kingston, in the following order: the twins Kingsley and Karl, then Keith, me (Lorna) and Nigel.) Their house in Malvern became filled with children and friends always coming and going. There was plenty of domestic help with raising the children and doing the laundry and keeping the house clean, but my mother maintained strict control over her kitchen because my father always claimed that he could taste the difference in the food that she cooked as

opposed to food cooked by anyone else. "I can taste your hand, Doris," he always said.

Christmas was the most wonderful time of all. Everyone wanted their car in top shape for the great season of party-going, and the garage was busy day and night. Even the most hard-pay customers would settle their debts in the season of Peace and Goodwill, so Marcus was always able to buy wonderful presents for Doris and the children. Toy pianos that played real tunes, lovely sleeping dolls and spinning tops and music boxes. Fabulous lengths of silk and soft shoes for Doris and more and more lovely furniture for their house. Their house, which always smelled of delicious food cooking, where the Salvation Army choir would stand outside and sing carols and Doris would invite them in and give them Marcus's famous Christmas eggnog as a thank you for serenading them. The Bible promised seven years of plenty, and that promise was made good during those prosperous years before they moved to Kingston. "In those days, we had the very best," my mother always said. And then war broke out in 1939.

My father had feared his grandmother's wicked tongue too much to tell her when his business began to lose money. "You pass you place, Marcus, to go and want to have garage business. You see me, I know my place, you woulda never catch me a eggs up myself bout me a open business. High seat kill Miss Thomas' puss! Nayga people must know dem place, what a way you bright fi go open garage business, is better you did keep you good, good work with the bank manager, it serve you right. Is that Hanover woman you go married to who encourage you inna that damn foolishness."

As it turned out, Marcus was to lose everything he owned. In the late 1930s, car parts and gasoline became increasingly scarce, and many of my father's customers were forced to

convert their cars into horse-drawn carriages by removing the engines. Also, Uncle Charley, who was supposed to look after the bookkeeping side of the garage business, drank and spent money in the same manner in which he ate.

Marcus never told his grandmother when the business closed. When she sent to call him, it was a week after he had had to padlock the gates himself, and pay off the two mechanics who worked with him. Dorcas had summoned my father when people in the village had brought her news of his failed business. He received a message from her that said: "Come and see me, but don't bring your wife." He went to see her and found her sitting up in her rickety old iron bed, her airless bedroom lit by one small, irritable little kerosene lamp. The room reeked of her old lady musk smell, the camphor oil she used to anoint her creaking limbs, and the kerosene oil from the lamp. She spoke these words to my father through the semi-darkness:

"I decide out of the goodness of my heart that since you fall so low, you can come back here and live with your wife and children and help me to plant red peas and cassava. But, you and that Hanover woman and your damn children will have to live under my jurisdiction. Although you are a big married man now, I am still your grandmother and under my roof, my word is law." The old iron bed creaked and groaned as Dorcas threw herself into her homily on the sins of flying past your place. She all but stood up in her bed in order to remind my father how she had never failed at anything in her life, because, "He who is low, fears no fall." She repeated her offer to have my parents come back and live with her, an offer she accompanied by the thumping of her fist on her bony chest to underscore the phrase "My word is law." My father responded by leaping up from the chair in which he was sitting, and as he strode out

the door, he said, "Don't worry about me, don't worry about me, my wife, or my children. We will be all right."

"I would prefer to die than to live under her roof again," he had said to my mother of Dorcas's offer. After Marcus's refusal, his grandmother took his name off her will and bequeathed her land to the government. Going to live in Harvey River was out of the question; there was no way to earn a living there. So my parents decided that their only alternative was to move to Kingston.

They had had one last dinner party in their Malvern house. One last big dinner party before the new owners came to take possession, before the truck that would take them into Kingston backed into the yard, drove over one of the flower-beds, and parked by the front door so that they could load what was left of their house filled with fine mahogany furniture onto the back. For that dinner party, my mother had cooked their favourite meal. Pot roast and rice and peas and brown stew chicken and fried plantains. And because no party in Jamaica is a party without curry goat, they had said to hell with the expense and purchased a young kid, and slaughtered and curried the tender flesh. As she spread the table with the damask tablecloth Cleodine had given her as a wedding gift, and put out all her fine wedding things, remembering all the "daintiness" that her sister had taught her, my mother was overcome by the knowledge that this was the last time that she would ever spread a table in this house where she had come to be so happy. A realization so final that she had to sit down suddenly in her seat nearest the door through which she would come and go to and from the kitchen to the table.

My mother remembered the morning they had bade miserly Dorcas and her house of meanness farewell. She had woken and found herself singing, "The strife is o'er, the battle

done; Now is the Victor's triumph won . . . Alleluia!" She and Marcus had carefully assembled their possessions and packed them into a truck belonging to one of their friends, on the day their house was finally ready to be occupied. "Thank you very much, Grandma Dorcas, for your kind hospitality," they had said to the wretched, miserly old woman, and then they had practically run outside to the truck and driven joyfully to their own house. Marcus blew the horn all the way from his grandmother's house to theirs. They sang a song that newly emancipated Jamaicans sang on the first of August 1838. "Jubilee, Jubilee. Me get full free. Me can stand up when me want, siddown when me want, liedown and gettup when me want, for me free." Yessir, they were free to laugh and talk and sleep and wake as they pleased, to cook big dinners and enter-tain any number of friends they wanted. "Why the hell would I spendup my money to feed a whole heap of hungry-belly people who should stay home and eat at them own table?" was Dorcas's response to a suggestion my mother once made to her that they invite some of their neighbours over for Sunday dinner.

She was well-acquainted with every corner of this house, every door, every window. "Brussels" and "tarshan." My mother had carefully stitched every one of the lace curtains that were now being taken down from the windows of their house. She could identify a Brussels lace from a Venice or chantilly lace with her eyes closed. She would rub a forefinger over the surface and correctly identify the lace in question. She had arranged every bed, chair, and table in that house, where they had kept the front door open from morning till night because they so loved to see their home filled with guests. They had planned to one day convert that house in Malvern into a paying guest house, for nothing gave them more pleasure than to see their

friends and relations enjoying hospitality Doris and Marcus style. But they never did get around to it.

"Doris girl, your nice life done," said a voice inside her. She walked over to the table and stared and stared at her place setting before her, trying hard not to cry. To calm herself, my mother rubbed the crest of the bird perched on a limb at the centre of the dinner plate. She ran her finger along the limb on which the bird sat, and a voice rose up in her. It said, "Doris, this limb is now broken." She imagined at that moment that the bird on the dinner plate flew up and out through the dining-room window from which the lace curtains were now removed. "You soon come back man, Marcus, and you cannot live in town, you just going to pay Kingston a visit," said their friends. My mother would remember little about that last dinner party in their house they were about to lose because she deliberately kept herself busy tending to the needs of their guests. The friends who were talking and laughing too loudly. The people who kept hugging her and saying, "We don't know what we are going to do without you." Some of them were even crying openly as she remained resolutely dry-eyed, but she would always remember one incident.

"Time for a song now, Marcus." My mother felt her heart fall when their friends began to say that. "You know we can't let you go to Kingston before you drop two tune, Marcus." O God why they want him to sing, Doris thought to herself. Why can't they put themself in his place? How would they feel if this had happened to them? Would they feel like singing? O Lord no, Marcus just tell them you don't feel good, tell them you not up to it tonight, of all nights. She watched his every move nervously, rubbing the insides of her arms along the sides of her belly, which had become high and wide after she

had given birth to four children. "Say no, you not singing tonight." She shook her head and tried to get him to catch her eye, but he refused to look in her direction. Instead he headed into their bedroom. She hurriedly put down the tray of cold drinks that she had been offering to their guests, saying in a "put-on," cheerful voice, "Have a last drink on Marcus and me." When she saw him come from the bedroom with the guitar, she made for the open front door and stood in the doorway with her arms folded. He took a seat in the living room beside his prized gramophone, the second thing that he had bought for their house after their marriage bed. She could tell that he was determined to avoid her look, which she had learned from her mother, Margaret, that cross between a cut-eye and a stare-down look that she'd brought with her from Harvey River.

What she did not understand was that his heart was so heavy right then, that if he did not sing, he was going to break down and bawl like a baby. He reached up and lifted the big heavy-headed needle off the seventy-eight record. It was Leadbelly singing "Goodnight Irene." Before that night they would always listen to that record together, sitting side by side on the loveseat, the third thing that he had bought for their house. He always wanted her to sit on his left. "On the heart side," he would say, "I want you always near to my heart." Always with one arm thrown around her neck and his long fingers stroking her rounded upper arm, they would listen to Leadbelly, and Marcus would say, "Wait, wait, the nice part coming now." This was how they liked to wait for Leadbelly to reach that part in the chorus when he sings, "Goodnight, Irene, goodnight, Irene, I'll *get* you in my dreams," for when he reached that part, they would both turn and face each other at the same time and laugh out loud. Every time, they laughed

together as if they were hearing Leadbelly's lascivious tone for the first time, "I'll *get* you in my dreams." They'd laugh till she caught herself laughing at Leadbelly's slackness, and she'd stop and say, "Marcus, you are too out of order," as if she had not become a little out of order herself, now that she was a married woman.

But that last night in their house, she could find nothing to laugh about as she watched my father carefully sit himself down alone on their loveseat so that the seams of his trousers fell just so. She watched as he held his guitar close to his chest, just like he sometimes held her when they were alone, and she knew she would never laugh at that song again. She watched as he shut his eyes tight and began to rock back and forth, and with a lump-in-his-throat voice, took up where Leadbelly left off. When she heard his voice begin to vibrate and break up, she stopped clutching herself and balled her hands into two fists by her side. She leaned forward, gathered up her strength, and began to call out to him silently, insistently from her place by the door. She felt herself begin to haul up strength from her belly-bottom, until she was almost standing on her tiptoes, and she strained towards him begging, no, commanding him without words: bear up. Don't break. Marcus, don't you cry before them. Not even if they are our friends, don't make them see you cry. "Sometimes I live in the country, sometimes I live in the town, sometimes I take a great notion, to jump in the river and drown: Irene goodnight, Irene goodnight, goodnight Irene, goodnight Irene, I'll see you in my dreams." That night she gathered up her strength and force-fed it to him so he could part company with Leadbelly. When he switched to his repertoire of rude songs, she touched her open hand to her belly-bottom in gratitude to her woman strength. "Bredda

Manny O mi find a Candy, Bredda Manny O mi find a Candy, Bredda Manny O mi find a Candy dash it wey you nasty bitch a puss shit." That night he did make them laugh, he made them laugh, he made them dance.

Later, as they lay on their marriage bed, without having bothered to remove the white candlewick bedspread, he had cried then. "How many times must I lose, Dor?" he had asked her. "How many times?" It was then he told her how his mother had lost her land. She had lost it, he said, because of him. He had gone as an apprentice truck driver at the age of fourteen to work in Port Antonio and there he had fallen sick with malaria fever. They had sent a message to his mother to come to him in the hospital and she had, in the emergency, used her house and land as collateral for a loan of thirty pounds from a Mr. Russell, the justice of the peace of that parish. Her son was sick, she was in a hurry, she did not read what she signed and that is how she lost her land, in the same way that thousands of poor Jamaicans have lost their land for nearly two hundred years. When she came back to Malvern, after a month of nursing her son, Russell had foreclosed on her house and land. She had taken her case to the authorities at Black River Courthouse, but Russell's friends who sat on the bench had found in favour of Russell. Everybody said it was the loss that had killed her.

"How many times must I lose, Dor?" And then it was she who was holding him close to her chest, saying, "no mine no mine no mine," and assuring him of the many opportunities that existed for him in Kingston, the businessplaces just begging for a good and capable man like him to come there and work. It was she who was saying that everything happens for a purpose and that one thing she was looking forward to (although she

was not an idle sort of person) was going again and again to the Ward Theatre to see moving pictures and concerts.

The more she thought about it, growing up in Kingston would make the children grow bright and uncountrified. Barbara, their brilliant first-born, could go to a very good school like St. Andrews High School for girls. But she had also said, as he kissed her in gratitude, that if after experiencing all the wonders of Kingston, they still really didn't like it, they should move right back to the country, where they would buy another house after they had worked and saved enough money. That night she knew in her heart that from then on, she was going to have to be the strong one, the one who would have to adopt her sister Cleodine's straight-backed walk and grim determination to move forward, come what may. And then he said to her, "Dor, let us make sure we keep our business to ourselves." My father had learned his lesson from the early experiences of their marriage and the mischief-making of his friends, like the cerassee sisters, and thereafter he always declared that what happened between a husband and a wife was strictly their personal business.

All the children in the Harvey household had grown up seeing their mother and father in agreement on most matters affecting the family. Sometimes if they disagreed openly and Margaret became loud and belligerent, as she was wont to do, David would suggest that they step into their bedroom and close the door and argue it out there. Sometimes as they lay in bed at night the children could overhear them talking about whether David should keep going to Cuba or not, or whether they should sell some of the land, whether David and his brothers should take a certain case, because everybody knew the accused had done what they said he had done. But before the

children it was always, "Your father and me," or "Your mother and me think this or that." When Margaret did not get her own way, she would say, "Mr. Harvey and I think this or that so." And so Doris began to rehearse what she would say to anybody who asked her how could she leave the country for hard life in town. "We have decided to try our luck in Kingston."

part three

On their first morning in the city of Kingston, before daylight, my father had woken up and dressed in the dark so as not to disturb her and the children. As he left, he whispered to her that he was going to return the truck that they had hired to bring them to Kingston to a driver who was waiting on Spanish Town Road so he could drive it back to its owner in Malvern. He said too that the same friend who had found these accommodations was taking him to see about a job and he wanted to be there early. She had murmured something like, "Where you going without breakfast?" and then she had fallen again into exhausted sleep. When sunlight, pouring in through the row of windows facing the street, made its way over the piles of furniture, across the wooden floor, and over to the small windowless room that was now their bedroom, my mother woke and heard the street cries of Orange Street for the first time. The night before, after entering the city of Kingston from the Spanish Town Road, when my father had turned the truck that carried them from St. Elizabeth up Orange Street, they had almost met with an accident. As my father rounded the corner, they saw thundering towards them a dray cart being driven at breakneck speed by two masked men! My father braked and pulled over suddenly as the cart

flew by, trailing the smell of shit. These were the pit latrine cleaners of the city of Kingston, many of them descended from East Indian indentured labourers who had been born as untouchables and deemed fit only to clean sewers, handle corpses, and to do the lowliest work assigned to human beings. Although there was no law in Jamaica which made them untouchables, these men still elected to do the sewer-cleaning work done by their forefathers.

At the gate of no. 117 Orange Street, my mother's face had fallen when she saw what was to be their new home, a set of three rooms off a central courtyard, with an enclosed verandah. Still shaking from their encounter with the speeding cart of the latrine cleaners, she saw that the street was lined with rows of houses and places of business all jostling with each other for space. By the light of the street lamps, she could see that there was no room for trees on this street. The small wooden gate of no. 117 was reached by climbing a brick platform, via stairs set into it. When they had walked up the stairs, pushed open the wooden gate, and stepped into the vast brick courtyard, my mother realized that things had truly changed. For the first time in her entire life, she was going to share a living space with complete strangers, many of whom she could feel peering out at her and her family from rows of dimly lit rooms.

The friend who had found this place for them was waiting at the gate to hand over the keys. When he saw how my mother's face had changed when she stepped from the truck, he told her that they were fortunate to find a place like this because Kingston landlords don't like to rent to people with children!

Her four children lay asleep, wearing the clothes she had dressed them in the day before, on one of the two beds that

they had hastily assembled last night. They were all exhausted from the long everlasting truck drive from Malvern to Kingston. All the way there the two younger ones, Betty and Vaughn, who rode with her in the cab, were restless. Betty kept asking where were they going over and over again, till my mother finally snapped and said, "What are you asking me for? I don't know," and she had felt bad the minute she had said it, for a remark like that would make her husband feel very small and ashamed because he had lost them their house. He did not respond, but just reached down and changed gears and stared hard at the road. In order to quiet the children and to change the mood in the cab of the truck, she had fed them biscuits and cakes and sweet drinks all the way to Kingston. The two older children, Barbara and Howard, rode in the back, seated on various items of furniture, happy to be having such an adventure. My father had made sure that they were secure by nailing a wooden gate across the back of the truck. Where were they going? She really, in her heart of hearts, did not know. This morning though, lying in this small bedroom in Kingston, she knew that soon the children would be awake and needing to be fed. Exhausted, disappointed, and overwhelmed as she was by her new surroundings, she felt guilty that for the first time in their married life, she had not prepared breakfast for her husband. She was not going to do the same to her children, so she ventured down into the yard in search of the kitchen. There was not a single tree in sight except for a headless breadfruit tree rising from the one unpaved space in the brick courtyard, its blunt silver-grey trunk bowing to the east. The only greenery in evidence sprung from discarded paint tins and old chamber pots arranged outside room doors and under the jalousie windows. These were planted mostly with mint bushes and common flowers like monkey fiddle and ram

goat roses. My mother saw that her new source of water was to be a metal standpipe springing out of a low concrete cistern and she later found out that each of the tenants was supposed to take turns scrubbing it, a system guaranteed to generate no end of strife. Like the Harvey River, the standpipe was the place where residents gathered to collect water for all domestic purposes. Unlike the people of Harvey River, who found refreshment and blessings in their source of water, she would soon discover that the residents of the tenement yard regarded the standpipe as the site for loud quarrels and even the occasional fist fight.

"I would prefer to dead like a dog in the city of Kingston than to bruk mi back chop cane." That was the sentiment of all who had elected to "make life" in the city, to live in rented rooms and share the same cooking and sanitation facilities, to work and educate their children and to one day own their own house and land; they always said house and land.

"These damn hurry-come-up Kingston landlords don't like to rent to people with children." This is what the friend who had found the place for my parents had warned them. He also warned them how some of the people who had not too long ago come from rural Jamaica to find employment in the city were in the habit of declaring themselves "born Kingstonians," which entitled them to make fun of the latest arrivals from the country. "If they trouble you, don't pay them any mind, Dor, we are only passing through" was what Marcus had said.

As my mother made her way to the communal kitchen, one woman called out to her friend, "Mi dear you see mi new style gramophone?" and the other one replied, "Yes mi love, I see you have one that can only play pon verandah." As most of my parents' furniture could not fit in their now much smaller

living space, they had had to pile much of it, even their precious gramophone, on the small verandah outside. When the other tenants woke that morning and saw the overflow of furniture on the verandah outside my parents' rooms, those whose worldly possessions hardly filled one small room immediately began to "throw words." Mocking phrases like "country come a town" rose up to meet her as she stepped down into the yard, saying good morning, good morning to everyone as she went, bearing a small newly acquired cast-iron coal pot stove that she intended to set up in the kitchen, which she identified as the long, low structure near the right-hand corner of the courtyard, with clouds of black smoke issuing from its narrow doors and windows.

"Ace-blank inna you arse" was what she heard as she stepped further into the courtyard. "Learn fi play domino bwoy." A group of big able-bodied men, including an old white-haired man dressed in a white sleeveless merino, sat crowded around a table, smoking cigarettes and drinking tea from large, battered enamel mugs as they slammed down bone domino tiles. It was 7 a.m. Women, some still in nightgowns, were plaiting the hair of small girls in the doorways of joined barracks-type rooms with narrow verandahs. One or two of them were vigorously beating children who were reluctant to go to school. "You duncey head little wretch you, you fi gwan a school, you want push handcart when you grow big?"

One young girl, who looked as if she had toiled all night somewhere, was slowly making her way to the farthest room in the yard, as two older children advanced towards my mother bearing brimming chamber pots. They were headed for the toilet that was housed in a ramshackle wooden structure to the left of the yard. The level of noise, and what her mother, Margaret, would have condemned as loud common laughter,

nearly drove her backwards. She was tempted to turn and go back into her rooms and bolt the door, but she kept going.

"Good morning, everybody," my mother had said to the women standing stirring their cauldron-like pots in the dark kitchen. Nobody answered. Nobody made a move to make room for her at the "firewall," the sooty concrete counter where all the stoves sat. Chocolate, tea, coffee, ackee and codfish, rank corn pork, green bananas, boiling cornmeal porridge, and flour dumplings contested for scent supremacy in the early morning air. From the recesses of the dark kitchen, one woman immediately raised a bantering, mocking song, a song with words intended to wound. Actually it was more of a chant that had just one line that she intoned over and over, "How art the mighty fallen, how art the mighty fallen." The other women took up the chant, and my mother left the kitchen in tears.

"She think she better than we," the same woman kept telling all the other women in the yard as they squatted near the standpipe with their wooden washtubs. "Then if she better than we, why she and her husband and pickney have fi live here so?" The hectoring woman was named Vie and she had taken an instant and virulent dislike to my mother. My mother could hear Vie and the other women in the tenement discussing her and her family from her rooms in those first few weeks. She tried to keep her children confined to the rooms and verandah and to do her laundry late in the afternoon instead of early in the morning, after all the women had left the pipeside, but every day she still had to face the kitchen.

"How art the mighty fallen, how art the mighty fallen." Every time she went into the kitchen there was Vie, raising her "How art the mighty fallen" anthem. Eventually even the other

women agreed that Vie took her hectoring and "throw-word" too far. How would anyone like it if every time you saw them they were saying, "How art the mighty fallen," when they did not even know you, did not know the circumstances of your life. Over time, Vie added to her chant a few other choice lines such as "Scornful dog nyam dutty pudding" and "High seat kill Miss Thomas' puss." At first my mother tried to ignore Vie, as my father suggested, and managed to make her way around the communal kitchen and bathroom arrangements by just watching to see when they were not in use. She also began to imagine that she was wearing her sister Cleodine's backboard every time she went down into the yard, her sister Cleodine, who would surely have a few things to say when she heard about where Doris and Marcus were now living.

In the 1650s and 1660s, what is now known as the city of Kingston, Jamaica, used to be Colonel Barry's Hog Crawle. The town itself was established on June 16, 1692, in acknowledgement of the importance of its massive harbour, said to be one of the seven largest in the world, its abundant good water, its proximity to natural resources, its fertile soil, and gentle breezes. Drawn up as a parallelogram one mile long from Port Royal to North Street, and half a mile wide from East Street to West Street, by 1716 Kingston had become the largest town on the island of Jamaica. According to travel writers of that time, Kingston was a city to be either hated or loved. Some writers found it to be one of the most backward and least attractive of southern cities, with narrow streets and dull, shabby houses. Others remarked on the handsome residences set far back from dusty roadways, showing white through shades of palm. Some referred to it as a city filled with hovels of low degree, dark with grime and populated by multitudi-

nous negroes. But a little later, travel writer Ethel Symonette described it as a place with everybody on the go, tongues busy effecting purchases with the confused jingling of streetcar bells, joining with the clear ring of horses' hoofs, the shrieking whistle of the locomotive making itself heard. A bustling little place with rows of good business houses, nice churches, and passable shops where good English stuff could be bought at a ridiculously low price.

By the end of the nineteenth century, Kingston boasted hotels like the fabulous Myrtle Bank and the Constant Spring Hotel, also the ornate velvet-curtained Ward Theatre, where touring thespians from Britain gave regular performances. Then in 1907 an earthquake shook the city and fires broke out all over. The citizens swore that Armageddon had come. The Kingston Parish Church lost its steeple, and the owner of Nathan's, one of the largest stores on King Street, was killed when his store collapsed on top of him. By the time Marcus and Doris moved there in 1940, the population of Kingston numbered 150,000.

~

My mother rose early and ironed a shirt for my father to wear on his first day at work. She was pleased because she had ironed the shirt perfectly, with no seams in the sleeves and no creases along the collar. She was especially pleased as she went singing down to the kitchen because her husband had found a job, and that morning he was behaving more like his old self as he patted her on her bottom playfully when she passed by him sitting on the verandah, polishing his shoes. "Marcus, you are too out of order," she half-protested, sounding again like the young bride Doris, reacting to her frisky young groom for the

first time in months – her groom, who was saying that maybe he would drop by to visit her in the telephone van that day when all the children were at school.

"Marcus, you mean we can soon move from here?" "I tell you we were just passing through," he had said. For the first time since they moved to Kingston the future began to look bright. He had gotten a job as a linesman at the Jamaica Telephone Company after weeks of job hunting, and my mother could not have been happier. She was singing, "God is working his purpose out" as she went into the kitchen. She did not give a damn about those lowdown Kingston women who were so vicious and unkind to her, for indeed God was working his purpose out. Her husband had found a job, they were just passing through, soon they would be leaving here, and just as she had that thought, Vie came buzzing around her like a damn rotten-teeth, one-frock locust.

My mother, who had been so excited and so anxious that my father should not be late on the first morning of his new job, would later swear that she heard George O'Brian Wilson's voice as she poured my father's tea into his favourite teacup while Vie bantered away in the background. Her grandfather's voice was asking, "Why the fock are you letting this eedjit bully you?" My mother turned and, like a great she-bear, slapped Vie, and my father's cup broke. Vie stood there stunned as my mother passed her, went upstairs, served my father a fried egg and bread, with no tea, which he ate standing up in the doorway before hastening to catch the tram to the telephone company. Then she fell on their bed in that cramped Kingston room and bawled like a baby, with two of her four children crowding round her, the two eldest having been dispatched to school early.

"What happen, Mama?" they kept asking until she had

become irritable and told them to shut up and keep quiet. She could not tell them that she was crying because she never in her life had lived under such rough conditions and that she never in her life had ever had to stoop so low as to slap somebody just to be able to live in peace. No wonder country people called Kingston, "Killsome." As far as she was concerned they could not pass through quickly enough. But strangely, after she slapped Vie, the rest of the women began to be quite civil to her, especially after the business about the one-pound note.

It was a one-pound note, it was definitely a one-pound note. The reason my mother was so sure of this was that it was the only money she had to her name and it was all that stood between her and my father's next payday. She had sent one of my brothers with it to the shop to buy a loaf of bread, a tin of condensed milk, and a tin of cocoa for supper. He came back with the change short. My mother sent him back to tell the shopkeeper that there had been a mistake, but he returned from the shopkeeper with a message that said it was not one pound that my brother had brought to the shop, but ten shillings. She hardly ever left her house in those early days, mostly because she was still getting used to her surroundings. Sometimes as she carried her wooden bathboard, which my father had bought for them to use whenever they used the communal shower, she wondered to herself how and when did she go from being a Harvey of Harvey River, to wife of Marcus Goodison, living in their wonderful open house in Malvern, to sharing the same kitchen and bathroom with jaze-ears Vie? Could be worse, could always be worse, but while there is life, there is hope, because God is working his purpose out. But this time she was forced to work it out herself. She just could not afford to lose that much money, so she tidied herself and ventured out to explain to the shopkeeper that he had

made a mistake. So there she was, this tall, shapely, attractive woman in a flowered navy blue crepe dress, worn with soft black leather pumps, walking quickly along with her children trooping behind her as she went to confront a thieving shopkeeper who had robbed her of the money she needed to send her children to school the next day. But when she got there, the shopkeeper insisted that it was ten shillings that my brother had tendered. My mother insisted that it was one pound, and the shopkeeper said that perhaps my brother had taken the money. My mother said she was sure that he had not. "If some people so great how come them have to be living right there on Orange Street, mixing up with poor nayga?" asked the shopkeeper to his wife, who stood silently supporting him. He began to make more and more really offensive remarks about people who thought that they were better than other people.

"Don't let them haul you down to their level. Walk away from them." It was strange how at times like these she relied on the queenly ways of Cleodine. So thinking about what her sister would have said and done, my mother turned to leave the shop, conceding victory to the shopkeeper, who was undoubtedly about to haul her down, but then she turned back and faced him: "You know, you should not do this to me. I am a mother, and that was my children's lunch money." As she said this, tears rolled down her face.

In later years she would always half-seriously tell people that whatever they did they should try not to make her cry because her tears would bring down grief on whoever caused them to fall. Maybe she was not really joking because a few mornings later there was a loud knocking at the door of their three rooms. It turned out to be one of the women she'd seen in the yard who was going from door to door to tell everyone that the shopkeeper's place had caught fire. My mother did not

say a word. She just walked with the woman down the street to where a crowd had assembled to watch the large wooden shop burning down to charcoal. Some of the people were still wearing their nightclothes. There were little children in their father's old shirts, even a few small boys wearing their mother's old dresses, looking like short kings in tattered robes; men in merinos and underpants; and one or two daring younger women wearing only slips, who had jumped out of bed when they heard the alarm. As my mother stood in the crowd, she heard people saying what a thief the shopkeeper was, how for years he had overcharged them, and how the fire was pure retribution. As she stood there, no doubt telling people around her how just a few days before he had cheated her out of her children's lunch money, the shopkeeper walked over to her in the crowd and without a word, he handed her a one-pound note.

*W*hen my mother awoke from one of her dreams, a dream in which she saw herself and her husband and children firmly planted like banana trees growing from the brick courtyard of the tenement, she said to Marcus, "We will never leave here if only you alone work." This is what she said, "Don't believe that I'm not grateful, but we can't live and save enough to move to a better place on just your wages." My father had said nothing. He had just folded up the newspaper and left for work. And every morning my mother rose early and made him his breakfast before he went off.

In those days she would buy a fresh loaf of bread from the Huntingtons Bakery's horse-drawn cart and a newspaper from the vendor for my father to read as he ate his breakfast. Later, after he left for work, she would sit and read for half an hour or so before she began the housework. She always read the obituary columns and she always read the want ads. "In yesterday's *Gleaner*, there was a notice for nurses out at Bellevue," she says. "We're just passing through, Dor, just passing through" is what he would say when he came home to find that she or his children had suffered some indignity from one of the other tenants, "We're just passing through." But her dreams never

lied. Her dream showed them stuck, planted right there, rooted, never to move.

"There was a notice in yesterday's *Gleaner*, they need nurses out at Bellevue Asylum. I will get somebody to keep Betty and the twins for me in the days. Barbara, Howard, and Bunny will be at school," she said later about the ad.

"You? Go to work at the Asylum? Doris, that place is a living hell, you can't manage a situation like that. How can a woman like you ever manage a situation like that? Your father would kill me if he ever found out that I take you out of his house to make you go and work at the Asylum."

"I'm going out there on Monday morning. We will never make it on your paycheque alone." My father is silent. When my mother got like that, she looked exactly like her mother, Margaret, as if her face was carved from granite. He knew better than to try and talk her out of it.

⌒

The Lunatic Asylum (Bellevue) had been established in 1862, through the compassionate efforts of men such as Dr. Edward Bancroft and Dr. Louis Q. Bowerbank, to replace the old Lunatic Asylum, which was part of the Kingston Public Hospital and was described in a report to the Jamaican Assembly in 1851 as "nothing less than a chamber of horrors." In the years before Bellevue, new patients were stripped of their clothing, had their heads shaved, and were issued with short, tattered gowns marked front and back with either MLA (Male Lunatic Asylum) or FLA (Female Lunatic Asylum). Sometimes one small bug-infested cell would house as many as fourteen patients at night. They slept on bare wooden platforms without covering, or on cold stone floors. Male and female patients were often flung

together in these cells, resulting in everything from pregnancies to murder. Two large tanks were provided for the inmates, with patients of both sexes bathing in the same water in the tanks.

Patients were fed rotting food and dirty water. The staff were generally unprincipled, uncaring, and indifferent. One matron was found guilty of using patients as her personal servants, and many of the nurses spent only a quarter of their working day on the premises. The patients were abused and ill-treated by all categories of staff, including washerwomen and labourers who beat them and forced them to do manual work and other labour both inside and outside the institution. The report described inhumane forms of punishment such as "tanking"; that is, holding down a person by force under water until he or she gasped for breath, sank unconscious, or sometimes even died.

Great care had been taken with the selection of the site of the new Lunatic Asylum, to be located along the Windward Road, and although it took more than ten years to complete, mainly because of the indifference of the then colonial government, the new facility was designed for patients to benefit from the sea breezes and from a more efficient and humane system of asylum management that sought to provide inmates with occupational and recreational facilities. In 1862, conditions at the new Lunatic Asylum stood in striking contrast to those at the old one; but by the 1940s, when my mother worked there for a short time, conditions had again begun to deteriorate.

As they rode together on the tram that first morning, my father kept asking her, "My God, Doris, you sure that you can handle this? I hear that place is a living hell, you know? I will try to get more overtime, you don't have to do this." She just said, "Don't make it any worse." And he had looked as miserable and downcast as the day they had driven away in the truck loaded

with their worldly possessions from the house they had lost in Malvern and headed for Kingston. So they had ridden to the Asylum in silence, for try as she might, my mother could not find the right words to say to him to make him feel not so small, not so inadequate. Because to tell the truth, she was frightened at the thought of going to work at Bellevue, and bad as she felt for her husband, she needed to be silent and to pray for herself, to ask the Lord who was her shepherd to walk with her through the valley of the shadow of the madhouse.

And so my father went with her through the massive iron gates and stood with her outside the door of the matron's office, where about two hundred waiting women were applying for the twenty or so positions as psychiatric nurses who would be trained on the job.

"Are you sure you will be all right, Dor?" He looked wretched.

"Go," she said, "I will see you at home this evening."

But before he left he made one attempt to cheer her up, to make her laugh. He could always make her laugh. "Dor," he whispered. "Look at that woman over there in the red dress," and my mother looked over and saw a very tall, thin woman dressed in a tight red dress wearing a close-fitting green hat. "She don't look like a bird pepper to you?" asked my father. "Maybe she should go down to Spur Tree and apply for a job at the pickapepper factory." And that made my mother laugh and say, "Marcus, you are too out of order," and then she said, "You don't have to wait with me, I will see you at home later."

"To subdue the lunatics, you have to be very strong," said the Matron, a big, tall woman whom my father would later say always looked like she was carrying a spear and a shield. "Very strong, I am looking for very strong women to train as nurses, so if you are weak you won't make it here."

My mother was trained as a teacher of young children, but she probably was taken because she was physically so strong. And yet nothing could have prepared her for the sight of rows of prison-like cells, in each of which was a sick man or woman, their bodies barely covered by short gowns made from flour bags. Sometimes more than one person was locked in a cell; some were lying in their own filth. Her pet goat, her Grandmother Leanna's mule, her mother's donkey, her father's horse, Nana Frances's pigs. Any one of those animals in Harvey River seemed better off, better cared for than these poor so-called lunatics. As the matron had told the ten women she employed on the spot, the role of an Asylum nurse really was similar to that of a penkeeper. And nothing could have prepared her for the truly terrifying sight of the superintendent of the facility who, convinced that lunatics were dangerous criminals, was to be seen patrolling the premises armed with a gun.

"You not up to this my dear, you might as well go home now," said the matron to one of the new nurses who had vomited at the sight of the caged patients. This time it was not Cleodine's backboard that helped my mother, it was not George O'Brian Wilson's rage, it was the compassion of her father, David, telling her to "treat them as sick children, that is what these poor people are, they are like sick children." "Sick children," she said later, "I made myself think of them as sick children, and those who mess themselves, I cleaned. Those who needed a bath, I bathed. And I mash the food and spoon-fed those who could not feed themselves." The rest of the time she spent trying to unknot and delouse the heads of women whose hair had not been combed for weeks and she pared toenails that had grown into claws.

"What is your story, little miss?" my mother said to a girl who was about thirteen years old, who, though she was dressed

in the short ragged gown of a mental patient, seemed to be behaving quite normally. If it were not for her age and her dress, she could have been a nurse, so caring was she of the other patients. "What is your story, little miss?" she asked as the girl helped her to spoon-feed an old woman who was convinced that the asylum was really a brothel.

"I am not living any whoring life, you think I don't know why you have me in here?" said the old woman. "You want me to sell myself to those sailors over there in the white clothes, and you are trying to bribe me with cornmeal porridge, but I am not eating it, and I'm not selling my good, good pumpum to any nasty dirty sailor."

"No, dear," my mother explained, "the men in the white clothes are doctors, not sailors, and you are too old to be talking like that."

"Oh yes," said the old woman who was bony and haggard as a yard broom, "Oh yes? It's because you don't know how the men dem go crazy for me."

The young girl was the only one who could get her to calm down. "Come Grandma. I won't make them do you anything," she said, and the deranged old woman, who had come to see the young girl as her granddaughter Beatrice, would say: "I am so glad you have come, Beatrice, these godless, worthless people want to come and turn me into a prostitute."

"Drink your porridge and don't pay them any mind," the young girl would say, and the old lady would quietly obey her. Once, the girl had even changed out of her flour bag uniform into a short dress that was too tight for her, and had gone off the premises, but she had come back before evening to help feed the older patients.

"What is your story, little miss?" my mother asked her.

"My mother get a new boyfriend after my father leave, she

start to send me to where him live to carry dinner for him sometimes when she have to work late. One evening I carry the dinner and him say I must come inside him room and wait till him finish eat and then him would give me back the carrier. When I was waiting on him, him start to look at me funny and ask me if I have boyfriend, and I say no, I am still a child, and him say I look big for my age. But when I go home and start to tell my mother what him ask me, she say she don't want to hear nothing from me. The next time she send me to carry dinner for him, I say I was not going, but she beat me and force me to go and him hold me down, and after that, I bawl and bawl till them say I was mad, and my mother boyfriend say is lie I tell on him, and my mother call police and lock me up. Matron say I can go home now, but my mother don't want me to come back. I wasn't mad you know, I wasn't really mad."

My mother persuaded the Matron to release the girl into her care, and she brought her home with her one evening, where she sat quietly on the verandah, touching everybody who passed by and whispering the same words over and over, "I wasn't mad you know, I wasn't mad." The young girl looked like a different person once she started to wear the dresses my mother sewed for her; and as soon as she could, my mother sent her down to Harvey River, where she lived among the Harveys for years, telling everyone who heard her story, "I wasn't mad you know, I wasn't really mad."

"There but for the grace of God," my mother would say. "There but for the grace of God, go I. You know how many of those people come to Kingston just to find work and hard life mashed them up?" Some of the patients who were collected enough to give her a name and address got my mother to write letters to their families telling them where they were, and how they were doing.

However, her job at the Asylum only lasted for a week or two. One day she came home from work to find that in her absence my sister Betty, who had been plagued by epileptic fits from the time she was a baby, had begun to have full-fledged grand mal seizures.

I never knew hard life until I came to Kingston," my mother would say as she gazed at her hands. "I used to have the most beautiful hands." Hard Life. When she sounded those words they became a fierce giant, a merciless enemy whom you had to struggle against. Hard Life was the hurry-come-up, ex-slave landlord who, now that he owned some property in the form of a tenement yard, wanted his turn to play busha, or slave master, to delight in lording his owner status over you, to extract exorbitant sums of money from you for the privilege of living in his dry-weather premises. To inform you loudly that he normally did not rent to people with children and that he would be coming every Sunday morning at 6:00 a.m. to beat upon your door and demand his rent, which you had better have or he would turn you out onto the street.

Hard Life was a levelling teacher, anxious that no pupil should ever outstrip him, who liked to shame you before your class, to expose your errors and mistakes and poor judgment to the mocking scourgings of those you thought were your friends before you got marked down. Hard Life was an ill-mannered visitor who came to call on you in order to search up your cupboards when your back was turned, so that they could go and tell everyone how things were bad with you. To lie

about you, that you had no sugar for your tea and that you had to trust or credit food. It was a vicious old hige who liked to suck out the secrets of your broken heart and regurgitate them before your enemies. Hard Life was a pyaka, a cantankerous flying spirit who fed on the bitter seeds of the bad-mind tree, who lived only to fly about and broadcast to others that you mash up, mash up, mash up. Hard Life was a gravalitous grudgeful John Crow who kept pressing its black suit for the day when it would attend your funeral and give a eulogy which picked at your remains. A lamentation over poor you. Hard Life was a Cyclops whose cast-eye you had to blind with psalms in order to escape from the dark cave in which it wanted you trapped, and he would have trapped you were it not for your own strength and for the ties of blood, the generosity of some of your relatives, who as soon as they heard that you were now living hard life in Kingston, began to send you regular food baskets. Country baskets filled with ground provisions, yams, potatoes, vegetables, fruits, corned beef and pork, bottles of coconut oil, baked goods, peas, cassava, plantains. These baskets were the Jamaican equivalent of the manna fed to the Israelites by Yahweh as they wandered in the wilderness.

All over the city of Kingston, happiness and contentment would be generated in cramped tenements with the arrival of these baskets sent by friends and relatives in the country. Families would partake of generous oily-mouthed feasts, and children would be told stories about life in the villages where this food came from. Normally ill-tempered mothers, nerves frayed from hard life in town, fathers burdened by hard work or lack of employment, would become carefree children again as they enjoyed the sense of ease and plenty generated by the largesse of those back home in the country. "See this soursop here, it come from a tree that my grandfather plant and my

navel string bury at the root." These food baskets were brought to Kingston on the backs of market trucks, or labelled and loaded onto the train and watched over by kind, considerate conductresses who knew they were doing a form of angel-work by delivering them. The conductresses knew how gratefully, eagerly, the people of Kingston greeted the arrival of the country baskets filled with fresh, life-sustaining things to eat. Our family began to receive regular baskets from Harvey River as soon as my mother's relatives found out that she was living in Kingston, and first thing that she would do when she opened one of them was to pass on some of the food to others who were even more in need. She would also share our good fortune with others whenever we received the sweet-smelling parcels that contained clothes, shoes, books, toys, and "delicacies" like sweets and biscuits from her sisters Albertha and Rose in Canada.

Days in our house were especially joyful when the postman dinged the flat round bell attached to the handlebar of his red bicycle outside the gate and called upstairs that he had a parcel from Montreal, Canada, for Mrs. D. Goodison. My mother would quickly rise from her sewing machine, slip on one pair of her soft pumps, brush her hair hurriedly, and go out to the gate to sign for the precious package. If we happened to be home from school at the time, we, the younger ones, would follow closely behind her, all happy and giddy with excitement; sometimes we'd even be chanting our special anthem for the welcoming of the parcel: "Parcel come, parcel come." "O my dear dear Miss Jo, my dear sweet Rose, my darling sisters," my mother would croon with tears streaming down her face as she loosed the strings that bound these generous parcels and distributed the contents to us. And we her children never did quite understand why the appearance of these marvellous packages filled with

largesse that smelled so nicely of "foreign" would make her cry, as we happily tried on our new shoes and clothes and sucked contentedly away on maple sugar chunks and black strips of licorice, which we called "wire sweetie." And what we really, really did not understand was why she felt compelled to always give away some of the things that our loving aunts had sent to us from Montreal to people who were more in need.

⁓

First, you put something soft under my sister Betty's head, like a pillow or a rolled-up blanket to keep her from battering her head bloody, and then you try to force a spoon between her teeth to stop her from biting and swallowing her tongue. You should also try to put some salt in her mouth to stop her from foaming. The seizures take my sister with no warning. She will be walking along and in midstep it will be as if some great unseen beast has taken her in its jaws and is just shaking her to and fro. "I fell out of the car in Malvern when I was carrying her," my mother would say. "Your father was driving and as he turned a corner going into the town of Black River, the car door swung open, and I tumbled out of the passenger seat. I was young and strong, I just got up and said no harm done. But I was wrong."

My mother would dream of life in Harvey River on days when her child had as many as four seizures, the days when she saw unspeakable things at the Asylum. In her mind she would return to the place where everyone called her "dear Dor," where life in her father's house was so easy, where she never had to work hard, where she was one of the fabulous Harvey girls. They used to sew their own bathing costumes in Harvey River, short loose tunics or bloomers with loose-fitting camisole

tops. She often envisaged herself in her favourite tunic of bright red cotton with tiny green and white blossoms. She would braid her hair into two long plaits that would become undone as she swam and her hair would stream out behind her. She and her sisters, gorgeous mermaids cavorting in the river named for their grandfather, were washed by the cool green water, the bowing bamboo screen around the river protecting their privacy. "Dive now, Doris." And she dived deep, feeling the water cover her completely. While she was under its smooth, cool surface, she took some of the hurts and disappointments life had dealt her that were written on what would have been bitter-tasting scrolls carried in her bosom, and lodged them in the eel holes and crayfish dwellings in the river. She never, ever again mentioned her troubles once she had lodged them there.

She loved being a wife, but she really, really was born to be a mother. She sometimes fed her children like mother birds do, passing food from her mouth to theirs. Like her mother, Margaret, she was known to put her own mouth to the tiny congested nostrils of any of her nine babies and pull mucus down to clear their heads. "A mammal is a warm-blooded animal that gives suck to its young." She had told this to her children as a fact, a piece of information she handed out from the great mine of facts she stored in her head.

"Mama, are you a mammal?" one of the children asked her. "Yes," she said laughing, "Doris is a mammal."

All the children in the yard seemed to know that Doris was a mammal because they were drawn naturally to her. They climbed the steps and stood outside the door, looking in at her seated at her sewing machine and called over and over, "Hello, Mama Goodie. Hello, Mama Goodie." All the children in the yard called her Mama Goodie. She fed them when their mothers, who did not like her, were not around. She called

them sweet names like "precious" or nonsense names like "my little noonoonkum" and encouraged them to go to school. Even Vie's ill-cared-for son, Errol, adored my mother; she was always feeding him, making whatever food she had for her own children stretch.

Little by little, she put away the fabulous Doris. The one who was the clothes horse, the one with the beautiful hands who, along with her handsome husband and her lovely children, was going to run a fine guest house situated in salubrious Malvern, where she would direct the staff how to provide the best accommodation possible for guests as she changed her dresses to preside over every meal.

She put away the fabulous Doris who took such pride in her mahogany furniture, as gradually the chairs, tables, and the gramophone on the verandah were broken by the children, stolen by the tenants, or just destroyed from hard use. She watched as all her china was broken and her fine linen torn, stolen, or just worn out from wear. And apart from always keeping one or two damask or lace tablecloths to "pull shame out of her eyes," that is, to put on a small show if visitors came, she forgot what her sister Cleodine had taught her about running a perfect household and she never worried much about those things again.

She put away her dream to travel to Montreal to see and experience snow first-hand and dress up and go shopping with her fabulous sisters. She began to live in two places: as Mama Goodie the mammal in hard-life Kingston, and as the daughter of David and Margaret Harvey in her memories of Harvey River.

Eventually my sister Betty's seizures became so severe that my mother had no choice but to stay home, where she could care for her. It was then that she decided to make her living as

a dressmaker; and for the next thirty years she would design and sew her extraordinarily well-made garments, charging very little money, to every and anybody who needed her services.

Funnily enough, the terrible Vie became one of her first customers. Soon after my mother made it known to some of the women in the yard who had become friendly to her that she was now taking in sewing, Vie announced that she had been invited to the wedding of one of her sisters in the country. She wanted, she said, to return to her birthplace in style, to "cut a dash." To make all the people – especially her sister who had predicted, no doubt with good reason, that Vie would come to no good – see how well she was doing in town. Well, who better to help her cut a dash than Doris? So Vie waited for my mother to come into the dark kitchen one morning, and there, before all the other women, she apologized for harassing her. And my mother accepted her apology, sewed her a fine dress, and everyone agreed that Vie never looked better in her life.

In the evenings, when she finished with her sewing, my mother liked to sit by the window in her rocking chair, watching for her husband, Marcus, to come walking down Orange Street. He moved like a young man, shoulders back, taking long, easy strides. Every time she saw him strolling down the street it was as if she was seeing him for the first time when he came up to her in her father's yard and said that he was thirsty, and since she was watering the plants, could she give him something to drink too? As she sat by the window waiting for her husband, she remembered how nobody loved to see an unusual sight more than her father, David, who had died in 1942, after years of being confined to bed. And she wished that he was still alive so she could have described to him some of the really strange people who passed right outside the front window of her house in Kingston.

Take Elephant, for example, the terrible giant with limbs thick and coarse as the trunk of the banyan tree, who, it was rumoured, made up his bed at night in the Mullings Grass Yard on Spanish Town Road, where hills of fire coal rose black before the Blue Mountains. The mules that pulled the dray carts of Kingston were tethered there too, and they were said

to be his only friends. By day, Elephant was to be found under the big trees in Victoria Park. He had a kind of open-air office there, where he was in the business of beating up people for pay. For a shilling or two, Elephant and Tom Pram and other "Big Tree" men would smite your enemies, hip and thigh. One day, as Elephant was lumbering up the street with a pack of children running behind him calling out, "Elephant, Elephant," he turned around like a great, wounded pachyderm and threatened to cut out their insides with a broken bottle, and we all had to run home and take refuge under our beds. When she heard about this, Doris ordered her own children, that is, the younger ones who had not heard this story before, to gather around her as she sat at her sewing machine. When Kingsley and Karl, Keith and Nigel and I were all assembled, she told a cautionary tale about the children who had teased the prophet Elisha. "Go up you bald head," the wicked children had chanted to the great prophet, and he had caused two great she-bears from the woods to tear apart forty-two of the teasing children. After that cautionary tale, some of us never teased Elephant again.

Elephant still had feelings, unlike Bag O' Wire, who just stared straight ahead and never, ever uttered a word. He looked like a stone man covered with tar and pitch, and like Elephant, he carried a rank, filthy burlap, or "crocus," bag over one shoulder that had earned him his nickname. Bag O' Wire was Jamaica's national traitor. Everyone knew that. He had been an official in Marcus Garvey's United Negro Improvement Association and he had betrayed the great leader. His present condition was seen by one and all as divine retribution for selling out Mr. Garvey.

Then there was Bun Down Cross Roads, who, unlike Bag

O' Wire and Elephant, still rose each day, bathed, and dressed himself in clean clothes, but instead of going to work in his office in Cross Roads, he now sold fruits from a tray on his head. Arson. That is what my mother told my siblings and I that he had committed. He had burned down his business to collect the insurance. After he got out of prison, he was reduced to selling fruits, but he called out his wares with the confidence of one who was to the manor born. That is, until anyone teased him, and then he would curse enough forty-shilling badwords — words that you could be fined forty shillings for uttering — to stain the air around.

"Why the young men always tease me?" Mother Muschette, the poor damaged woman who stood dressed in her wedding gown outside the Kingston Parish Church and waited in vain for her groom, a younger man, to appear, always asked my mother that question. In between stays at the Asylum, "Madda" Muschette lived on the street, pulling away from any man who passed too close to her. My mother could not recall if she had seen her there when she worked briefly in the Asylum; but every time Madda walked past our window, with the groups of jeering boys chanting, "Madda Muschette, where is your husband, Madda Muschette?" she would look directly up at the window to see if Doris was seated there, and she would cry out her sad question to her. My mother would order the boys to get away and stop tormenting the unfortunate woman.

But she would have told her father, David, that of all the people who walked the streets of Kingston there was none more tragic than Pearl Harbour, the long-haired, willowy, fair-skinned fallen woman. Everybody knew Pearl's story, how she came from a wealthy near-white family of doctors and professional people but now led the life of a "sport" or

a "harlot." Pearl was often either moderately drunk or stone-blind drunk, and she possessed a scorching vocabulary that she had no doubt picked up from doing business with sailors. She was a terrifying sight, this woman who had once been a great beauty, as she lurched through the streets of Kingston during the day in her stained and rumpled nighttime dresses. She looked like a moon-in-the-gutter or a flung-down star that had been bombarded with black ice. Everyone taunted her and sometimes she cursed them, saying how their mothers were whores too, or else she pretended that she did not care what they said. For after all, she was "a living dead," too drunk to care. Even child-abusers, hypocrites, murderers of body and spirit, and robbers of widows and orphans all felt they were better than she, that they were entitled to use her as a vessel for their venom and contempt. Poor Pearl Harbour. Such stories, there were such stories about Pearl Harbour. Like how she had got her name when she serviced an entire man-of-war ship. But one of Doris's customers, a hospital matron for whom she sewed uniforms, had told her another story about Pearl. The matron used to work with one of Pearl's doctor relatives, who told her that as an innocent young girl poor Pearl had fallen hopelessly in love with a handsome ginnal, a trickster, whom she had followed to wicked Kingston. She had opened her soul-case to him, and he had rummaged in it, sold the contents cheaply, and then discarded her. This act of betrayal had drawn her down to utter perdition. She was now a walking corpse. "Back to back, belly to belly, I don't care a damn, I done dead already." They could have written the words of this song, "Jumbie Jamboree," for her.

Then there was the German watchmaker, Mr. Gruber, whom all the children loved to stand and observe performing

his meticulous tasks. Mr. Gruber was a man who did things with balletic grace and precision. A short-statured, sandy-haired man of few words, he would sit in his small shop with his magnifying glass screwed into his right eye, and wield the delicate tools of his watchmaker's trade. He never acknowledged the presence of the children who liked to stand outside the door of his shop, but every day he would put on a spectacular performance for them. At 4 p.m., Mr. Gruber would carefully lock and bolt the doors of his shop, then wheel his shining Rudge bicycle out onto the street. He'd position himself alongside the bicycle and begin to tap his feet on the black surface of the hot asphalt. Soon he'd be tapping faster and faster until he is running on the spot. Then he begins to push the bicycle forward and to run alongside it, picking up speed as he goes. Faster and faster runs Mr. Gruber and then, when you least expect it, he leaps straight up into the air, hovers like a hummingbird for a fraction of a moment, before he lands squarely on the bicycle seat. He then bends over and with his rump in the air and his head thrust forward pedals furiously up the street. By this time the children are all cheering, "Spring mount, Mr. Gruber, take a spring mount."

A few doors up from Mr. Gruber's was Mr. Mead the chemist. Whenever my mother sent one of the children to buy glycerin for earaches, or a black, foul-smelling sticky ointment that was excellent for reducing swelling, Mr. Mead would send them back with exact instructions as to the proper use of these medicines. "Remember to tell your mother to use one and a half drops of this, no more, no less. You only need to use enough ointment to cover the top of a sixpence, not a shilling, a sixpence." Mr. Mead ran the drugstore at the corner of Orange and Charles streets and he must have discovered the fountain of youth back there in the curtained-off room behind

the store where he filled prescriptions, for he looked the same year after year, a tall, dark man who wore a fresh, white jacket every day. Next to Mr. Mead's dispensary was what everyone called "The Hat Shop." But Doris had told her children that the two sisters who fashioned standoffish, pastel buckram and silk flowers into Sunday hats for ladies were "milliners."

On the other side of the street was Smith's Garage, where Mr. Smith once hosted a very formal cocktail party. All sorts of elegantly dressed people rolled up in cars that he had no doubt repaired, and entered into the transformed interior of his workplace, now scrubbed clean and festooned with crepe-paper decorations. An invitation had come in the mail addressed to Mr. and Mrs. Vivian Marcus Goodison, and Marcus, giving no sign that he was still troubled by the loss of his own garage business, had put on his suit and looked very dapper. Doris, for the first time in a long time, had made herself a new dress, and together they had crossed the street and attended the cocktail party. When they came back she taught the children the phrase "hors d'oeuvres," and she gave them some devilled eggs which she had wrapped in a napkin.

As Doris sits by the window, she hears the calls of the vendors and the servicemen who go up and down Orange Street, each with their own unique song. The bottle man who would ask "aaaaaaaaaaaaany pint bakkle?" and the travelling soldering man — who was probably the Jamaican incarnation of Ogun, the West African god of iron, now coming to weld the holes in the pots and pans and chamber pots of trans-ported Africans — announced his presence with a hissing "Sssawdereeen." The mango sellers had complex calls, because more often than not there would be two of them pushing a cart laden with luscious, ripe mangoes. One would sound the call and the other the response:

Mango
 Hairy mango
Number eleven
 Mango
Governor
 Mango
Blackie
 Mango
Sweetie come brush me
 Mango
Ripe and green
 Mango.

Theirs was the most melodious of all street calls, the most poetic, except for the call of the Arab dry-goods seller, who would chant:

 Attar of roses, attar of roses
 good for your noses
 Come to you from me and Moses.

Sweet and sour of breastmilk, Johnson's baby talcum powder, and the faint vinegar of perspiration, that was my mother's perfume. I remember one of her two long grey-and-white plaits had come loose from the crown into which it was pinned across her head, and was dangling down one side of her smooth face that was the colour of a biscuit (till the day she died she never had a wrinkle). I reached out and held on to the escaped vine of her hair. In this early memory of my mother, she was breast-feeding my baby brother as I sat pressed up against her in the big cane seat rocking chair, so I must have been about three years old. For what seemed like a long time,

there was only the rubbery sound of my baby brother sucking hard on her left breast, then I felt her soft body shift in the chair as she shifted him from one side to the other. Then the cry of the soldering man came hissing in through the window that faced the street: "Sssawdereeen."

~

The children are all asleep. As always Doris watches by the window for Marcus to come home. It is the rainy season, time of hurricanes, June too soon, July stand by, August look out you must, September remember, October all over. It is a rainy August night, and Marcus has not yet come home. He has been out putting up the telephone lines that have been torn down by the high winds and the heavy rains, so that important people can communicate with each other again. In those days most people did not have telephones in their homes. Sometimes at night she falls asleep before he comes home. Sometimes he comes in and wakes up her and the children to feed them ice cream. Royal Cremo's Neapolitan Brick ice cream, vanilla-cherry, and chocolate-striped ice cream. These sleepy late-night celebrations took place unexpectedly, for no particular reason except for the fact that Marcus, like Doris, always loved celebrations and rituals. That is why there were always white lilies in the vase on their mahogany bureau on Easter morning; and on Christmas day all the children were awakened early to toast the joyful season with a cup of Marcus's famous eggnog; and every year on the third of April, which was Doris's birthday, Marcus put on a suit and Doris got all dressed up and he would take her out to see a movie at the Ward Theatre, just like he did in the early days of their marriage.

Then as always she hears his footsteps coming up the

stairs, and when he appears in the darkened doorway he looks like the logo on the bottle of Spanish sherry that one of his friends gave him for Christmas, featuring a silhouette of a man in a wide-rimmed hat and a flowing cape. She feels great relief. Only after he takes off his hat and raincoat and galoshes does he look like Marcus. The mysterious black-cloaked, hatted figure has disappeared, and he says something like, "This is not a night for man nor beast to be outside." "I worry about you out there in Kingston at night," says my mother. "You worry too much," he says. "I promised your father that I would not make you worry." He had promised her that she would never have to worry, that they would have a nice life. "I have certain dreams and plans," he had told her when he was courting her. "I want to have my own garage business and I'd like me and my wife" — when he said the words *my wife*, he had looked meaningfully at her, then repeated the phrase — "me and my wife, to run a first-class guest house up in Malvern," and then he had asked her if she had ever been to Malvern. She said, no, she had been only to Montego Bay and Savanna la Mar, but that she never stopped hoping one day to go to Montreal to visit her sisters and see snow for herself.

\mathcal{O}ne evening Marcus arrived home from work and came in the door saying, "I brought somebody to see you," and lo and behold it was her brother Edmund, whom my mother had not seen since he had run away from Harvey River before my mother met my father. "I saw this man standing with one foot on the running board of a taxi on East Queen Street, a man wearing a felt hat pushed to the back of his head, just like in that photograph on your bureau, and I said to myself, my god that must be Edmund Harvey. So I went up to him and said, 'Hi, brother-in-law.'" My mother can't quite believe her eyes that after all these years she has met up with her runaway brother. They can't stop hugging each other. She immediately offers him some dinner, and he says, "Thanks, just as long as there is no yam in that dinner."

Uncle Edmund pushed back his chair from the dining table and lit a Four Aces cigarette. He recommended to my mother an iron tonic that he says all taxi men are taking. Taxi men exchange information that is vital to their business. They are always concerned about their health because they work long hard hours. They read the newspaper every day because they have to have good conversation with the passengers, especially tourists, who always have an endless list of questions to

ask the taxi driver. "It's as if when they take your taxi they expect you to be the Minister of Information," said Edmund. "And although you don't want to be telling them any foolishness, then again, you can't tell them everything, especially when it comes to Jamaican politics. So when one of those tourist ask you something like, 'So don't you think that Jamaicans are lucky to be governed by England and have a Parliament and a British Governor,' you just say Oh yes and drop off the damn idiot at the Myrtle Bank Hotel and take the tip that he give you.

"'You are one smart Jamaican fellow, don't listen to all this crazy talk about Independence.'

"'You are right boss,' said the taxi man.

"I just make him go on none the wiser that I don't care a blast about England and Missus Queen and that I agree with Norman Manley that Jamaica should be an independent country," says Edmund.

"Taxi man have to know what is what," he tells my mother. "Taxi man have to know every bar and brothel in Kingston, every bank, government building, theatre, night club, statue, and monument. Taxi man have to know how to give the tourists what they want, and that is why I always said taxi man don't make good husband. We are always on the move. Morant Bay one day, Montego Bay by the same night, Port Royal next morning. Taxi man mostly live alone, we live cowboy life, so taxi man stay." Edmund draws hard on his Four Aces cigarette.

"So you going home to rest now, Edmund?"

"No sir, the night is young, I am going to catch a midnight show out at Majestic Theatre. Doris, you brother is a real Kingstonian."

After that, Uncle Edmund came to visit at least once a week and he was always telling stories to illustrate why Kingston was a more exciting place than Harvey River, where

he swore he would never return, neither in life nor death. Kingston to him was the place where the most fantastic and fascinating things happened. Take, for example, the story of the old man in the yard where he lived, an old man called Tata, who had a bosun growing inside his pants, a swollen giant testicle the size of a yellow heart breadfruit. You could see the shape of it when he walked his rolling off-centre walk. Everybody said he should get it cut, but he believed that if they cut it, he would surely die. All the boys in the area claimed to have seen this terrible thing that grew underneath the old man's trousers. They gathered in packs and stormed the toilet when Tata used it. They peeped under the door, and the old man became hysterical. He threatened to kill them for their insolent out-of-order behaviour, their outrageous lack of respect for an old man. It was a kind of rite of passage. The boys would not be men until they had seen Tata's bosun, until they had stared at this awful, unnatural ball, and had walked away still seeing, not struck blind or dead. "The other day they give him one whole bottle of white rum to drink," says Edmund, "and two grandsons lift him up and carry him down to public hospital. The doctors gave him gas and cut off the bosun. They said it is the biggest one anybody ever see in Jamaica, maybe in the whole world, and them send it gone to England for the doctors over there to examine it."

My mother had a story of her own for her brother, one to illustrate how bad people from Kingston could be. She told him of a situation right there in the yard next door to where we were living, which had to do with a young woman named Lizzie who had come from the country to help her sister Bernice after Bernice had had three babies in two years and ten months. Lizzie looked like a baby duck, a dill-dill, because she had big wide lips and wicked bandy legs; and she spoke so

badly that everybody laughed at her. She would say "guddung" instead of "go down" and "gittup" for "get up" and "tandey" for "stay there," and she called her sister "Sta Bernice." All the other women in the yard she addressed as "ma'am" . . . yes ma'am, no ma'am. Lizzie was always working. She washed line upon line of birdseye nappies gleaming white. She made "tie-leaf" or "blue-drawers," delicious portions of grated sweet potato, dark sugar, and coconut milk, spiced with nutmeg then wrapped in banana-leaf parcels and steamed. Lizzie cooked a fine mackerel rundown, flaked salted mackerel cooked in a spicy, savoury lick-you-finger coconut custard, causing Mr. Vincent, Bernice's husband, to joke that Lizzie was such a good cook that he should have married her instead of her sister. After a time, Lizzie stopped calling the other women "ma'am" so much. She also began to grumble, saying that her sister could help herself a little more instead of just lying down all day and complaining about how weak she felt.

Then one day Bernice said that she was going to the country to see about herself because she couldn't understand how she still felt so weak even after she got so much rest. She knew a man in the country who would give her a good bush bath and a read-up. She left Lizzie in charge while she was gone. Lizzie said that she heard from the country that the obeah man said that Bernice's case was a hard one. That somebody was working hard to keep her down because the obeah man said he kept getting a vision of somebody driving two long ten-penny nails into Bernice's right calf. "When Bernice came back from the country, nobody in the yard want to face her," said Doris, "because if the obeah man did not tell her that Lizzie and Mr. Vincent were now along with each other right out, then Bernice lose all around. But Vincent tell her himself. Tell her openly that Lizzie was a better woman than

her any day and advise her to go back to the obeah man in the country. Bernice leave that same evening, but she come back the next morning when Vincent gone to work, and beat Lizzie till she soft. I guess she rest enough, and she was not feeling so weak any more."

"Edmund, you better take care, you hear. Kingston is not an easy place," said my mother, "a place where it is not easy to raise up yourself if you fall."

~

My mother found out first-hand that it is sometimes hard to raise yourself up because God knows there are always people who are eager to see you stay down. Like her oldest sister who hadn't come to visit her because she was not sure that her chairs were good enough. When she finally did come to see her, she came in a dream, shaking her head, saying, "Poor unfortunate you, you have no luck." This was Cleodine's greeting to her from the gateway of the Harvey home because in the dream my mother has been forced to return to her parents' house with all her children. "Poor unfortunate you," she repeats, but that is just the warm part of her greeting. "My dear, you are like a pipe, everybody just comes, turns you on and uses you and then walks off and leaves you," says Cleodine as she strides up the stone path leading to the Harvey house. Even the flowers in the yard seem to fold in on themselves as they hear these words. The bold-faced hibiscus shrink their red-and-gold petals and roll themselves into tubes, displaying only their pale undersides. The loud chirping cling-cling and grass-quit birds abruptly shut up, and a flurry of April butterflies who were flightily making the most of their short lives settle nervously on branches. Cleodine must have risen before dawn to

put herself together for this visitation. She was wearing a gorgeous silk dress of cocoa brown, awash with gold-and-orange blossoms. Her dark brown leather pumps had been polished and shined by the yardboy, her brown leather handbag with its shining clasp looked positively plump with prosperity, her hair was styled in an upsweep, and her gold-rimmed glasses gleamed on her straight nose bridge. She decided against wearing a hat but carried instead an umbrella trimmed with ochre lace held high above her head.

Even in a dream it is hard to recover from somebody likening you to a standpipe. It is harder to gather yourself when they quickly repeat it. "Just like a pipe, everybody just come, use you and then walk away, you meet it my dear, you really meet it." And my mother wants to ask her what is this "it" that she has met and to remind Cleodine that she herself has met her "it." But she is doubled over by that lethal repeat, that vicious one-two jab.

But if Cleodine came to her in dreams to liken her to a standpipe, others came too, and for the rest of her life my mother lived by these visitations.

At first Doris had thought that it was the clip-clop of the breadman or the milkman's horse coming down Orange Street in the before-day morning. She thought to herself that maybe she should struggle up out of sleep, get out of bed, and wake one of the boys to go out into the street and buy fresh milk or a warm harddough bread. But the sound of the hooves kept coming, right up to the gate and then she heard them inside the yard. The hoofbeats then sounded as if they were climbing all the way up the steps and into the room and then she saw her grandmother Leanna sitting astride her grey mule right next to

her bed, her long necklaces of silver coins soldered together, tinkling like bells. Just like she did when she was a young girl, Doris jumped onto the back of the mule and Leanna guided it out of the room, down the steps into the brick-paved court-yard, where all the tenants were standing looking in amazement at the tall flanked grey mule ridden by the jet-black old woman in a dress the colour of laundry blue, her silver money jew-ellery shining in early light.

Doris clung to her grandmother's waist, pressing her cheek to the woman's bony back, inhaling her strong body scent of cinnamon and escallions. She closed her eyes and time slowed down so that the short ride across the courtyard felt as if they were riding forever over the green pastures of Hanover and Westmoreland. As they rode, the guinea grass soaked with dew water flashed and bathed the soles of their feet and the night-blooming jasmine sprayed their faces with her last ounce of essence before closing her white vials. The early morning air carried the potential sweetness of green sugar cane before it hardened into iron stalks at the sun's urging, stalks so hard that a man could break his back trying to cut them down. They rode past men and women asleep in small huts and long barracks-type dwellings. This was the grace hour when they existed in dreams as ordinary men and women, free to lie down or get up whenever they wanted. This was the hour before they rose to meet cane. To seed and weed, to cut and harvest it. The hour before some would run away or stay and undermine it, withdraw their enthusiasm from it, throw words and sing bantering songs, and meet in secret at night to plot bloody overthrow of it. They rode past the time, before cane, when Jamaican people planted mainly corn and cassava, hunted wild boar and coneys, and went to sea in magnificent boats they had

fashioned from trees; when their artists made sacred wood carvings that would survive for hundreds of years; when their scientists discovered how to extract poison from the roots of cassava; when they played an early form of soccer and lived mostly in peace, till three leaking ships filled with lost men came towards them bearing Hard Life.

Doris and her grandmother rode past all the amazed tenants straight into the kitchen where Leanna dismounted and used her riding crop to clear away a space for her grand-daughter's stove on the firewall. "Patience, you are going to have to study patience and take what you get till you get what you want," she had said, and then she had mounted her mule and ridden away, clearing the gate effortlessly. But not before she removed one of her money necklaces and draped it around my mother's neck. "Control the silver," she'd said. "You will never get any big money in this life. Massa will always hold that, so learn to control the silver."

Doris always said that it was after her grandmother Leanna came and made a space for her on the firewall that the women in the yard all started to befriend her.

My mother's paternal grandmother, Nana Frances Duhaney, also appeared to her one night, paraphrasing the words of Moses: "Doris, Doris, take off thy shoes from off thy feet, for the ground which thou standest on is not holy ground but hard work ground." She had bent down and removed Doris's soft pumps from her feet because Doris, in a determined effort not to let herself go, had been wearing her leather pumps around the house like her sister Cleodine. Nana Frances had come, bent down, taken the shoes off her feet, and told her that the only way that she was going to be able to manage all the hard work she would now have to do to raise nine children was to

go barefoot around the house. She told her to uncover her feet in order to draw up strong energy through the wooden floor-boards and through the metal pedal of the sewing machine.

"You don't have to go to school today," Doris would say to one of the children or "be very careful how you play with such and such a child," or "give me that slingshot, somebody could lose an eye today." Her own mother, Margaret, had come the night before, serious and unsmiling. Invariably she came only when she had to warn her about some possible danger to one of the children.

Doris's father, David, had appeared, fully dressed except for his shirt, and stood right there in the yard, under the beheaded breadfruit tree, and had said to her: "Remember your confirmation promise, my daughter, don't forget your promise that was given you from Isaiah 43: Fear not for I have redeemed thee, I have called thee by name, thou art mine, when thou passest through the waters I will be with thee, and through the rivers they shall not overwhelm thee, when thou walkest through the fire thou shall not be burnt." And then he had turned to go, but before he left, he looked over at the men playing the seemingly unending game of dominoes and said, "How is this different from what rich men do up at the Liguanea Club, where black people can only pass through those gates as maids and waiters? This is a poor man social club," and then he pointed to the old white-haired man who seemed to be in charge of the ongoing domino game, and whom my mother heard everyone call Papacita. David said, "You see Papacita there, he worked more than ten strong men when he was young, cutting cane all over Jamaica, and then he spent years more in Cuba cutting hectares and hectares of cane. Nobody in the history of the world ever cut as much cane as Papacita. Let him play domino now, God knows he shouldn't

do any more hard work." And David goes through the gate saying, "These people are no better or no worse than people anywhere, anything that you can do to help them, help them and you will be surprised to know how they will help you."

For weeks Doris puzzled over what exactly her grandmother Leanna had meant when she advised her to "control the silver." One Saturday she was buying food in the Redemption Ground Market and she found herself telling an old woman, from whom she was buying escallion, about the dream of her grandmother riding into the yard to see her. And the woman explained to her that there was a time in the history of Jamaica when all the silver coinage on the island had found its way into the hands of enslaved men and women, enterprising Africans who cultivated their food plots and sold their produce in the Sunday markets around the island. "Them had was to send away a England go make more silver money," the woman had said. She also said that many Jamaicans had bought their freedom and their own land by saving these small sums of silver money and that her great-grandmother had been one such Jamaican.

Of course George O'Brian Wilson had appeared to her from her earliest days in Kingston, and she always maintained that it was he who had instructed her to slap Vie. Whenever the Irishman appeared to her, she would wake up in a no-nonsense mood and woe betide the man, woman, or child who crossed her that day. "Take your damn cloth and go if you can't wait for me to finish sewing it," she would say to an impatient customer. And like her mother, she would remind any of her children in no uncertain terms, "No child of mine will ever rule me." It was a foolish, foolish child who would challenge that statement.

One of the women in the yard came to Doris and said, "I wake up this morning and drop and break my eyeglasses, Miss

Goodie, you think that you could just read this letter for me that my son write me from England?" Of course the letter needed a reply and her glasses still had not been fixed, so my mother wrote a reply. And so it went, with both women agreeing to blame the woman's illiteracy on her broken glasses. The woman began to do small favours for my mother, like buying food at the market for her and taking her clothes off the wash line, and she never did get her glasses fixed. Once it was known that my mother would read letters and never, ever mention the contents to others, and write replies to letters, again without mentioning the contents, and fill out forms and write letters of recommendation and give good advice, more and more people in the yard began to stand outside the door saying, "Hello Miss Goodie, I have a little favour to ask you." When their children came and stood outside the door and called to her, she began to invite them in and taught them what she taught her own children. Soon, even Vie's son knew that a T was like a telephone pole, and a G was like a water goblet that would pour forth fresh water if you tilted it.

was seven years old when I first saw the place that had produced my mother's people and which was to shape my imagination for the rest of my life. In July 1954, I joined the great exodus of Kingston children sent to visit with relatives in the country during the summer holidays. I remember being wedged in the back seat of a small, black Morris Minor motor car with three adults all related to my mother and going on the longest journey of my life up till that point — fourteen hours from Kingston to the parish of Hanover. Stops were made along the way: for gas; for me to be sick; to put water in the radiator; for us to pee in the bushes; to fix flat tires; for them to wrap my chest in newspaper to seal my motion sickness; for food and drink, including a mandatory fish and bammy stop at Old Harbour. We finally got to the town of Lucea in the parish of Hanover late at night, and I slept at the home of my mother's cousin, whose name was Tamar. "Palm tree," my mother said, that was the meaning of her name. Tamar had four children, Wesley, Vivian, Joyce, and Lyn, but she still looked like a young girl. She was not tall and slender like a palm tree, she was short and neat-looking, dressed as she was when I saw her for the first time in a pink floral dress. I guess she was more like a flowering shrub.

Later that next day I was taken by car to the village of Harvey River, five miles from Lucea. Harvey River is set in the interior of Hanover, under the Dolphin Head Mountains. My mother's family home was a large wood-and-stone house set right off the village square. As we approached, I noticed that there was a beautiful flower garden flourishing in the front yard. The house was occupied by Aunt Ann and her children, Myrna, Colin, and Joan, now that David and Margaret Harvey were dead.

It was not a manicured yard like the gardens that I had seen in the suburbs of St. Andrew when my father took us on Sunday afternoons for drives from where we lived on Orange Street in downtown Kingston. This garden was thick with pink June roses and oleanders and red flowering hibiscus, and foaming white "rice and peas" bushes that stretched out and brushed against you when you walked up the short stone-paved path to the front door. I did not know the names of flowers then, but the first one I learned was "jasmine," the tiny starry white flowers which proceeded to perfume the evening with a lovely scent that was activated once it grew dark. Also, there was a large field of white lilies that grew behind the house, giving off a honey-and-spice perfume so fragrant that clothes which were hung on the wash line came in dry and sweet-smelling. When night fell and nobody made a move to turn on the lights, I became anxious. Tamar's house in Lucea, where I'd slept the night before, had electric lights, so I thought that all of Hanover was similarly lit. Instead, my Aunt Ann called her son, Colin, to bring the lamps. Several fat-bellied, glass-shaded kerosene oil lamps with the words Home Sweet Home picked out in white script between two lacy borders were brought. They were the source of light for the entire house. The lamps threw up tall, macabre shadows on the walls of the house that

I had imagined as a fairy-tale dwelling in the golden afternoon light. Now this same enchanted house seemed sinister and frightening, and I suddenly wanted to go home, back to Kingston, where there was no such garden but where there were bright electric lights. I started to cry softly, then I began to cry loudly, then I added a refrain to my crying. I want to go home, I want to go home. My aunt never said a word. She just told my three cousins to go to bed and leave us alone.

She let me weep for what seemed like a long time. Even when I drooled all over the front of my good pink-and-white dress, she said nothing to me. We just sat there at the dining-room table — she, who looked like a woman in a Gauguin painting, and I, a younger version of her, sat in the gathering darkness with the Home Sweet Home lamp casting a water-wash yellow light between us, arranged in a composition that could have been painted on velvet and titled "Crying for the Light." She said nothing, she just let me cry. When I sobbed myself into silence, she lifted me up and put me into bed with my cousin Joan, where I fell asleep at once. Early next morning Joan shook me awake, saying that it was time for us to have our morning bath in the river. For the first time I saw the river that was named for my mother's people. Then, it seemed like a huge wide green sea with the cleanest swift-moving water. My cousins could swim, they just ran down the riverbank and leapt into the water. And I jumped right in after them; but because I could not swim, I nearly drowned. So I quickly learned to stay in the shallows and watch them swim the river, bank to bank. But I was so happy. I felt somehow that I would never come to any harm as long as I was immersed in that water named for my family. I felt that I should allow the currents to sweep me along and whenever I sensed that I was out too deep, I would just wade back to where my feet could touch ground. When my

cousins were ready to leave, I did not want to get out of the water. They laughed and said, "Think it's you wanted to go back to Kingston last night!"

For breakfast Aunt Ann had given us big mugs of chocolate tea with coconut milk. The chocolate was made from the cacao trees in Grandfather David's cacao walk. Rich, dark-brown like sweet mud, the chocolate fat floated on top, painting an oily moustache on your upper lip every time you put the mug to your mouth. There were hot toasted cassava bammies spread with yellow salt butter – cocoa like rich wine, and bammy like fresh host, a pure country communion after my river baptism. After breakfast, I joined the band of village children roaming all over the countryside, stoning fruit trees and eating fruit in various stages of fitness. Green common mangoes that you sliced and ate with salt (you always walked with some salt twisted in a piece of brown paper for just this reason), ripe common mangoes with names like blackie, stringy, number eleven, and beefy, and sometimes even good mangoes like Hayden, Bombay, and Julie, which were mostly cultivated in people's yards and did not grow wild in the bush. Common mangoes grew in the bush, and you ate as many of them as you wished, until you got a running belly, which would mean a visit to the pit latrine, which I dreaded as much as I did the lack of electric lights.

That summer I tasted fruit I had never eaten before. Small tart green jimbelins, fragrant rose apples that grew by the river, pods of musky stinking toe and slick mackafat. We heard stories, such stories. Under the shadow of the Dolphin Head Mountains is a cave. They said that there used to be a young man in a nearby village who disappeared one day as he walked home from school. The villagers searched for him for days and had almost given him up for dead when someone who had

gone to gather firewood found him sleeping near the mouth of the cave. The story he told was that he had been walking home from school when he heard what sounded like singing coming from inside the cave. He went deep inside, following the sound of the singing, and there he found a pool, so he drank some water from it and promptly fell asleep. He was not sure whether he was awake or dreaming, when he sensed that the cave was filled with people in bright robes. They told him that the water in the pool was really palm wine. They sung to him and told him they were sorry because they had helped to sell his ancestors to the slave traders. They said that they wished to repay him for the terrible wrong they had done, and this is how they would make amends to him. From henceforward he would be very lucky: they said he was never to answer to the name Cyril again and that he was to insist from now on that everyone call him Lucky. After that the boy really became very lucky. He won every bingo and raffle held at church and school functions and he bought one cow from which he got seven calves. He went to Montego Bay and some tourists took a liking to him and sent for him to come and live with them in England. He went to London and, years later, married one of the Queen's relatives. All the children in the village kept going to the cave in the hope that they would see the apologizing Africans again, for all of them wanted to have Lucky's good fortune to travel and be loved by a relative of the Queen.

There was also a house there which they said was haunted. They said that a very wicked woman used to live there. She was an obeah woman and she had harmed a lot of people. Wicked, vengeful people would pay her money to do bad things to their enemies and to innocent people whom they wanted to "keep down." Before she died she asked that she be buried with her face turned down to the ground as she was too ashamed to

meet the gaze of her Maker on Judgment Day. We were advised to run by that house while chanting the Lord's Prayer for protection, throwing pebbles behind us.

About noon we would return home for lunch, where we roasted breadfruits and big pieces of salted codfish over a wood fire. Then we would mix big mugs of "lemonade," made with sour Seville oranges, sugar, and water. We ate al fresco, sitting without shoes on the tombstones of the dead Harveys. At first I was frightened by this, but all my cousins did it. And my cousin Joan, who had been very close to our grandmother Margaret, convinced me that it was all right. She had played in the family plot for a long time and no harm had ever befallen her. It was true. She was very beautiful, slim, and graceful, so one day I sat beside her on our grandparents' tombstones; and though like any Kingston-born child I was frightened of duppies, after I sat there a while and nothing happened I became quite used to going to the family plot and sitting on the tombstones of all my Harvey relatives.

Soon after I returned to Kingston, we moved to no. 30 Studley Park Road, a move made possible by the fact that my two eldest siblings, Barbara and Howard, were now working and contributing to our family's finances. Barbara was at the Gleaner Company, where she would eventually become the editor of the evening newspaper, and my brother Howard went to work at the Jamaica Telephone Company. Everyone in our family was happy because, except for a nurse and her sister who shared the apartment downstairs, we were the only other occupants of our new home, which had three large bedrooms, a wide living and dining room, and a long enclosed verandah. The house was situated almost opposite the gates of All Saints Government School, which my brothers Kingsley, Karl, Keith, Nigel, and I attended. Even if it was not the prettiest of

houses, no. 30 Studley Park Road provided the answer to our family's prayers, for there we had our very own kitchen, bathroom, and toilets. And there was the sewing room.

I took to sitting in the sewing room although I had no real interest in sewing, assuming as I did then that my mother would always be alive to make me fabulous dresses, and asking questions of my mother about the Harveys, those who were living and those who were buried under the stones on which my cousins and I used to sit.

When you came up the long flight of stairs which led up from the yard, you stepped into the living and dining room where a massive wooden table with turned legs occupied a good one third of the room's space. The table is where we ate all our meals, the older children seated on a variety of chairs, the younger ones on a long wooden bench. Like the children of David and Margaret Harvey, my mother's children never knew hungry, and we ate, too, using a variety of cutlery and dishes. Mixed in with everyday knives and forks were always a few heavy ornate silver forks and spoons and some beautiful bone-handled knives; the dishes we ate from did not all match, and mixed in with them were always one or two with the bird-on-a-limb "Pareek" pattern by Johnson Brothers. If you passed the table and turned left, you'd enter the room which was my mother's domain, the sewing room. It was here that the women for whom she made dresses sat and discussed "big woman business" as they waited for my mother to fit or finish their garments. This was also the room where my mother taught neighbourhood girls to sew, free of charge, so that they could as she always said "earn a bread and be independent." This large room had a high ceiling and one window which looked out onto the street. Under the window was my favourite seat,

a huge brass-tipped trunk that was used to store fabric. It was one of the few things left over from my parents' earlier life. Two beds, three or four chairs for the women to sit on, and my mother's Singer sewing machine completed the furnishings.

My mother always sat with her back to the door, so that the light from the south fell across the cloth she was sewing. Sometimes for as much as seven hours a day, every day except Sunday, she could be found in that room, her long bare feet tilting at the wide wrought-iron pedal, her right hand spinning the wooden handle, bobbin, shuttle, presserfoot, many miles of fabric passing under her hands, arriving as cloth and leaving as fine garments. She sometimes ran the sewing machine like a racing car driver, bending her head way down, her long grey-and-white plaits curled around her face like slow smoke.

There is a constant stream of people, mostly women, coming through the sewing room to see her. They are not all customers, some come to ask her to read or write letters, to ask her advice, for her help, her opinion. She mediates in disputes too, sometimes saying, "A soft answer turneth away wrath" but at other times: "Don't allow people to take any liberty with you."

That is what she must have told the woman whom she helped to run away from my father's friend Beadle, because one day, just like in those blues songs my father, Marcus, loves, Beadle woke up and found his woman gone. "Gone, Mrs. Goodison," he comes to the sewing room to tell my mother. "The woman pack up and gone." The sight of a grown man who has only recently moved to Kingston from Malvern, St. Elizabeth, openly crying like a baby renders all the women speechless. Even the flint-hearted Miss Mirry, our helper, who always had a bitter proverb to suit any occasion, is silent as everyone stares at the man whose workman's khaki uniform

makes him look like a whipped schoolboy. Strangely enough, Doris, who is usually so sympathetic, says only, "This is all very unfortunate."

"Whatever happens between you and your husband is nobody else's business, except if he is ill-treating you, and God knows that wretch was ill-treating that poor woman," says my mother after Beadle has left. "Of course she is gone. I packed her suitcase for her early this morning, and I call my brother Edmund to come in his taxi and take her to the wharf. That ship has sailed by now."

She roughly turns the handle of the sewing machine and pumps furiously for a few minutes. Everyone in the room rides the waves of her indignation as my mother drives the sewing machine forward. Suddenly she stops. "He treats her like a dog. All his money goes to the rum bar, and when she has her period he orders her to sleep on the floor as if he was not born of woman. I am glad that I helped her to escape."

The other women are silent, gazing in admiration at her. They have never seen this freedom-fighter side of her before, the fearless Doris who has just a few hours before helped to spirit away a battered woman to safety. Then a slender pale-skinned woman who chain-smokes, wears matching red lipstick and nail polish, and speaks with an American accent says: "I was with a man like that once. I met him on the fourth of July at a picnic when I lived in Georgia, and talk about a hot love! I believed I'd die if I didn't marry him . . ." and here she switches into Jamaican patois, "but see me, and come live with me" — and, as if in a chorus, all the other women finish the proverb with her — "is two different things."

"Every time he beat me, he sent me flowers, or perfume, as if he was trying to cover up his stinking behaviour. Every time he black-up my eye, he would swear up and down how he

would never hit me again. Till the next time." And then she suddenly stood and lifted up her dress to reveal a deep keloid scar running down her right thigh. The women make loud sympathetic noises and glance quickly away from the horrible sight. The woman from Georgia lets her skirt hem fall and then turns around and picks up her cigarette, which she had carefully rested on the windowsill before she stood up. When she lifts the cigarette to her lips to take a deep draw of tobacco and menthol, her hand shakes and so does her voice.

"I knew I had to leave the son-of-a-bitch after he did that. So you know what I did? I got my sister to send me a telegram from Jamaica to say, 'Come quick, Mother is dying.' I bawled non-stop for two days until he said that he, *he* was giving me permission to come to Jamaica but only for two weeks. Well, I bid him one tender farewell at the airport, and I never went back. I left a house full of clothes, jewellery, and furniture, but what use would they be to me if I'd let him kill me?"

"I could never stand up and make a man just beat me so, me and him would haffi fight, after him not me father or me mother," says Betsy, who is jet-black and has a wonderful open face. Her gums are dark, almost purple, and she has perfect white teeth. Betsy is also almost six feet tall.

The woman from Georgia now has tears in her eyes. She blows a long stream of cigarette smoke through the window.

"When you talk bout beating, my grandmother give me one terrible beating with a tamarind switch the first time I see my period," says Edith, a cheerful young girl whom my mother was trying to teach to sew — without much success she'd often say — because Edith's world really revolved around blues dances. She lived for Saturday nights when she would boogie till dawn in various dance halls, dressed in tight blouses and wide swing skirts cinched tight at the waist with a broad belt

that showed off her eighteen-inch waistline. Edith was always happily singing the latest Fats Domino song under her breath as she hemmed a dress or serged a seam but today she laughs a harsh, embarrassed laugh when she says, "She say she beat me fi warn me fi no get pregnant."

"Damn old-fashioned behind times foolishness," says the lady from Georgia. "After all, it's a natural thing that God made to happen to women." Then she snorts and says, "All the same, God seemed to save some of the worst things for women."

"Mind you fly in God face," says Betsy, who was sitting on the floor near my mother's feet. Betsy is a "Mother," a spiritual leader in a revival group. Doris sometimes sews the cobalt blue robes that Betsy wears when she preaches, all full of the spirit, on the street corner.

I was sitting on a chair in a corner where my mother could not see me. I was willing myself to be invisible, praying that everyone would forget that I was in the room and just keep talking so I could hear, so I could learn about big woman business. On other occasions, if the conversation was becoming too grown up, my mother would say, "just stick a pin right there" to whoever was speaking, and then she'd turn to me and say, "leave, this is not for a little girl's ears." But today she says nothing to me, so I just keep still, glad to be in on big woman business.

"You know, when I see my health," says Betsy, "my grandfather call everybody in the house and tell them that they were not to treat me like a child any more, for now I could be a mother; and him shake my hand and give me five shillings and tell me to buy anything I want with it because I was now a big young lady!"

I remember that day when at age ten I was part of the big woman group, how everybody in the sewing room nodded

their approval when Betsy told that story, because it seemed like the proper thing to have done.

"You can learn a lot from old people," said Edith. "Is a old lady name Edna who always tell me that when things bad with you, when you broke and down-hearted is when you must dress up in you best clothes, for is better you make people envy you and grudge you than make them feel sorry for you."

That was the signal for everyone to contribute their own words for the big woman to live by.

Doris: "My mother, Margaret, tell me, Rose, Miss Jo, Cleodine, and Ann that a woman must always at all times have a good nightgown and a good clean panty put aside in case she have to go to the hospital."

Edith: "My grandmother tell me I must always keep at least one good woman friend who I can trust, who I can tell anything to and who won't turn round and disgrace me."

Betsy: "For there is nothing worse than when you friend chat out you private business; even when the friendship done, you mustn't chat out you friend private business. You see me Betsy, if you tell me a secret, me carry it to the grave, for the Bible say that if you betray you friend secret, that friendship can never in life ever fix again."

Doris: "That is true, it's like when a man stop love you; reconcile yourself to it. Know that it finish and done with, and never you force up on him, for the more you try and make him love you, the more he will hate you."

Betsy: "But some woman will do anything to make a man stay with them, you know. You see that American woman Miss Simpson? Me understand say is some a her pum-pum hair she cut and parch and sprinkle like black pepper over King Edward food and that is why him left the throne of England and married to her."

The woman from Georgia laughed so hard when Betsy said that, that she choked; and Edith, who was laughing till tears ran down her face, had to slap her on the back.

My mother frowned and glanced in my direction. Her look said, "you did not hear that." Then in order to bring the conversation back from the edge of the pit where Betsy's inside dish on poor Wallis Simpson had taken things, she told a story about her sister Ann to illustrate why a big woman had to be wise in order to protect herself in the world.

"When my sister Ann got married and went to live in Montego Bay, she had a lovely friend, a Mrs. Doris Melbourne, who lived next door. Well, my sister Ann's husband was not the best provider, and so when Ann get any money from her sewing she just give it to Mrs. Melbourne – who was separated from her husband – so that she could prepare meals for both families. When dinner was ready, Mrs. Melbourne made her daughter Elaine come to the fence and say to Ann, 'My mother is inviting you and the children to have dinner with us.' And Ann just take her children and go next door and have a lovely meal with her friend. When her husband come in late, asking, 'Where is my dinner?' Ann just say, 'There is no dinner because you never gave me any money to buy anything.'"

"Lord that one good," says Edith.

Then, my mother did something she had never done before, she turned in my direction and included me in the big woman circle. "You see Lorna, there? Up to yesterday I send her to go and help Mrs. Percy with something that will prevent her from going to the poorhouse one day."

I remembered that the day before my mother had answered the telephone and when she hung it up she said, "Go to Mrs. Percy and she will give you something." I liked going to Mrs. Percy's, which was above the grocery and bar run by her and

her husband, for there was usually a quadrille group practising in the paved area beside the bar. I loved to see the dance – which I later learned had originated in the courts of Europe – being performed by neighbourhood people like the tall, elegant man known as Cubana and the local hearse driver the children called Bald-head Morty. When Mrs. Percy saw me she'd said: "Oh, your mother send you for the cloth to make my dress. Excuse me, Mr. Percy (she always called him Mr.), I'm just going upstairs to get some cloth to give to Mrs. Goodison."

Her husband just turned and scowled at her without saying a word. We went to their rooms above the shop, and she pulled out a drawer and took out a length of cloth. Then she reached into her bosom and extracted some well-creased pound notes, which she then folded into the fabric. She'd put the cloth in a bag marked "The Buzzer," the name of a store on King Street, and she'd handed it to me. I now knew the reason.

"Poor woman," said my mother, "she married to this man and work her fingers to the bone for him. By accident one day she find him will, only to discover that the man intend to leave everything to the children by him first wife. Well, from she find out that she is not in his will, she been taking money out the till and sending it to me to keep for her. Once a week she come here and collect the money and bank it. Imagine the poor woman have to be stealing out her own money because under the law a married woman have no rights."

"That is not thief, Miss Goodie. That is take, the woman taking what belong to her by right," says Edith.

There is silence in the sewing room after that story. I sit in my corner feeling very grown up to have been included in the big woman business for that day. I look over in my mother's direction in time to see her switch on the tiny light above the presserfoot of the sewing machine just before she

finishes stitching the seven-inch zip into the placket of the hobble skirt.

"Oh, look at the time," says the Georgia lady.

"Here is your skirt, my dear, give it a good press before you wear it."

"You see me here swapping laugh for peas soup; I have to go get ready for church tonight," says Betsy, "so when I must come back to fit my dress, Miss Goodie?"

"Tomorrow midday," says my mother, "come and get some dinner and I will fit your dress afterwards."

"All right everybody, God bless and keep you till I see you tomorrow if life spare," says Betsy.

"Wait for me and I will walk with you to the bus stop," says the lady from Georgia as she folds her hobble skirt into a shopping bag marked "Nathan's Department Store."

"You can go now, Edith," says my mother, "try and come early tomorrow." And with those words my mother rises from her sewing machine and closes the room for the day.

\mathcal{H}ow you put up with Miss Mirry?" Everyone asked my mother that question. Miss Mirry had come to work with our family as a domestic helper shortly after my father started working two jobs, one installing telephones at the Jamaica Telephone Company, and the other, which he did on weekends, as a driver to a doctor. She moved with the family from Orange Street to Studley Park Road and stayed with us for almost fifteen years until she walked off kissing her teeth one day and never came back. Miss Mirry was a short, stout, very dark-skinned woman who always wore a head-tie because her hair was grey and she did not like to look old. She had a face that seemed to be frozen in a permanent "kiss-teeth," so that her lips were twisted to one side, and her eyes squinched up. She had a large straight nose and sometimes she smoked cigarettes by turning the lit end inside her mouth.

Miss Mirry hated everybody, including the woman who came once a week on Fridays to iron our clothes because my mother said Miss Mirry needed help. Still Miss Mirry hated the woman and spent every Friday throwing words about "people who come to box bread outta other people mouth."

And there was Mrs. Hinsula. Only my mother seemed to feel any sympathy for the woman she once described in this

way: "She used to be a real big shot lady, married to a rich man from Cuba, till her husband left her." And now Mrs. Hinsula — or Señora Hinsula, as she sometimes called herself — was reduced to living off the charity of others. Every Sunday for years she came to visit us exactly at dinnertime, and when she arrived, it was all that Miss Mirry could do to hand her a clean plate. But my mother always welcomed her warmly, and in addition to feeding her she would prepare a parcel with rice, flour, sugar, a tin of condensed milk, and a bar of soap for her to take away with her. One Sunday she added a nice thick slab of salted codfish to the parcel, and Señora Hinsula declared, "No, no, no, I cannot possibly take that saltfish, it would smell me up on the bus." Miss Mirry exploded and called Mrs. Hinsula "a poor show great" who still behaved like she was somebody when everybody knew that she did not have a pot to piss in or a window to throw it through. Her shoes were so worn out that my brother Keith used to say that Señora Hinsula walked not in, but beside, her shoes. My mother told Miss Mirry to stay out of her business, "I know what she is going through. She is just trying to hold on to her dignity. You have to hold on to your dignity."

Mostly Miss Mirry seemed to hate me. The sight of me made her crazy. We must have been enemies in a previous life in West Africa because without a doubt that is where Miss Mirry came from. All I had to do was to pass by her as she bent over our wooden washtub scrubbing our dirty clothes, or as she stood at the cistern washing dishes, and she would begin to fume and hiss like a steaming kettle, muttering words like *wutliss, facety gal*. I did not like Miss Mirry either, but we were not allowed to be disrespectful to her as my mother believed that children should be respectful to all their elders. That is why we called her Miss Mirry instead of just Mirry. Miss

Mirry twisted up everybody's name, even her own. Her name was Miriam Henry, but she called herself Mirryam Endry. She called my sister Barbara "Baba," and she said she came from "Ullava," which was really the town of Old Harbour. Most words in English just refused to obey her tongue, and she did not much care.

Miss Mirry had a weakness for younger men, and on our grocery list — which my mother filled out and sent to the Chinese grocery every Friday — we sometimes saw added the odd bottle of beer. Between items like twelve tins of condensed milk, ten pounds of rice, and ten pounds of sugar, there would appear two bottles of Guinness Stout that could not be accounted for by Marcus or Doris nor any of us nine children. But we all knew who it was that had "trusted" or charged these dark bottles of potent brew to offer as blandishments to some younger man. Once the Sunday chicken dinner arrived at the table missing one leg because she had secured the other drumstick for her latest love.

Miss Mirry did not permit us to eat the fruits that our father brought for us, his own children. The house at Studley Park Road had a long narrow room situated between the kitchen and the bathroom, a room she called the "buttery." In it, she would hide the bunches of ripe bananas or baskets of mangoes my father would bring home. To get at these fruits, my brothers devised a plan. They would go into the toilet, which was next to the buttery, and climb through the space above the connecting wall. They had to be careful when they jumped that they landed in the piles of laundry that she also stored in the buttery. After their soft landings, they would eat as many of the bananas as they could, stuff their pockets with the mangoes, and climb back over the wall into the toilet. They then pulled hard on the chain and emerged. One after the other

they did this whenever they knew that Miss Mirry was hiding a bunch of bananas and a basket of mangoes. The best part came when she discovered that the fruits were gone and that there was just a pile of collapsed empty yellow skins strewn across the floor of the buttery. Then she exploded and called us damn thieves for eating the fruits that our own father had brought to feed his children.

It was Nigel, the youngest, who came up with an idea to get back at Miss Mirry. She could not read, and he would sit on the top step (where he didn't have far to run and hide behind my mother when Miss Mirry chased him up the flight of stairs that led up from the yard to our rooms) and spell out his curses at her.

Y-o-u i-s a d-o-g, a d-i-r-t-y d-o-g, a u-g-l-y d-o-g.

"Yu think I don't know what you calling me?"

"What I calling you?"

"Yu facety little boy."

Y-o-u i-s a d-i-r-t-y D-r-a-n-k-r-o.

Well it was all over now, because Nigel's spelling of John Crow, the bald-headed scavenger vulture, was making everyone hysterical. The rest of us were laughing at her, and Miss Mirry was foaming at the mouth, but she couldn't say exactly what was being done to her. Nigel, as far as I know, was the only person who ever got the better of Miss Mirry. But she once gave me a tamarind leaf bath in her washtub when I had measles, and she told me as she bathed my itching skin that "every sickness in the world have a bush to cure it."

Miss Mirry also said of the wedding of Lennie the yam man who married Miss Pinky, who was a hunchback, at our house, that "Every hoe, have a stick a bush." This agricultural analogy was an appropriate one for Lennie, and it was probably my mother's love for the great Lucea yams grown in the

parish of Hanover that made her so tolerant of Lennie, the yam man who had come to bear a remarkable resemblance to the yams he sold. He was a large, thick man; *earthy* would be a good word to describe him. Lennie would come two or three times a week and announce his arrival by standing at the foot of the staircase which led up to our house, bawling, "Miss Goodieooooooooh." Lennie drank john crow batty white rum, a cheap, coarse, dreggy, and extremely potent rum, which was drawn from the bottom of the rum barrel, and he would sometimes burst into fits of loud crying when talking to my mother. Though her dreams of running a fine guest home never did materialize, in her house everyone was treated as an honoured guest. So, rising from her sewing machine, she would direct Miss Mirry to brew Lennie a cup of ginger tea. As she prepared the tea and then handed it ungraciously to Lennie, Miss Mirry would hiss and Lennie would drink in loud slurps, moaning through the cleansing sting of ginger tea, shaking his head from side to side, and muttering that only Gawd alone knew the crawse he bore. My mother would tell him to bear up, then she would buy Lucea yams from him.

The "crawse" turned out to have something to do with the ill health of his woman, Miss Pinky. But she was really the one with the crawse. When he brought her to meet my mother, we saw that she was hunchbacked, and looked like one of the last of the Jewish peddlers who walked about the streets of Kingston with a big pack of goods on their backs, a burden that caused them in the approaching distance to appear to be bent almost double. Miss Pinky was almost exactly half the size of Lennie. Her head came to a point just above his belt, and when she smiled she looked like a very young girl. When she took a seat in one of the chairs in our dining room, she swung her legs in circles above the floorboards.

Doris was pleased to meet Miss Pinky and told Miss Mirry to give her something cool to drink. Miss Mirry, who was undoubtedly the world's most ill-tempered person and did not like taking orders from anybody, had been making stabbing motions at the floor with the broom, pretending to be sweeping, in the hope of overhearing all about Lennie and Miss Pinky's business. When my mother sent her to get Miss Pinky something to drink, she shuffled off in my father's old shoes with the backs folded down, hissing and grumbling, muttering something in which the words "too much excitement" featured.

The next morning at breakfast, Doris announced her big news. Lennie and Pinky would be getting married in a few weeks. My father, who could not abide Lennie's coarseness, said he assumed the wedding would be held in the Redemption Ground Market. But my mother said no, she had told them they could have the wedding right here in our house. My father did not laugh. For the next few weeks my mother proceeded to make arrangements for Lennie and Pinky's wedding, including designing and sewing the wedding dress. She was proud of her reputation for being able to make garments to fit any kind of shape. Unlike her sister Cleodine, she never turned a customer away, and all her customers felt free to enter our house and to sit anywhere they pleased. My mother had sewn for many brides in her life. She was an artist, an artist who created with shining white bolts of slipper satin, crepe de chine, organza, chiffon, guipure lace, Brussels lace, and Venice lace. She hung "tears of joy" pearls, iridescent sequins, and diamond-like rhinestones upon her creations, which turned ordinary women into queens, ethereal bridal beings, their glowing faces framed by mists of illusion tulle flowing veils or fingertip veils. They floated up the aisle followed by cathedral trains. She sewed for many brides who were seven and eight months pregnant. For

them, she had devised a cunning apron cum peplum, which artfully camouflaged the offending belly. She never discussed what dressmaking sleight of hand she employed to make Miss Pinky's dress fit her so well, but everyone agreed that Miss Pinky's gown suited her perfectly.

When the day of the wedding arrived, my father announced that he would be working overtime that night. My mother was in her element, grandly directing the proceedings as the mistress of the revels. She installed Miss Pinky in her bedroom, dressed her in bridal finery, and led her forth, transformed into a beautiful bride. Several large ladies, referred to as "eegla ooman" (higgler women) by Miss Mirry, came and took over the kitchen — which caused Miss Mirry to fume and hiss even more and mutter under her breath about never-see-come-see, hurry-come-up people — and soon the aroma of curried goat and chicken wafted about the yard, spicy harbingers of good feasting to come.

Miss Pinky looked lovely, everyone kept saying so. Everyone also kept saying that my mother had lived up to her reputation for being able to sew to fit any shape. The wedding was attended by scores of other women like the eegla ooman and their male equivalents. These women, who had grown quite well off from selling food in the market, were dressed in rich brocade and lace, "quality cloth" according to Miss Mirry, and the men wore dark suits and felt hats. The guest of honour was a doctor from the University of the West Indies Hospital, Pinky's doctor, and the guests kept remarking on how Doctor Goldman was just sitting there, laughing and talking like an ordinary man right there in our living room. The table was splendidly decorated, with pink asters and asparagus ferns pinned to its corners, and Doris's best cut-glass carafes filled with dark red wine. The wine-filled carafes glowed against the

white lace of the tablecloth and set off the architecture of the cake, which was a tall four-storied creation, covered in thick, white icing and studded with flat silver discs, like nail heads. Several smaller round cakes branched off independently from the central one. The cake was rich with raisins, currants, prunes, and cherries and redolent of spices, overproof rum, and sweet Puerto Pruno wine. If you ate enough of it, you became deliciously light-headed.

Over the course of the wedding celebration, almost every single person stood up in my parents' living room and gave a speech, a toast, or rendered an item. As is the custom in Jamaican weddings, the bride and groom were showered with words to live by. Many of the older guests quoted passages from the Bible about how a man should leave his mother and father and cling to his wife, for in the same Bible, it said that it was not good for man to live alone. Some of the guests wished for Lennie and Pinky to be as well suited to each other's needs as a "tumpa knife and green banana" and also "like Isaac and Rebecca." I stood there with my brothers and sisters among the weddings guests and listened as even the eegla ooman and man who sold in the market confidently quoted line after line from poets such as Wordsworth, Keats, Shelley, and Claude McKay.

In thinking back, I realize many of the guests at the wedding that day would probably have taken part in poetry and elocution contests at meetings of Marcus Garvey's Universal Negro Improvement Association, enabling them to give the gift of poetry to Lennie and Pinky as a "a thing of beauty" to be to them "a joy forever." The last speech of the evening was made by Doctor Goldman, who spoke about "hope springing eternal in the human breast" and made references to how courageous the bride was and how it was necessary to have faith and be optimistic.

Afterwards, Lennie and Pinky opened the dance floor to Mickey and Sylvia's "Dearest." The dancing ended at about 1 a.m., and Doris got to keep one of the smaller cakes off the big cake and she took it into her bedroom for fear we, her children, would rise in the night and devour it.

A few months later, Pinky was operated on, but it was too late. She died, and they buried her in her wedding dress. Lennie was drunk for two weeks straight after that, and even Miss Mirry was moved to say that she felt sorry for him.

ear Mrs. Goodison, Would you please sweeten my mouth today with some of your dinner? Love, Teacher Bernard." Our house at Studley Park Road became a hospitality centre, much of which revolved around my mother's seemingly bottomless cooking pot. Teachers from All Saints School; our schoolfriends, many of whom became important Jamaican statesmen and entertainers; relatives visiting from the country, many in the process of immigrating to England, who had come to receive a crash course from my mother on how to look and behave stylishly in a new land, all came to eat every day from Doris's bottomless cooking pot. The main meal of the day, "dinner," was served at noon, and all the children came back from school to eat it. Marcus and our eldest brother, Howard, would drive up in the telephone company van and as soon as they arrived, the miraculous midday feeding would commence. Many of our schoolfriends who came to eat at our house did so to avoid eating Bullo slush, the free school lunch provided by the government for Jamaican schoolchildren. My mother began running a guest house of sorts after all.

Bullo slush came by handcart each day, steaming and sloshing from side to side in a big square galvanized tin. It

was cooked in a kitchen somewhere in the city and dispersed to primary schools throughout Kingston to provide a hot nutritional meal for the city's schoolchildren. Bullo slush was a dark brown lumpy stew in which portions of gristly mystery meat moved like the fins of a shark. Many children claimed to get running belly from eating it. Bullo slush gave off a faintly medicinal smell, the same smell given off by the free cheese and milk powder distributed at school. There were rumours that iodine was added to all "government food" so that in case the schoolchildren had any cuts, this food would heal them.

Like her mother before her, Doris cooked huge amounts of food every day and much of the money she made from sewing went into feeding the multitudes. You could "smell her hand," as her father once said, from the moment you turned into the gate. She always cooked the midday meal herself. Miss Mirry acted as her assistant, cleaning the seasoning and picking grains from the rice. My mother believed in the culinary power of garlic, always scraped with the edge of a knife; and many white circles of sliced onions, pimento kernels, lengths of escallion were pressed hard to release pungent juices, and were added to with sprigs of fragrant thyme, sliced country pepper, black pepper, and salt. All these were rubbed into the meat with clean, bare hands. And the meat – beef or pork, mutton or chicken – was seasoned then browned in huge iron Dutch pots, then covered with just enough water and left to stew into succulence. To the bubbling gravy she added Marcus's favourite sauce, Pickapepper Sauce, whose bottles had on the label a rendering of a gaudy plumed parrot picking a red pepper. Then tomatoes and thyme were added to the bubbling brown gravy. She cooked deep pots of rice, steamed verdant leafy bundles of iron-rich calaloo, grated carrots, sliced tomatoes,

because she believed in the importance of eating vegetables; and she fed all the children who came, including a few of my brothers' schoolfriends who had become Rastafarians.

~

Below All Saints School, along the gully bank, was a Rasta camp from which the sound of hypnotic drumming and chanting issued night and day. Neighbourhood rumours of dark deeds, from ganja smoking to human sacrifice, ran rife and fuelled my mother's fear that her sons might be drawn by some compelling, ganja-smoking force, to go down and join the Rastafarians. She prayed night and day to the God of the Church of England, and dispatched all her children to Sunday school at All Saints Anglican Church every week without fail. "The Church of England, all the Harveys were born into the Church of England," she would say, and she would tell her children again and again how the Anglican religion had brought the Harveys through everything from Uncle Howard's murder to the robbery by George O'Brian Wilson's legal family of the property willed to Margaret by her father, and because of their faith, the Harveys were still going strong. Surely, she said, it was the teachings of the Church of England that had kept her going when she and my father had lost their Malvern house. And in her early days in Kingston, what but the Anglican religion had helped her to rise up every morning and read from the Book of Common Prayer and choose a good Anglican hymn to sing to herself over and over as she faced the hostility of Vie and the women in the yard – "God is His own interpreter, and He will make it plain" – to help her to make sense of all the changes, the upheavals in her life. My mother could

not see how an angry God, who had to be worshipped in clouds of ganja smoke, could help her or her children.

Fireball, thunder ball, earthquake, lightning, fire bun, Babylon, fire fi you, Babylon, fire fi you. On every street corner in Kingston in the 1950s, there had suddenly appeared fierce "Beardmen." Some of them said that it had been the great Jamaican prophet, Marcus Mosiah Garvey, who had announced "Look to Africa for the crowning of a black king. He shall be the redeemer." And so it was in 1930, Ras Tafari Makonnen, direct descendant of King Solomon and the black Queen of Sheba, was crowned Emperor of Ethiopia and given the title, Haile Selassie, King of Kings, Lord of Lords, Conquering Lion of the Tribe of Judah. And thus it was that the descendants of kidnapped and dispossessed Africans found a god who looked more like them.

My mother said she could understand why they felt this way, for slavery had been a most wicked and dreadful thing, but she did not want her sons to become Rastafarians. Rastas wore their locks like Samburu warriors. Dread, uncut locks because the Bible that they lived by said that a razor must not touch the hairs of your head. The Dreads, with their wild, red eyes, poured scorn and destruction on Babylon, Babylon being the system of government that Jamaicans as colonial subjects lived under, Babylon being Jamaica, a strange land to those who considered Africa to be their true homes.

"Rule Britannia, Britannia rules the waves, Britons never, never, never shall be slaves," sang the ex-slaves, the ones who celebrated Empire Day, the Queen's birthday, by going out and lining the streets in town and country, and waving small Union Jacks. When the children went to school on Empire Day, they were rewarded with a penny bun (a kind of coarse lump of the Queen's birthday cake). Was there a special fund in the coffers

of the colonial government to provide penny buns for the black children who sang that Britons would never be slaves? Some Calypsonian sang, "Build me a road make I walk on the sea to see my mother country." He did not mean Africa. Every New Year, the Queen gave Jamaicans a message. Sometimes she and her family came to visit and everybody lined the streets again and waved small Union Jacks.

My mother took all of her children to see Her Royal Highness, and when I said that I did not want to see the Queen, she said to me, "So you think that you are your own big woman now?" I remember standing there on King Street, totally miserable as the sun blazed down upon lines of Jamaicans waiting to see the Queen go by. When she finally passed by in a big topless car, we could see that she was a small woman who waved her gloved arm mechanically and smiled. All I kept thinking was that I really did not see why I had to stand up for such a long time to catch a glimpse of the Queen for such a short time.

The Dreads were capturing land all over Jamaica, seizing Crown land and building settlements and camps and sending smoke signals to young men in clouds of wisdom weed. There was explosive Nyabinghi drumming and chanting, days and nights of endless reasoning, reasoning upon reasoning, to turn Babylon's logic upon its bald head. But there were things about Rastafarians that fascinated my mother, who loved words, like the strange language they spoke with "I" as the centre of all things. According to Rastafarians, there was no separation between people, so you and me became "I and I"; even a great crowd of people became a multitude of "I's." "Africa is I father's home, Africa I want to go," cried the Dreads on the streets of Jamaica. They said there was no more understanding, for too long had Jamaicans been kept under so Babylon could stand, so henceforth the I and I would "overstand"; and

"Bungo," which used to be a curse word signifying black and uneducated, would be a title of honour. Bungo Natty would be a high title because knotty hair offended the aesthetics of Babylon and the texture of black hair was something black people could not do anything about without causing great discomfort to themselves.

The reason for this subversion was explained to my mother by one of the young men, known as Phantom, whom she used to feed from her bottomless cooking pot. Although he no longer ate her food, because Rastafarians preferred not to eat salt, he always came to visit with her and to be received as an honoured guest, as she was known to receive everyone. Having nine children of her own did not prevent my mother from becoming very attached to other people's children, and Phantom was one of the many neighbourhood children for whom she cared deeply. He was honest, hopeful, and ambitious – qualities my mother found endearing in combination. "Phantom," she had asked him, "why a nice young man like you from a decent home, who went to high school and who your mother try with so, go and take up Rasta?"

"Mother Goodie," replied Phantom. "Babylon don't like how I and I talk, Babylon don't like how I and I walk, for I and I mouth too big and I and I nose too broad and I and I skin too black and as for I and I hair, I and I won't touch that. Everything about this kidnapped African is like poison to Babylon. So what Rastafari come to is this, block this game, turn over this table. I and I will not play by Babylon rule book, for that book no fair, I and I take I self outta this three-card game, and who want play it can play it, now mum is the word, parapinto is the game. I and I prefer not to eat no salt, and I and I will touch no part of pig, that is why the I cannot partake of that lovely plate of stew peas that the I has offered the I, because I

and I foresee that a day will be coming when what sell in a shop will not have buyer, I and I will live close to the ground and grow the green herbs and eat the iron of the quick-springing ilaloo, and build our structure with ground provisions until that bright morning when I and I work being over I and I will fly away or will board the Black Star Liners which will come at last into Kingston Harbour. You know Mother Goodie, them arrest I last year and the first thing that Babylon representative do is to walk scissors through I head. Years now the I cultivate these dreads, no razor walk near these locks. I let them clump together as they see fit, grow like stout vines and hang long down I trunk. They accuse the I of breeding lice, rumour, and propaganda of forty-leg in the dread head. Mother Goodie, Babylonians are Delilah's descendants. The I watch I locks lying like woolly serpents at I feet, locks which were once woolly serpents alive on the I head, then I turn and see the grinning house slave holding up scissors like a forked spear, claiming him is warrior, him cut I down and conquer I. I drum for him, a funde mental mourning song, for his living death to come. Life set on a wheel and it will wheel, wheel and turn till the I turn come, must come. Come down Babylon, come down, come down offa Black Man shoulder."

Years later, we were told by a family friend from Ghana that at the same time Rastafarians were becoming a force to be reckoned with in Jamaica, in parts of West Africa, specifically in Cape Coast, in the town of Oguaa, dreadlocked men had also begun to appear. Wild-eyed men who lived apart from the rest of society, in remote places, by deep lagoons, who dressed in rough, woven crocus-bag garments and carried staffs would appear on street corners and chant.

"Wona nyi, wegya nyi. I am your mother, I am your father Ahomaka wo mo. There is joy in it, papapahpa. Very well," cried

the Dreads on the streets of Ghana, lending cosmic support to the Dreads of Jamaica.

Some of the neighbourhood boys began to disappear down the gully bank. You would see them on the street, dreadlocked strangers with red eyes who stared past you because they no longer knew you. For fear that a similar fate would befall her sons, my mother prayed harder and harder to the God of the Church of England to preserve her sons from what she saw as a state of perdition, because once these boys "sighted up" Haile Selassie, it seemed they never again returned to normal life.

But ironically, it was the same Phantom who became one of the first converts to leave Rastafari and to take refuge in the land of Queen Elizabeth of England.

～

Phantom appeared in our yard one day carrying a cardboard grip. He was dressed in a brand new, tight-fitting continental suit made for him by the great Jamaican entertainer and tailor, Clancy Eccles. He was wearing a shiny pair of Three Castle shoes and his shorn head was covered by a "stingy brim" felt hat. This outfit in later years would become de rigueur for English entertainers, and this is gospel: it was introduced to Britain by Jamaican immigrants. Phantom had come to tell Mother Goodie goodbye and to bid a general farewell to us all, saying:

> People I am leaving, for
> Rasta-ism is "ism"
> Cramp and paralyze all "ism" and "schism"
> Rasta-ism is no ambition "ism"

Rasta-ism is ganja "ism"

Rasta-ism is live-like-dog "ism," Rasta-ism is old

nayga "ism"

At that point, a black Zephyr 6 taxi drew up outside and Phantom went out the gate, with my mother wishing him "travelling mercies" and giving him a large slice of cornmeal pudding wrapped in a grease-proof bread bag to sustain him on his journey. He climbed in and departed for the wharf, driving past the ice cream parlour operated by the beautiful Chinese woman named Cynthia, past Miss Dinah's grocery, and the barbershop operated by Sillo, a man who was proud to be an African, so proud that he called his barbershop Addis Ababa Shop. Phantom boarded an Italian banana boat called the *Ascania*, having paid a passage of seventy-five pounds, and set sail for England, leaving Rasta behind.

Everyone expected Phantom's ship to sink. We waited to hear that it had been swallowed up by the waves because there was a traitor to Rastafari on board. But it did not sink, and years later he came back on a visit and told my mother of his time there.

Phantom said he had landed in London, England, and because he did not want to run into anyone in the Jamaican community who might have known him, he took a train to Wolverhampton, where he had no friends or relatives, and so had no one to show him the ropes. The only thing that he knew about that town was the name of the football team, the Wolverhampton Wanderers, because he bet on them when he used to buy the football pools. Nobody would rent him a room except for an old woman named Miss Dicey O'Riley, who drank glasses of jet-dark porter all the time and kept

walking through the house in various stages of undress, crooning "The Rose of Tralee," thus forcing Phantom to come in late every night and leave early in the morning every cold and lonely day of the year. He got a job in a factory where the first thing that happened to him was an English boy started asking him about his Three Castle shoes. How come a Jamaican like him owned such a good pair of shoes? When the boy found out how much the shoes cost (seven pounds) and knew he couldn't afford to buy a pair, he threw one of Phantom's shoes in the lye pit, out of bad mind and spite.

Phantom had been writing to his woman and sending money home, but had received no reply. No "Dear Phantom . . . I hope these few lines find you in the best of health, enjoying the maximum capacity of relaxation." So after a while he took himself to the London dockyard, having calculated when the *Ascania* would be in port. There he looked for the cockney sailor he had befriended on the voyage coming over. He begged him to go to his yard in Jamaica and to inquire of his woman who was no longer called his queen why she did not write to him. Using Nyabinghi patience, he waited the forty-two days until the ship went to Jamaica and returned to London. The sailor said that Phantom's woman had said that she had never received a letter, much less a pound note from him since he left for England and she was just getting ready to forget him with another man.

Phantom told the sailor that every month he had put a letter with money in it in the big blue postbox. "No mate," the sailor said, "that big blue box is the garbage tip." And Phantom took that as a sign that he should return to the fold of Selassie I, for under Babylon system he was spending his labour for nought and nothing, selling his birthright for a mess of garbage.

From that day, Phantom sight up Rastafari once again. When he came back to visit he had regrown his locks and every Christmas for years he would send my mother a Christmas card, sometimes with a white Santa on it; and when we laughed at that, my mother said, "Leave him, it's the thought that counts."

After her last daughter, Ann, married and left Harvey River to go and live in Montego Bay, Margaret found herself alone in the house for the first time in her life. On this day, she got up from the rocking chair by the window and checked in every room to see that the lamps were out and the windows closed. Just to make sure, she called out to the helper Mina, knowing full well that Mina had gone about her business after she'd been paid that afternoon. Mina had gone down to the river to bathe the minute she finished serving Margaret her lunch of Saturday beef soup, then she had come back and dressed herself in the good white jersey dress that Rose and Albertha had sent from Canada in a barrel of clothes for the people of Harvey River.

"This dress must be worn to church" is what Margaret had told the girl when she had given it to her. And here it was, midday on a Saturday, and Mina had hauled on the good good white dress, pushed her feet into the nice black patent leather shoes that had also come in the barrel from Canada, and dressed to the dickens, had almost run through the gate, shouting behind her that she was going up to Dinalvah to see her mother. Margaret called out to her that she had "better not fly past her nest and come back to work late next morning." But

she knew that Mina was not really going to see her mother; Mina was going to see her boyfriend, who lived in the barracks occupied by workers on the San Flebyn sugar estate.

Mina's mother's name was Delmina. The Harveys always told how all the women in that particular family were called Mina or Delmina or Elmina because Mina's great-grandmother had been shipped as a slave from the port of Al Mina on the Cape Coast of Ghana. When he was alive, David used to say, "Mina's people are determined to remember that they were stolen from Africa." Margaret herself did not see the point in remembering those things. She knew that there were people right there in Hanover who were still fully into their African ways. Right there in the neighbouring parish of Westmoreland, there was even a rocky place named Abeokuta that they said was just like a place named Abeokuta in Nigeria. People from Abeokuta called themselves "nago" people. They talked their Yoruba talk, ate pounded yam, cassava, or breadfruit, which they called "tum tum" or "fu fu," and they danced their "ettu" dance in a slow shuffling circle to the beat of goatskin drums.

When her daughter Ann was still living at home, Margaret used to overhear her and Mina giggling away together, and Ann would say to Mina, "All right now, Mina, talk some African talk for me." And the girl would talk her strange talk for Ann, who would then imitate what Mina had just said. But if they saw Margaret coming, they would stop immediately. Truth be told, Margaret just did not understand her last daughter. What could she possibly find so interesting in Mina's African business? But that was Ann all over, just so free and easy, taking serious things for a joke.

Imagine, thought Margaret, after that blessed Baptist minister Thomas Burchell rode up and down all over Hanover, all over Jamaica, preaching to help abolish slavery and to turn

these people from their dark ways, you still could not take the tum tum and fu fu business out of them. They said that Thomas Burchell was so zealous in his preaching and abolitionist work that he kept five or six horses which were worn down to shadows from his constant riding across the island, preaching Christianity to people like Mina and her relatives who were still sharing out God's power. Some of these people still believed in different gods, one god for this, one god for that, one for healing and another one for war. Assistant gods did not appeal to Margaret. What would happen if one day your mouth were to miss, your tongue slip, and you summoned the god of old iron and war instead of the god of softness and peace that you badly needed? The idea of one All-Powerful God who was in charge of everyone and everything appealed more to her nature.

Now these days with her husband buried out in the front yard and with all her children grown up and gone from the house, Margaret feels the need to call upon that one All-Powerful God more than ever. She feels her own great strength waning, she is exhausted all the time; even the act of pulling off her dress exhausts her. She has to pause with her long pink flannel nightgown bunched halfway across her chest in order to catch her breath.

I imagine that Margaret never told a soul this, but it is certain that she talked about their children to her dead husband, David. After he had died, she had had to wear red and black underwear for the first time in her life because people said that if a widow did not do this, her husband's ghost would come back and try to make love to her. But red or black underwear or not, sometimes she senses his presence very strongly in the house; and every night since his death, she's certain that he gets up from under that white stone slab outside in the yard

and comes into their bedroom just to look in on her, and when she feels him about, she talks to him.

"Your daughter Cleodine is doing well, she and the husband send clear to England to buy an organ for her to play her music at Rose Cottage. Oh and I hear from Doris and Marcus, the big girl Barbara is doing wonders. She get a grade one, one you know, in her Cambridge Senior certificate, and she going to work at the Gleaner Company because she want to be a reporter. I'm so glad that they will have a child working now to help them . . . I don't hear a word from Edmund this last few months . . . I hope everything is all right. Miss Jo and her Barbadian husband seem to be getting on fine but she write to say she is not feeling so well these days. Mmmm. If you ever see the sweet photograph of herself that Rose send, my god D, she have on one lovely fur coat and she just stand up there smiling in the snow like a real Canadian . . . Flavy him still going from church to church, church to church, and Ann . . . Ann as I tell you gone to Montego Bay with that man she married. That man that she choose over all the other good good Hanover men who come here to court her. She find fault with everyone, that one foot too big, this one forehead too shine, she turn down all those good responsible men for this stranger man from Montego Bay. This same man who even Ann herself admits is not the most reliable of men, but then she turn round and tell me that he make her feel like the most beautiful woman in Jamaica.

"From the first time I see that big black car drive up to our gate and this tall big chest man step out, my spirit just grow cross, especially when the man step bold bold into our yard and I ask him, 'What can I do for you?' and him say, 'I have come to see your daughter, Mother Harvey,' and David, I say, 'Well, that is between you and my daughter, but don't call me

Mother Harvey, I am not your mother, I did not give birth to you.' And David, when I say that I just get up and go inside and slam the door. I hear the two of them out there talking and I pay them no mind. From that, almost every Saturday I see him drive up in the big black car, and as I see him step into the yard, I get up and come inside, and a little after that you daughter dress up in a new evening gown — she sew a new one for herself every week — with just some little piece of lace or crochet throw cross her shoulder, and she and him gone in the black car. I warn her till I tired, I say, 'Now that your father gone you think that you are a big woman who can just do as she like, but this is my dead husband house and you cannot rule me in here.' You know what she tell me? She say, 'You' — that is me, her mother, you know — 'you and Mrs. Cleodine Campbell think that God give me life just so the two of you can rule over *me*; well, make tell you, you are not the boss of me!'

"And is just so it went on, David, till a few months ago, when one day I was sitting down talking to Mina in the dining room. I say to Mina: 'Today my mind give me for a piece of dry Lucea yam and I want that yam from no other ground except my dead husband ground.'

Hear Miss Mina she: 'But Mother Harvey, yam outside in the pantry.'

'Did that yam come from Mas David ground?'

'I don't tink so, ma'am.'

'Well,' I say. 'Did you not hear me just tell you that my mind don't give me for any other yam except yam from my dead husband ground?'

'I don't even know if yam is there.'

"Well, I tell you, when I hear that I nearly drop down! I stand up on my foot and I say to her, 'If no yam is there, it must be you and you damn blasted boyfriend fault, for I'm paying

him to work my husband ground, and if he is not doing that, it is because you are there dividing his mind, and the two of you are there with your quakoo bush African business!' And while I'm saying this, in walks you last daughter and the man. And hear him: 'Mother Harvey, I have come to tell you that your daughter and I are getting married.'"

Margaret did not attend the wedding of her last daughter although the wedding was held in her house at Harvey River. If her husband, David, were alive, he would surely have prevailed upon her to put on a show of support for their child's wedding, for as he always said, "Things must be done decently and in good order." But according to family lore, Margaret Aberdeen Wilson Harvey arose on the day of her last daughter's wedding and proceeded to go about her business as if that day were just any other ordinary Saturday. She dressed in one of the demoted church dresses which she usually wore around the yard, she put on her husband's old work boots, and she proceeded to attend to her usual domestic chores, paying no attention to the bride or groom or the assembled guests. Then at some point in the proceedings, she took up her usual seat in her rocking chair in the living room and right in the midst of the assembled guests, she proceeded to puff upon a long chalk pipe, blowing clouds of smoke over the wedding party.

The union did not turn out to be a success. Maybe it was the sight of swatches of her long silky black hair lying like question marks on her pillow when she raised up her head each morning, and what those swatches of hair told her, that made Ann eventually decide to leave her husband, for her hair was falling out from her grieving over her bad marriage. Whoever heard of reading hair? Well, some people can read cards and some can read tea leaves and coffee grounds. But hair reading?

As far as I know, my mother's sister Ann is one of the only people who knew how to read hair. This gift came to her during the course of her short marriage to a man who claimed that he had fallen in love with her because of her great capacity for happiness, for her bubbling over source of mirth, for her wonderful openness, her clear ringing laugh that summoned everyone who heard it to start laughing too. This man who through his irresponsible ways proceeded to snuff out her joy. But Ann grows able to read the future and to heed warnings sent to her by her guardian angels, who, three years after she married this man, begin to write frantic messages to her with her hair on the white tablet of her pillow.

Go Home reads hair. *Go Home Now. Go Home before this bad marriage kills you.* And then, *Go Home, Your Mother needs you!*

Margaret is sitting in the rocking chair by the window when the truck rolls up with Ann and the children. She tells Mina to go and help her daughter to bring the children inside. When a weeping Ann tries to explain to her why she has come back home, Margaret, sounding like the daughter of George O'Brian Wilson, cuts her off by saying, "What's done is done, you have children to raise, stop the damn bawling."

After Ann helps her mother to get dressed for bed and assists her up the three steps into her big mahogany four-poster, Margaret says, "Ann Rebeker, do one last thing there for me, just rub my foot with some of that Canadian healing oil that your sister Rose send." Margaret dozes off while Ann rubs her feet. Ann gets up and makes her way to the other side of the house to her old bedroom, where her children now lie sleeping. Before she leaves she makes sure to close the door of her parents' bedroom, where her father's jacket is still hanging in the wardrobe, his felt hat still resting on the bureau.

And Margaret would have woken up in the middle of the night, feeling blessed that she was no longer alone in the house. Pleased that once again she had children around her, and most of all relieved that her last child was safely back home, away from the dangers of a bad marriage. She would have talked to her dead husband about all this and told him how God moves in a mysterious way, for their youngest daughter is now a big help to her in her old age, that the house is much brighter with children around. How Ann seems more mature and responsible now, that she is a very good mother. "She much more considerate and obedient to me. The other day she just come and say to me, 'Mummah, I want to thank you.' I say, 'For what?' She say, 'Because now I realize what you went through to bring me into this world and to raise me,' and I say, 'Now you know what it is to be a mother, Ann Rebeker. Now you know what it is to be a mother.'"

_F_or weeks my mother's mind had been running on Margaret. As she went about her wife and mother business, it was as if her own mother was beside her, reminding her how things were to be done. "Better you buy a small piece of meat without fat, and stretch it with vegetables than to get a whole heap of fatty meat." "The first thing that a good woman do as she wake up is to put on water to make tea for her family." "No child should rule a parent."

And at night in dream after dream, she kept seeing her mother with her two long grey-and-white plaits, smoking her chalk pipe. In the most recent dream, the smoke from the pipe curled into her good eye and clouded it, then David's face appeared in the pupil of the eye.

Doris woke up washed in a cold sweat and shaking. She told Marcus that they should try to go to Harvey River to visit her mother, but he said he had to wait on his leave. By evening, the news of her mother's death reached her. It was brought to her in person by her brother Flavius.

On any other occasion she would have said, "Flavius Harvey, I long to see you till I short," but when she saw her brother standing in the doorway of her sewing room that day, she knew that this was not a time for childhood jokes.

Flavius stood in the doorway, with his hat placed over his heart. "Dor, I have bad news, I come to tell you that our mother is gone," was what he said.

"Gone? Oh my Lord, oh my God. When Flavvy, when?"

"Last night. Ann say she heard her cry out during the night 'my head, my head,' and Ann run into the room just in time to see our mother fall back onto her pillow, stone dead."

Doris, seated at her sewing machine, drops her head onto her chest; Flavius steps into the sewing room and sits down heavily on the trunk. He and Doris weep like small children.

Doris and her brother sit at the dining table and talk as if they were the only two people in the world. Every time one of my mother's children passes through the room, they mutter something like, "Sorry, Mama, sorry Uncle Flavy, sorry your mother dead."

Except for the eldest siblings, Barbara and Howard, most of the children had no real memory of Margaret because their visits to Harvey River were so infrequent, but they always felt her presence, for Doris quoted her every day on all domestic matters, including the rearing of children.

Long into the night, Doris and her brother keep a wake for their mother. Flavius tells her how a few days before she died, their mother had sent to call him to tell him she had heard that he and his wife, Arabella, were quarrelling because she did not want to leave the Seventh-day Adventists and go with him to join the Jehovah's Witnesses. "'Flavius, marriage is a give-and-take business,' she told me, 'don't you expect to find God on earth and don't expect another human being to understand everything about you.' Those were the last words she ever spoke to me," said Flavius.

It was then that Flavius told her about his recurring dream; the dream in which an angel of the Lord would appear to him

as he wandered in the desert, and whenever he was about to sit down at an oasis, the seraph would say, "Keep moving, Flavius, this is not where you should pitch your tent."

He told Doris how his quest for the one true church had taken over his life. How sometimes when he prayed he found himself begging God to take him home so that he could see his Maker face to face.

Flavius said that his search for the one true religion had come about because of his need to really and truly know the Almighty, and that was what was causing him to change from one church to another. Since he had begun his quest, he said, he had received many visions in which his body moved or was moved in strange ways; and he was taken up to other worlds and shown things that he, like St. Paul, dared not speak of.

Doris sat there in silence for a while and then she reached across the table, took his hand, and said, "Oh poor you, no mine, no mine, I know that one day you will find what you are seeking for. We all have to stick together now. Now that we are motherless and fatherless."

For weeks after they returned from my grandmother's funeral, my father came home early every night and paid special attention to his grieving wife. Every evening he brought her some small present like ice cream or cake, and he tried to cheer her up by bringing her stories. My mother, who loved nothing better than a good story, was sitting with her feet in his lap as he pared her nails one Saturday evening (she would never cut her nails on a Sunday as she considered it bad luck). "Dor," he says, "guess what happen to me today? I had to make one quick swerve so as not to crash the telephone van because this man in the car ahead of me suddenly let go of his steering wheel. My God, the man give up on life right before me," he

said. And then he paused for a moment before he said, "But you know, Dor, I can see with him." There was a short silence, a slightly extended beat before my mother, outraged and appalled at the thought, rose up and roared like a great wounded mammal, "Never you say a thing like that again." She wrenched her foot from my father's hands and stood up over him, shouting: "Nobody should ever take their own life, nobody. That is the biggest sin. The only sin that God will not forgive. The only way to die is to go when God call you like how He call my mother, Margaret Harvey!"

*I*n the early morning hours of Monday, September 2, 1957, when the Montego Bay-into-Kingston train reared up off the tracks at Kendal and headed for grassland, my brother Howard's shoes flew off his feet. They were indigo-coloured suede and they had completed his dance outfit, a powder-blue zoot suit which perfectly suited his slim, six-foot-two frame. We, his brothers and sisters, had watched him admiring himself in the wardrobe mirror that Saturday evening, watched how he had put himself together just so. How when he finished straightening the lapels of his light blue suit, worn with a light blue shirt, and laced on his dark blue suede shoes, he had tenderly, carefully put on his midnight blue fedora, arranging it low on his forehead, slightly to the side. That Saturday evening he was bound for a dance at Forrester's Hall, 21 North Street, in Kingston. There is no evidence that among his friends at the dance there was a girl with red hair, but maybe he felt that the fundraising outing in Montego Bay the next day, which was organized by the nuns and priests of St. Anne's Roman Catholic Church, was sanctified and that a Papal blessing had the power to cancel out one of my mother's edicts. Or maybe he was just feeling restless, adventurous like any young man clad in a powder-blue

zoot suit, his head crowned and protected by a midnight blue fedora. Besides, he was over twenty-one, and he could hardly tell his friends that his mother insisted that no child of hers should go out on a public holiday. So he boogied, yanked, and shuffled all night and half-danced down to the railway station at Pechon Street and boarded the train from Kingston to Montego Bay in the early hours of Sunday morning, where he spent the whole of Sunday partying with his friends.

On Monday morning, the telephone at our house rang at about 3 a.m. It was one of my brother's friends.

"Hello, Mama Goodie, Howie at home?"

"Why are you calling at this hour of the morning to ask me a question like that?"

"Please, Mama Goodie, just look and see if he is there."

My mother at that moment became fully awake, put the telephone down, and went to the room where her sons slept, to check if her eldest boy had come home in the early hours of Monday morning as he often did after a weekend of partying or "bleaching," as Jamaicans call staying out all night. His bed was empty.

My brother's friend blurted, "Mama Goodie, I'm sorry to tell you, but I believe Howie was in the train that crash early this morning at Kendal and kill a whole heap of people."

Calm, for some reason my mother became completely calm, her mind goes underwater, for the next few hours she will do everything as if she was swimming under the waters of the Harvey River. She woke up my father. They woke the whole house, consisting of their eight other children, who were all fast asleep. "Your brother Howard was on a train that crashed this morning." My siblings and I always felt hurt and deprived, hard done by and wronged by my mother's ban on outings on a Sunday or public holiday. When all our schoolfriends boasted

of the grand time to be had at Alterry Beach, at Dunn's River Falls, or Puerto Seco Beach, all the Goodison children could do was keep quiet.

"See me tomorrow on the choo-choo train, sorry you won't be on it," said our schoolfriend Jimmy, who was to come home from the Kendal crash without a leg.

In the cold before-day morning, my parents drive down to Kendal. The whole way there my mother sings over and over in an unsteady watery vibrato the same hymn, "God Is Working His Purpose Out." They reach the site of the crash and hand in hand they make their way through the mass of maimed and dead bodies which had been flung violently down in the wet grass by the horrible capsizing of the derailed train. My father is openly weeping. My mother — who had tied a scarf over her long pepper-and-salt hair, which she had plaited as if she was going swimming — is singing softly. Over and over she rides the calming current of the hymn's words as she and my father look and look quickly away from the bodies lying in the wet grass, searching for their son.

Then my mother sees her tall first-born son walking towards her. His forehead is bloody where death clawed him, but he is walking towards them barefooted, the morning sun behind him. Flying glass had ripped open his head, but his best friend, Hoover, who was sitting beside him, received a fatal head wound. My mother would always wonder if the Angel of Death had mixed up their names, or if her brother Howard, guardian angel of the nephew named for him, had somehow intervened and stood between him and death. She would wonder too if in the process of saving him he had also given his nephew the gift of great peace, for in the years after his brush with death she would watch her eldest son become a deeply compassionate and spiritual man, one who would speak with

260

quiet authority to his siblings about the importance of tolerance and kindness.

On August 6, 1962, Jamaica became an independent country. The Union Jack went down and the black, green, and gold flag of our newly independent Jamaica was hoisted. On the radio they said that the Queen had given Up Park Camp, which was where the now departing British soldiers were billeted, as a gift to the Jamaican people, who wondered how she could have taken it back to England anyway. Independence Day was not celebrated on August 1, which was the day that slavery was finally abolished in 1838, but on August 6, and our leaders said to a country in which 80 per cent of the people are black that the black in our new black, green, and gold flag, stood for "hardship." "Hardships there are, but the land is green and the sun shines." And my father, Marcus, is dying.

For a year he suffered from constant indigestion. Eventually his dinner had to be cooked differently from the rest of the family's so that he became like a child again who had to be fed baby food, soft bland foods like steamed chicken and mashed potatoes and egg custards. Sometimes in the night he vomited in the bathroom. What did Doctor Donaldson say, Marcus? "That I have a stomach ulcer. He gave me these Gelusil tablets." For months he ate small, round, chalky white antacid tablets all the time. He ate them by the dozen, hoping that their soothing, milky chalk would coat the angry inflamed sores in his stomach. But they only got worse. My mother said, "I tell you that Doctor Donaldson is a quack. He is the Company doctor. He does not care a damn about you. You better try to see a doctor at the University Hospital."

At the University Hospital the doctors cut Marcus's stomach open, then quickly sewed him up again because the sores

in his stomach were cancerous and spreading rapidly. At age fifty-five he lay in the front bedroom of the house at Harbour View that he and my mother had just bought. He lay there, in a drugged sleep, his body rapidly shrinking, taking up less and less space in their double bed.

"Marcus, what do you think we should do about adding on another bedroom and a carport?"

"I don't know, Dor, can't you see that I am not dealing with worldly things now?"

And Doris, who knows this but does not want to hear it, breaks down and weeps.

"Papa, guess what, Karl take my good shoes and give them away."

My brother Karl, who was born a social worker, would make periodic raids on our possessions, taking our shoes and clothes and giving them away to the really poor children of Kingston, then lecture us, his siblings, about having more than one pair of shoes when some people have none. Normally, my father would have told him that he should at least ask us first before he helped the really poor with our things. But my father just smiles a half-smile and says:

"That's just material goods." Then he closes his eyes.

My cousin Joan sits with him sometimes, she just sits there, quietly holding his hand. I tried to but I cannot sit still and watch my father die. So I learn to cook egg custards and milky baby foods to feed to him. Sometimes he says, "Come and sit and keep my company," but I cannot sit and watch him die. On Monday, December 6, 1963, his stomach became rock hard. He was vomiting blood, and the only place for him was the hospital.

"Hello, Dr. Thompson. How is my father?"

"Marcus went about an hour ago."

My brother Nigel was outside in the street playing football. I stood on the verandah and called out to him.

"Nigel, Papa dead."

He said nothing. He just kept on playing football, kicking the ball up and down the street. He played until the street lights came on and he kept playing, kicking the ball harder and harder. He played until people began to turn off their lights to go to bed, he kept on playing football. Then he stopped and abruptly sat down on the sidewalk under a street light and dropped his head into his hands.

\mathcal{C}leodine knows that ignorant, cruel people call her "Mule" because she has never birthed a child. Sometimes they even call her "Grey Mule" because she is so light-skinned, but they never call her so to her face, never. Behind your back is "dog" but to your face is "Miss Dog." No, they never call her anything to her face but "Miss Cleo, Mi Missus." Or her married name.

All she wanted was one child. One child. Not a whole brood like her sister Doris, whom she once referred to as a "baby-factory." She eventually adopted a child from a nearby village, a girl with a yellowish complexion like hers. But try as she might to make her into a young version of herself, confident, gifted, erudite, and superior, the child proved to be gifted only at mischief-making; and by the time she ran away to Kingston with a truck driver at the age of sixteen, she had managed to earn the undying dislike of every member of the Harvey family, so dedicated to creating trouble for others was she.

"Queen Cleodine," her husband used to call her. "My queen," he called her. She wouldn't have believed that he would ever have the gall to disgrace her because he used to say himself that he was so lucky to be married to somebody like her. She had eventually told him, "Since you are mixing up with these

common women in the village, you are never, never again in life to touch me." She is determined as always that they will never haul her down, never. Her back becomes straighter than ever. She walks to church each Sunday, dressed perfectly. She is partial to fine linen dresses tastefully trimmed with hand-embroidery. Her pumps are leather, soft for her long feet. She fashions her hats herself, there is no chance, none, that some blasted commerown will ever wear the same clothes as she. She walks through them every Sunday, fixing her spectacles on her narrow nose bridge.

He built her coffin while she was still alive. One day her husband came up with the suggestion that since she was so particular and fussy, since she did not like for a lot of strangers to be crowding up her yard at any time, that they should make arrangements for their funerals while they were still alive. She said nothing, just allowed him to call in the carpenters and make the two coffins, then he stored them under the house. It was her brother Flavius who noticed them and Ann remarked on it too, that her coffin was stored directly under her bed-room. It was as if the man was hoping that she would fall right through the mattress and the floorboards and nestle perfectly into the cedar dress that he built for her. Her brother Flavius asked Clement why in the name of God he had put his wife's coffin right under her bed. Clement acted as if he hadn't even heard. Flavius just stood right there in the yard and began to pray the Lord's Prayer.

In her heart Cleodine was praying too, calling on David and Margaret and all the Harvey generations to protect her. In a dream her mother came to her, right there on the front veran-dah, she came and said that she was sorry, that she had been taken in by appearances; that she should have looked past this man's dashing caballero act that he had learned in Cuba and

Panama; that she should have seen that he had lived the loose life too long and that he would never truly be able to settle down. Now that had to be a dream, for Cleodine never heard her mother say she was sorry in all the time she was on earth. Cleodine got that from her. She too did not believe in saying "I'm sorry." She believed that you should try to do a thing right in the first place and then there would be no need to be sorry. After that dream Cleodine woke up in the middle of the night and played the organ until morning. She was alone in the house so she disturbed no one.

Still, when her husband suddenly fell ill, she nursed him, cooked for him herself, tried to give him all the healthy food he didn't want to eat. "Leave out the fatty pork and the beef," she would tell him, "that kind of food is not good for your heart."

They eventually hauled out his coffin from under the house and put him in it. My mother went down for the funeral with some of her children. She was a widow too now but she had nine children. If each child represented an opportunity to help a parent, my mother had nine more chances to get a drink of water than her sister. At the funeral, when Cleodine was sitting in the front pew with her eyes dry, Doris went and put herself beside her sister and took her hand and sat there with her hand in hers for the entire funeral.

⁓

The day after my mother died, I go to Papine Market to buy food for the people who would be coming to pay their respects to the family at my brother Keith's house at #8 Marley close. Weighed down by loss, I walk slowly into the market and as I approach the stall where my friend Peggy sells yams, she calls out to me, "My friend, what happen to you?" I come up and

stand by Peggy, who is seated before a big heap of yams, and I say, "Peggy, my mother dead." And the minute I say that, she turns to the woman to her right, then to the one to her left and the one behind her and tells them, "Her mother dead." Immediately these women leave their stalls and come and circle me and begin to sound the Jamaican Om: "nuh mine nuh mine nuh mine nuh mine." I just stand there weeping, allowing their sounds of consolation to push back my grief. And as I am standing there in their midst, my mind drifts back to the time I'd told my mother I wished that I was dead, and how she had almost killed me for saying something so horrible.

I had been about twelve years old at the time. It was a Saturday morning, and just as I was escaping deep into one of my sister Barbara's books, my mother called me into the sewing room and presented me with a two-page shopping list which she had drawn up in her beautiful, confident handwriting. "A good fist, we Harveys all have good fists," she'd always say in admiration of her own handwriting. And so, with her good fist, she had smashed my plans to spend the day reading *The Loneliness of the Long-Distance Runner*.

I didn't like going to buy trimmings. It meant taking the bus downtown to King Street and walking from store to store and trying to get the exact match to the things on the list. My mother's standards were very exacting. If the colours were a little off, or if you bought one-inch belting instead of one and a half inches, or if you bought buttons which in her opinion looked cheap because you had skimmed off some of the trimmings money and bought an ice-cream cone from the cafeteria on the second floor of Times Store, she would become harsh, angry, and insulting about your lack of good taste. At such times she looked just like her mother, Margaret, did in a photograph taken with David in the yard at Harvey River on their

fortieth wedding anniversary. "Mummah look vex in this photograph because Puppah give away almost everything that they owned," my mother would say.

As I stood there, wilting under my mother's fierce gaze, I thought on the injustice of my seeming to be the only one of her children who was available to buy trimmings. And the more I thought upon this, the more I became convinced that a serious wrong was being done to me. The boys could not be sent to buy trimmings for the same reason that my mother did not let them do housework, such activities being unmanly. My sister Barbara was at work at the newspaper, and my other sister Betty was never able to go out on her own because of her epilepsy. It just did not seem fair to my teenage self. I started to cry at the misery of it all, at being the only one chosen to do this errand which, as my mother pointed out, would help to put food into our mouths. I stood there weeping as she handed me the list of zips of various lengths and beltings of different widths and buttons to be bought at Triff Hyltons and covered buckles and accordion pleating to be collected at Amy Cruz's. Through my resentful tears, I said, "I hope that a bus runs over me and kills me when I go downtown, and then you will be sorry that you forced me to go."

I would live to regret saying those words for many years to come, for my mother repeated them to everybody as proof that I was a Don't-Care girl with a divided mind who was in danger of "becoming dead to trespasses and sins." She was not intimidated by my hysterical adolescent attempt to guilt her out. She ordered me to go and buy the trimmings anyway. As I left the house in tears, I wondered what would happen if a bus did run over me. Would people say, "the poor little girl get a warning man, her mother should never force her to go downtown and buy no trimmings that day, I am telling you, the woman well

hard, look how she send the poor child to her death." Fortunately for both of us, I completed my trimmings errands without being killed by a bus, and now here I was, more than thirty years later, crying in Papine Market because my mother was dead.

One by one, the women standing around me begin to testify to the goodness of one's mother. "There is nothing like a mother, no sir, there is nothing like a mother's love." "Even if your mother is the worst woman in the world, you still have to love her because she give you life." One woman tells of her mother's peaceful passing in the care of a loving daughter: "I did just bathe her and put on a new panty on her and put her to sleep on a clean sheet, and is just so she sleep off." Each of them tell me about this rite of passage when your mother becomes your child, and I stand in that loving circle of women, like Sally Water of the children's ring game, with weeping eyes as they comfort me, no mind no mind no mind.

As I stood there with Peggy and her friends in the market, I remembered how just two days ago, the day before my mother died, I had gone to look after her and I'd noticed that her face was glowing. I swear she looked like a bride. I remembered with great shame how sometimes I had been downright ungracious about going to take care of my mother in her last days because she could be very demanding. Some days the twelve-year-old girl who resented being the one who had to go and buy trimmings would rise up in me as my mother would telephone me at 6 a.m. and issue me orders to cook her Sunday dinner and bring it to her before midday, or insist that my brother Keith and I take her to three different doctors in the span of two days because she did not like what the first two had told her, which was essentially that her mighty heart was giving out, and that there was very little that could be done for her at age

eighty-five. But the day before she died, I felt blessed and privileged that I had been able to do something for her.

"Who sent you here?" she had asked after I told her I was leaving. I had no answer for that question so she answered it for me. "God sent you," she said. We both laughed. "Is there anything else that you want me to do for you today?" I'd asked her, and she had said that she could not think of anything more that I could do.

I was standing in Papine Market thinking of how I'd spoken on the telephone to Aunt Ann and her daughters Joan and Myrna in Montreal the night before, and at the end of our tear-filled conversation they had said that they wanted to send special fabric to make my mother's shroud. I remembered how my mother had shown such strength after my father died. How she had sewed appropriate dark dresses for me and my sisters and how she had walked with such dignity down the long path from the church to the burial site in the Half Way Tree cemetery. How after the funeral she had received visitors, feeding all who came and treating them like honoured guests, and how for weeks she did not break down before her children. If she cried, it would have been in the privacy of her bedroom at night, where she now slept alone after so many years of marriage. Then one Sunday morning, she got up early and went into the kitchen to make breakfast, and as she stood by the stove, peeling green bananas from their skin before she dropped them into the pot of boiling water, she broke down and began to bawl. I will never forget the sound of her crying as long as I live, for in between those wrenching sobs that were being hauled up from her belly-bottom, she was saying, "O my Marcus. My Marcus Goodison, there will never be another man like you."

"My friend, you look shaky, you better sit down," says

Peggy. "Yes, yes, make her sit down," the women say as they break up the circle to lead me to an upended wooden crate next to Peggy's stool. I gratefully sit down and one of the women says, "What you want is a water coconut to wash off your heart." She goes over to her stall and selects a green coconut which she expertly cuts open with one swift sweep of a machete, then she comes back and hands it to me. "Drink this, it good for you. Just sit down there and drink the coconut till you feel better, my friend."

"Yes, thank you. Thank you very much," I say, nodding.

Then all the women return to their respective stalls, leaving me to sit on the wooden crate, drinking the water coconut, and thinking about how my mother came to know happier days, such as when she would go to visit her sisters Rose and Ann in Montreal. In the years after my father died, my mother made several visits to Canada to see her sisters, and she was finally able to see snow for herself.

"Doris, the taxi is waiting outside," Rose said. "She change her clothes ten times already," said Ann.

"The two of you just leave me, for I am not going to Expo 67 to hear Tom Jones sing in these stockings that are too light-coloured for this dress."

My mother must have found the appropriate stockings, for she and her sisters did go to see Tom Jones, and she did have wonderful times visiting with them in the city of Montreal. When she came back to Jamaica, she told us:

"Every Sunday we would go up to see Miss Jo at the Mount Royal Cemetery. She has a lovely view of the city from where she is."

In the decade after my mother lost her husband, and with some of her children still living at home, she became a caretaker again as her brothers and sisters, recognizing her strength and

compassion, turned to her as their own lives became diminished by age, illness, and fears. My mother nursed both Cleodine and Edmund in their old age, and they both died in her house.

It was with great reluctance that Cleodine had made the decision to spend her last days in my mother's humble house at Harbour View. After Clement's death, she had continued to live as mistress of Rose Cottage for more than fifteen years; but by 1975 the lifestyle she had been accustomed to was becoming too difficult for her to maintain. For one thing, full-time domestic help was now hard to come by since the passing in 1974 of the minimum-wage law, which stipulated that domestic helpers should have a five-day work week and be paid double for work done on weekends. Cleodine began to find herself more and more alone in Rose Cottage as newly liberated helpers — who were no longer to be referred to as maids — refused to do her bidding. Besides, as she got older, she did not become easier to get along with. She finally consented to go and live with my mother after she suffered a mild stroke. Before she left Rose Cottage, she locked away her prized African violets in an empty room where they gave up their intense colour to the darkness and died.

Doris finally persuaded her to come to Kingston so she could take care of her. And take care of her sister she did, drawing her hot baths and cooking her healthy foods so that Cleodine was able to recover quickly from the stroke, at which point, as she had when they were children living in David and Margaret's house, she proceeded to order about her younger sister, who by then was in her sixties. This went on for three years until one Sunday morning Cleodine arose and got dressed in all her finery to go and attend services at St. Boniface Anglican Church in Harbour View. She stood before the mirror of the mahogany bureau that she had brought with her from Rose

Cottage and secured her hat with a pearl-tipped pin, then turned and picked up her handbag and fell forward, managing before she landed to snap the shining clasp on her handbag shut. My brothers drove her to the hospital, where she died before evening.

In accordance with the clear and specific directions in her will, her body was returned to Kingsvale, Hanover, where she was buried in the churchyard. In his sermon, the minister said that her disciplined, industrious, and dignified life had been an example to everyone who had ever met her.

About a year after Cleodine's death, Edmund arrived. Though he had enjoyed his taxi-man cowboy life, he had grown increasingly lonely and frail, and he feared dying alone. Doris nursed him for the last years of his life until he peacefully passed away in his sleep.

The one request he had before dying was that his body should not, under any condition, be taken back to Harvey River for burial. He hinted that his duppy would make things very uncomfortable for anyone who should try to take him back there. The family granted him his request by burying him in the May Pen Cemetery in Kingston, in a spot facing Spanish Town Road. As we stood in the cemetery watching the mason sealing Uncle Edmund's grave, my mother addressed him for the last time. "Edmund," she said, "you rest in peace now, I know you don't want to go back to Harvey River, so you just lie down right here where you can see your taxi man friends driving by."

Later, when Flavius became ill, he had wanted to come and spend his last days with his sister Doris too, but by then her mighty heart had begun to give out and she herself was in need of nursing.

It had been her beloved sister Rose's death years before that

had begun to weaken my mother. Accompanied by my brother Keith, she had made her own straight-backed way across the tarmac at Norman Manley Airport and boarded an airplane to Montreal for the funeral of her beautiful sister. She had come back an old woman, leaning heavily on the arm of her son.

After my mother's death, her sister Ann would swear that all the Harvey girls came regularly to visit with her in her Montreal apartment, and she often dreamt that they were all dressed up in their finery and walking into the town of Lucea. Ann died ten years after my mother, following the tragic death of her youngest child, my cousin Joan.

My mother loved her people, her "generations" as Jamaicans call their blood relations. Every one of them meant something to her. The night before she died, I dreamt that my father had driven up to my mother's house in Harbour View in a big black limousine. He had driven straight through the locked gate and up onto the verandah, and even in the dream I knew that he had come to take Doris to where her people were congregated, waiting for her to join them and to enter into her rest. The day she died, she sat up in bed and began to say her husband Marcus's name and then the names of her parents, Margaret and David. Then one by one, she called out the names of her brothers and sisters.

I was sitting on a wooden crate in Papine Market with long eyewater running down my face when I remembered my mother's last request. "When you come again," she had said, "bring me an onion." And then she said, "Don't forget me."

And so I wiped my eyes and walked over to the food stalls, where I thanked the women who had stood in a circle and comforted me. I bought onions and Lucea yams from Peggy, and from the other women, balls of hard cocoa paste to make chocolate tea as Jamaicans call hot cocoa, and cassava bammies

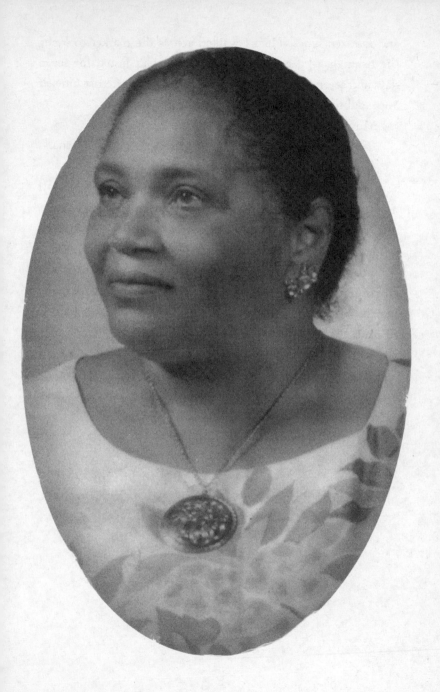

and a dozen limes. Then I walked across the market to Fishy the fishman, who once told me how he had fasted for seven days and seven nights, until on the last day Jesus Christ himself appeared to him at the eastern gate of the market.

"Eight pounds of butterfish please, Fishy."

"What you doing with so much fish today, Miss Lorna?"

"Fishy, my mother dead."

He looked up at me as he scraped the iridescent scales off a butterfish and said, "She is resting with the angels now."

My mother's hands always smelled of onions. My mother had a bottomless cooking pot. She could sew clothes to fit any shape and the first word that all her children learned to read was SINGER. My mother was one of the fabulous Harvey girls. She was the seventh child of Margaret and David Harvey, and the wife of Vivian Marcus Goodison. Her nine children are alive today and drawing on the blessings she earned for us. She dipped her finger in sugar when I was born and rubbed it under my tongue to give me the gift of words.

Epilogue

I have no idea where I am. I have woken in pure panic in a place solid with darkness which smells like the rusting interior of a brass trunk. The bed I'm lying in is not my own, for it does not face an east window. I cannot locate the door by which I entered here and my frantic scrabbling along the walls on either side of this narrow bed does not summon up a light switch.

"Say the Lord's Prayer, say the words 'Our father' over and over, if you can't remember the whole prayer, shorten it," my mother would say. This is urgent, chant Our father, our father, our father, our mother, our mother, our father. Mother, where am I?

And so I sing slow enough to do what I need to do next, to identify myself, to myself. Here is what I say to myself in that tomb place. My name is Lorna Goodison. I was born on the first of August, which is celebrated as Emancipation Day in Jamaica. I was born at 6 a.m. on a Saturday morning after my mother took a cold shower. My father's name is Vivian

Marcus Goodison; he died when I was fifteen years old. My mother's name is Doris Louise Goodison; she was born a Harvey, of Harvey River. Harvey River is in Hanover; Hanover is the smallest of the fourteen parishes of Jamaica, which is 345 square miles. Jamaica was first named Xamayca, which we were taught means land of wood and water. The Blue Mountains rise up to seven thousand feet. The Dolphin Head Mountains contain the headwaters of the Harvey River. My son's name is Miles. I am a writer. I can turn this darkness into the river at night. My mind like the riverbed will become cool and still. I dive and under the surface of the water, I know what I'll find. The evidence of my generations. The small schools of fish will flutter by like my mother and her sisters and brothers. Cleodine, Albertha, Howard, Rose, Edmund, Flavius, Doris, and Ann on their way to school. A pair of old mullets who rule the river will come too, representing David and Margaret, my grandparents. The wild-haired water grass and tenacious weeds will wave and bow, respect due. But I'm alert too, under this dark water, watching out for the pincers of the crabs that can bite. Under this river there are shocking eels, quick and slippery, and there are secrets hidden in the holes where they coil. The don't-care girl is still dancing there under the river. There are lost pearls and hopeless cases and the bones of runaway Africans down there as well as wedges of iron-hard brown soap which the women of Harvey River used to wash acres of clothes in this same river. As long as I swim in it, I will be borne to safety. And so I swim until morning comes and reveals that I'm sleeping in a small baroque hotel room, with the heavy velvet curtains drawn, after giving a poetry reading in Hanover, Germany, and immersing myself in the waters of the river named for the Harveys calmed my night fears.

Afterword

New York made a writer. I went to the great city convinced that I was a painter who secretly wrote poems and stories. By the time I left, I had become a writer and sometime painter.

I had gone to New York from Jamaica in the summer of 1968 to attend classes at the school of the Art Students League, and on my second week there I witnessed a most amazing sunset over the Hudson River. It was straight from the Book of Revelation: fiery crimson, gold and purple clouds twisted and scrolled across the horizon assuming such weird and fantastic shapes that I wondered if the drama of the Apocalypse was about to unfold right there as I sat mesmerized in the backseat of a cab hurtling along Riverside Drive. I remarked upon the unusual sunset to the taxi driver, who informed me with a New Yorker's "don't care" attitude that it was really pollution from industrial smokestacks that was causing the clouds to behave in that way. But when I wrote and carefully described the splendid polluted sunset to my mother,

Doris, she replied with a question: "Who were the Hudsons that the river was named after?"

Whenever people in my family thought of going away to live in a big city, they usually went to Montreal or Toronto. But I chose to go to New York because I had read and heard so much about that city in books like Paule Marshall's *Brown Girl, Brownstones* and in songs like "Manhattan," sung so sweetly by Dinah Washington. Besides, I had dreams of becoming a great painter, and after spending a year at the Jamaica School of Art I decided that I wanted to be trained according to the old system; I wanted to paint with a "master," and at the Art Students League there were masters like the brilliant African American painter Jacob Lawrence. So I came to New York in the hope of working with him; and after painting for one term with portrait painter Robert Brachman, I was fortunate enough to get a place in Jacob Lawrence's class in the winter of 1969.

I credit my time in New York City with force-feeding my senses, its extraordinary sights and sounds overtaking me on a regular basis and producing that spontaneous overflow of powerful feelings that William Wordsworth called poetry. I had been made to memorize Wordsworth, along with the other English Romantic poets, from the time that I went to All Saints School in Kingston at the age of seven, and one day while I was passionately reciting "I wandered lonely as a cloud"—a.k.a. "The Daffodils"—it occurred to me that I had no idea what a daffodil looked like, and that maybe I should be reciting a poem about a flower I'd actually seen. Since there weren't any such poems in our school reader, I thought that maybe one day I should try to write one. In a sense, "I wandered lonely as a cloud" irritated me into writing poetry.

But it wasn't that simple. Looking back now, I realize how lucky my siblings and I were to have gone to that school. It

produced many of Jamaica's internationally known artists, athletes, and reggae musicians, including Marcia Griffiths and Bunny Wailer. Unfortunately, it no longer exists.

It wasn't just poetry that we learned there, though we learned dozens of poems by heart, and I was part of a choral group that recited verses. The headmaster, Ralston Wilmot, took us further afield. His favourite song was the old standard "Vive l'amour, Vive la companie," which he taught the entire student body to sing with great gusto; and so the students, in the grateful way of the young, christened him "Vivilla." And music was part of my household, for I grew up in the midst of modern Jamaican music, and a number of the great musicians of the time were friends of my brothers Bunny and Kingsley, who would both go on to work in the Jamaican music industry.

I was also taught drawing, painting, and imaginative composition by a real art teacher, in a spacious room located just opposite the huge playing field where students were encouraged to excel at sports. She even entered one of my paintings in a competition run by the Institute of Jamaica, where it won a prize.

From the time I was five or six years old, gazing in wonder at the black Christ carved by Edna Manley above the altar of All Saints Church, I knew I was going to be an artist. I had taken to sitting still and staring fixedly at cover illustrations by Norman Rockwell on the copies of *The Saturday Evening Post* magazines brought home by my sister Barbara, who was then a young reporter at the *Gleaner* newspaper. I was also enthralled by the movies that my siblings and I would go to see on Saturday afternoons at the Ward and the Carib theatres, and by the live stage shows where visiting artistes like Frankie Lymon and the Teenagers, Clarence "Frogman" Henry, the Platters,

Fats Domino, Little Anthony and the Imperials, Professor Longhair, and Paul Anka would dazzle local audiences with their smooth harmonies and fancy footwork.

I also remember being completely enchanted by performances given by visiting ballet troupes; and one Christmas I had the unforgettable experience of being taken to see the world-famous Welsh actor Emlyn Williams read excerpts from stories by Charles Dickens and from Dylan Thomas's "A Child's Christmas in Wales." I learned early on that the world of art and the imagination was a wonderful and magical place.

At the age of twelve I went to St. Hugh's High School for Girls, also in Kingston, where I became the beneficiary of a colonial education that in addition to regular academic subjects (from a curriculum imported directly from England, including two compulsory years of Latin) offered weekly music appreciation classes and drama and elocution lessons, where the girls of St. Hugh's would perform operettas—usually Gilbert and Sullivan—with the boys from Kingston College. Among the subjects we studied were English literature, French history, botany, and art, all of which I particularly enjoyed. I also loved comparative religion, where we learned about all the major religious traditions of the world.

In English literature classes we were taught the works of a wide variety of writers such as Geoffrey Chaucer, William Shakespeare, Richard Sheridan, Ben Jonson, John Milton, John Keats, John Masefield, Rupert Brooke, W. B. Yeats, T. S. Eliot, and D. H. Lawrence. We even read plays by John Osborne and Robert Bolt. But never once were we introduced to a poem, a story, or a play by a West Indian or African American writer; and very rarely did we ever encounter anything written by a woman. I secretly began to remedy that, writing the poems and stories that I wanted to read, poems and stories by a little

Jamaican girl who wanted to see herself and her people reflected in the books she read, a girl who had never seen a daffodil but who did not find the idea of dancing flowers in the least bit strange.

Partly because my sister Barbara was now the professional writer in the family—I figured that job was taken—and partly because by the time I graduated from St. Hugh's I had had enough of reading poems, stories, and plays written by men from England, I decided, nonetheless, that I was going to spend my life reading great books and producing paintings. I would have my studio up in the Blue Mountains, where I had lived from age fifteen with my sister and her family in their house by the Gordon Town River. Still, books and writing kept coming into my life; and I went to work first as a bookmobile librarian and then as a copywriter in an advertising agency before going to art school.

By the time I left New York, I was writing almost as much as I was painting; and it was in New York that I wrote a number of the poems that would appear in my first collection, *Tamarind Season*, which included a long narrative poem titled "For My Mother, May I Inherit Half Her Strength," which has been widely anthologized. In many ways, it was an early draft of this memoir; it was my first attempt at singing a praise song for my parents, at finding a way of understanding their lives and recording a way of life in rural Jamaica that has all but slipped away.

One of the most satisfying things about that poem, and one of the things that I hope this book catches, is how their story seems to resonate with people in different countries, and from different cultures. I remember giving a reading at a school in London, England, where a little Italian boy came up to me and told me that my poem about the life of my parents was

also the story of his own grandparents. I think that my family's story is one that is shared widely around the world, and especially in the Americas.

In 1983 I went as a visiting writer to the University of Iowa's International Writing Program, and there in Iowa City, in the company of writers from more than fifteen countries, I experienced firsthand the sense of shared humanity that can be generated by stories, plays, and poems. In Iowa I wrote many of the poems in my second collection, *I Am Becoming My Mother*, which won the Commonwealth Poetry Prize for the Americas in 1986. I was fortunate enough to be spending a year as a fellow at the Bunting Institute at Radcliffe College in Cambridge, Massachusetts, when the prize was announced, and soon after I began to receive invitations to travel abroad to give readings in Europe and Africa and in different parts of the United States.

I had expected my mother to say, "Go, and be yourself," for that is what she would always say when I'd tell her I was off to give a reading somewhere. But this time when I told her that I'd received an invitation to read my poetry at the University of Michigan in Ann Arbor (which would lead to an offer to teach creative writing there) my mother said, "Go, and make your own way." Maybe she sensed that the semester as a visiting writer was going to be the beginning of a new life for me, a life in which, like her, I would learn to live in several places at once. Over the past fifteen years, in Kingston, Ann Arbor, and Toronto, I have gradually become part of a community of writers and scholars and students who have greatly encouraged the growth and development of my work.

Some of my students at the University of Michigan

(including many of the athletes on the Wolverines football team, whom I regularly teach) go to Jamaica—usually to Negril—for spring break. They invariably return all sunburnt and relaxed, and ask me, "Lorna, how could you possibly leave Jamaica?" I always tell them that I'm only doing what people in the New World have always done, going to places where there are opportunities to earn a living. "Making life," we call it in Jamaica. This is what my mother meant when she told me to make my own way. This is what she and my father had done when they moved to the city of Kingston after their comfortable life in the country came to an end. She found out what it was like to have to start out on her journey all over again just when she thought she was safely home. She learned how to cope with "hard life" by drawing upon the great store of wisdom and knowledge generated by the experiences of her ancestors. I hope I have inherited half that wisdom.

Acknowledgements

In reconstructing and re-imagining the story of my mother's family and their forebears, I have of course taken certain liberties, including, on some occasions, changing dates to suit narrative flow.

~

First, last, and always, I give thanks and praise to the Most High.

There are many people I would like to thank for their support in making this book possible: Dawn Davis, for her wholehearted belief in this book; Bryan Christian, for being so solidly behind it; Gilda Squire, for getting the ball rolling; Christina Morgan and Shatima Washington, for all their help and support; Marilyn Biderman—much much thanks; Ann Harvey Moran, who blessed and assisted this project; Jan Sharp, the presiding spirit of this book; Myrna Moran, for her gracious help; Barbara and Ancile Gloudon, with love and thanks; Howard Goodison, who is a wise man; Paulette Goodison, my niece and

my friend; Keith and Jennifer Goodison, with much thanks; Betty, Bunny, Kingsley, Karl, and Nigel Goodison, with much love; Joyce King, my cousin; Ali Darwish, sincere thanks; Reverend Michael Granzen; Jennifer Glossop, who pointed the way; Janet Irving, Sylvie Rabineau, Leigh Feldman, and Janet Silver— thank you for keeping this project alive; Roy DaSouza and Neville James, for the information about automobiles; Dr. Freddie Hickling, for information about Bellevue; Rex Nettleford and Philip Sherlock, two elders who taught us to honour our ancestors; Helen McLean; Patrick Waldemar; Petrona Morrison; Errol Moo Young; Tony Robinson; Vivian Crawford and everyone at the Institute of Jamaica; Jean Smith; Barry Chevannes; Louise Bennett, "Miss Lou," for the story of "Nayga Bun"; Maxine Brown Lawrence, who typed a very early draft of this book; Ben, Vangie, and David Clare, for their Hanover hospitality; Liz and Bob Food, with much love; the handsome Avie Bennett, with Respect Due; Ambassador John Robinson; Reverend Carol Finlay; Brian Corman; Isabel Bassett; Lincoln Faller; Sid Smith; Neville Dawes; Eddie Baugh, John La Rose, Sarah White, Michael Cooke, Larry Lieberman, Jahan Ramazani, and Michael Schmidt, for encouraging my poetry, which has fed this book.

Thanks also to the incomparable Ellen Seligman, who said "I want to bring this book home," and for doing just that with grace and authority; the amazing Anita Chong — Cleodine and I thank you, Anita; Elaine Melbourne, my good friend and mentor, who helped me stay the course for the twelve years it took to complete this book; my beloved son, Miles, who made me many cups of tea when I first began to write this book at the Ponds of Georgetown in Ann Arbor, Michigan. And finally to my best friend, tender companion, and unfailing encourager, John Edward, for never doubting that this book would become a book. Thanks, Sweetie.

Denis Valentine

LORNA GOODISON is an internationally recognized poet who has published eight books of poetry and two collections of short stories. In 1999 she received the Musgrave Gold Medal from Jamaica, and her work has been widely translated and anthologized in major collections of contemporary poetry. In 2008 *From Harvey River* was named the winner of Canada's largest nonfiction prize, the British Columbia Award. Born in Jamaica, Goodison now teaches at the University of Michigan. She divides her time between Ann Arbor and Toronto.